ETIENNE APPERT
Story & Art

EDMOND BAUDOIN
Art, pp 76-77, 104-105

•

BEN CROZE
Translator

•

VICTORIA PIERCE & MARK WAID
US Edition Editors

VINCENT HENRY
Original Edition Editor

JERRY FRISSEN
Senior Art Director

RYAN LEWIS
Junior Designer

MARK WAID
Publisher

Rights and Licensing - licensing@humanoids.com
Press and Social Media - pr@humanoids.com

RIVER OF INK. This title is a publication of Humanoids, Inc. 8033 Sunset Blvd. #628, Los Angeles, CA 90046.
Copyright © 2021 Humanoids, Inc., Los Angeles (USA). All rights reserved. Humanoids and its logos are ® and © 2021 Humanoids, Inc.
Library of Congress Control Number: 2020952872

Life Drawn is an imprint of Humanoids, Inc.

First published in France under the title *Rivière d'Encre* Copyright © 2020 La Boîte à Bulles & Etienne Appert. All rights reserved.
All characters, the distinctive likenesses thereof and all related indicia are trademarks of La Boîte à Bulles Sarl and Etienne Appert.

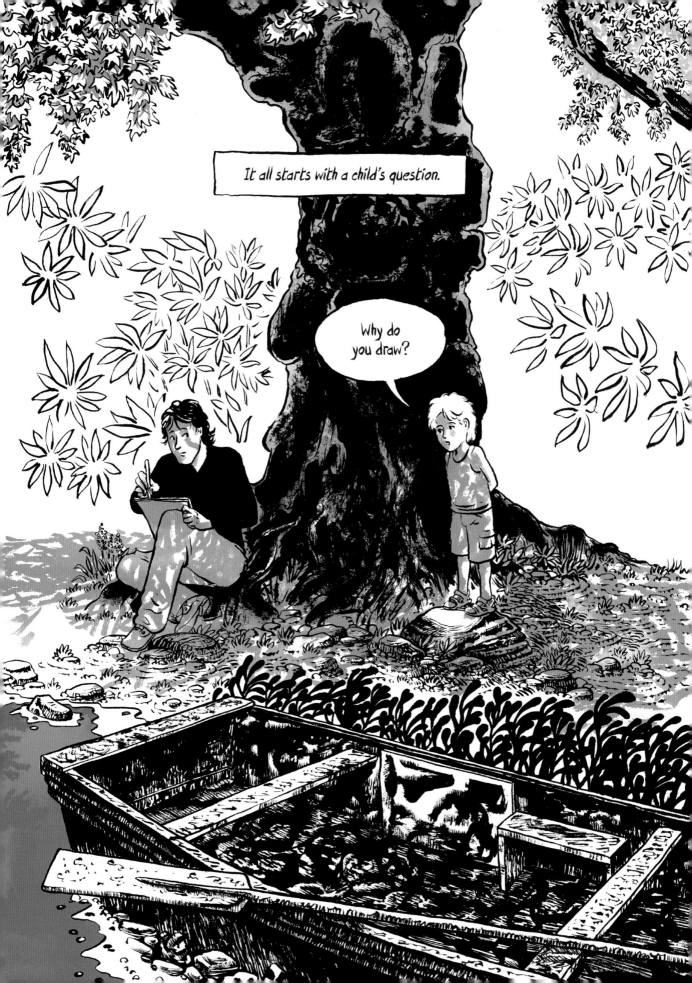

I read in the boy's eyes that a superficial response won't do.

The innocence of a real question deserves more than an ordinary explanation.

I don't know.

You know, it's funny: I've been drawing for almost forty years now, and I still don't truly know why I do it.

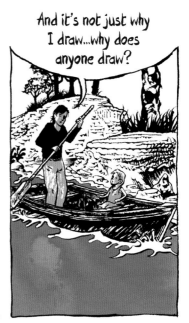

And it's not just why I draw...why does anyone draw?

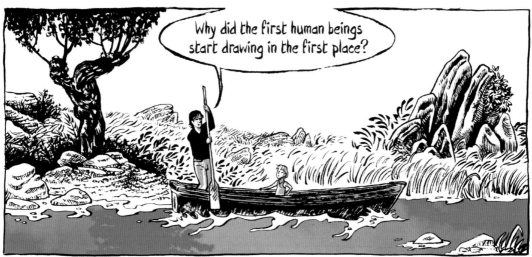

Why did the first human beings start drawing in the first place?

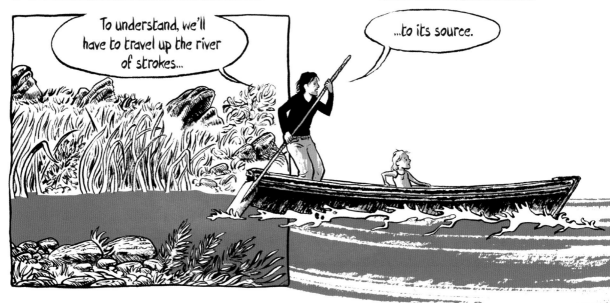

To understand, we'll have to travel up the river of strokes...

...to its source.

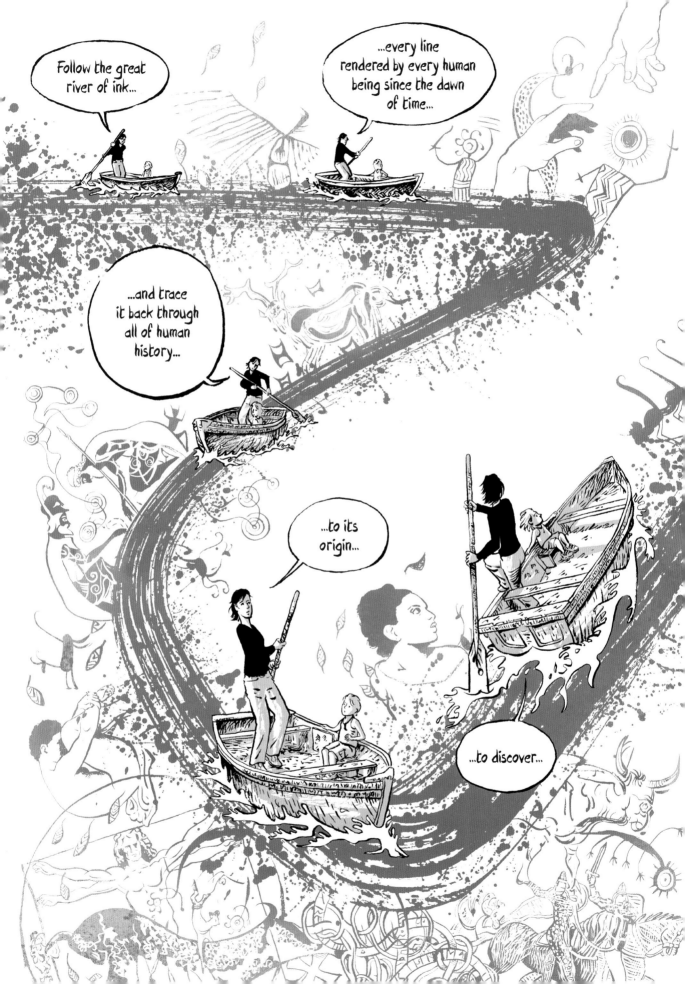

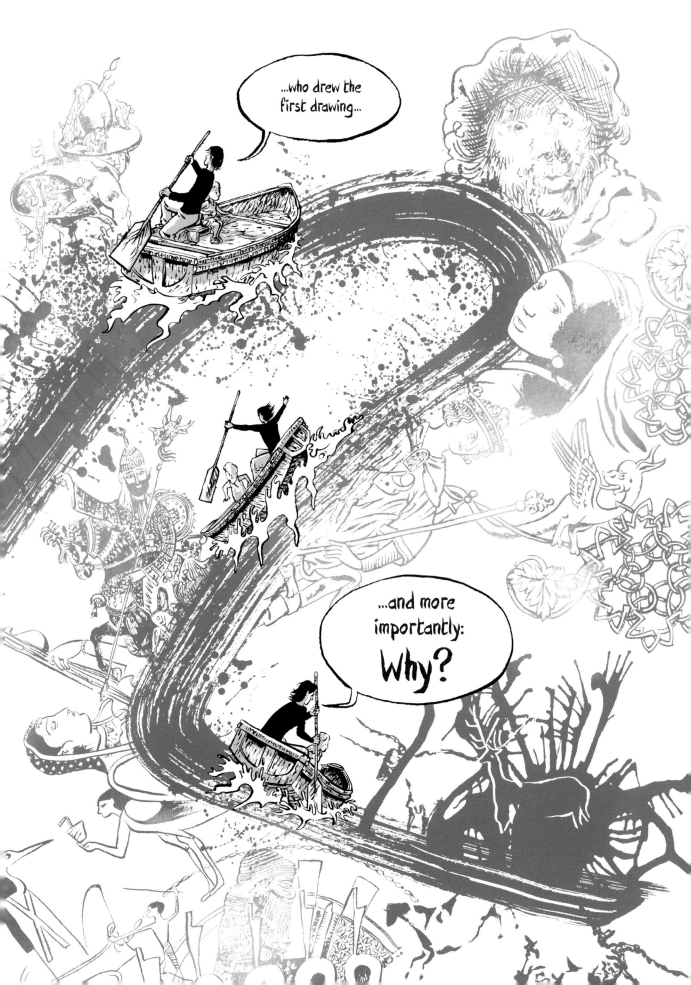

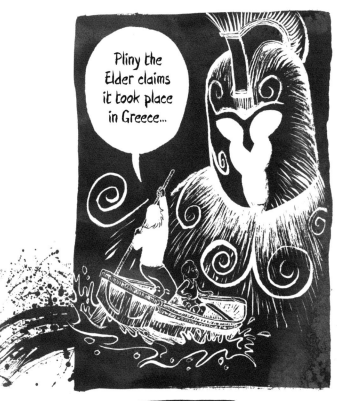

Pliny the Elder claims it took place in Greece...

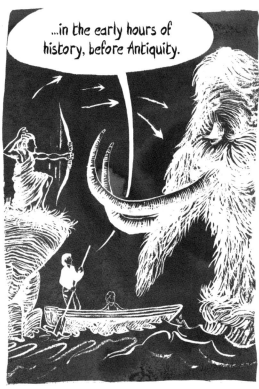

...in the early hours of history, before Antiquity.

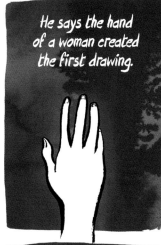

He says the hand of a woman created the first drawing.

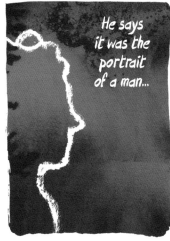

He says it was the portrait of a man...

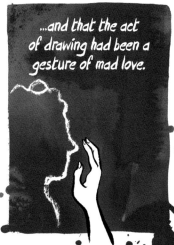

...and that the act of drawing had been a gesture of mad love.

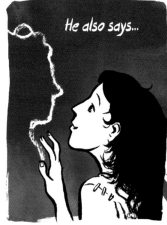

He also says...

...that in order for the first hand to draw the first line that day...

... a great deal of shadow was needed...

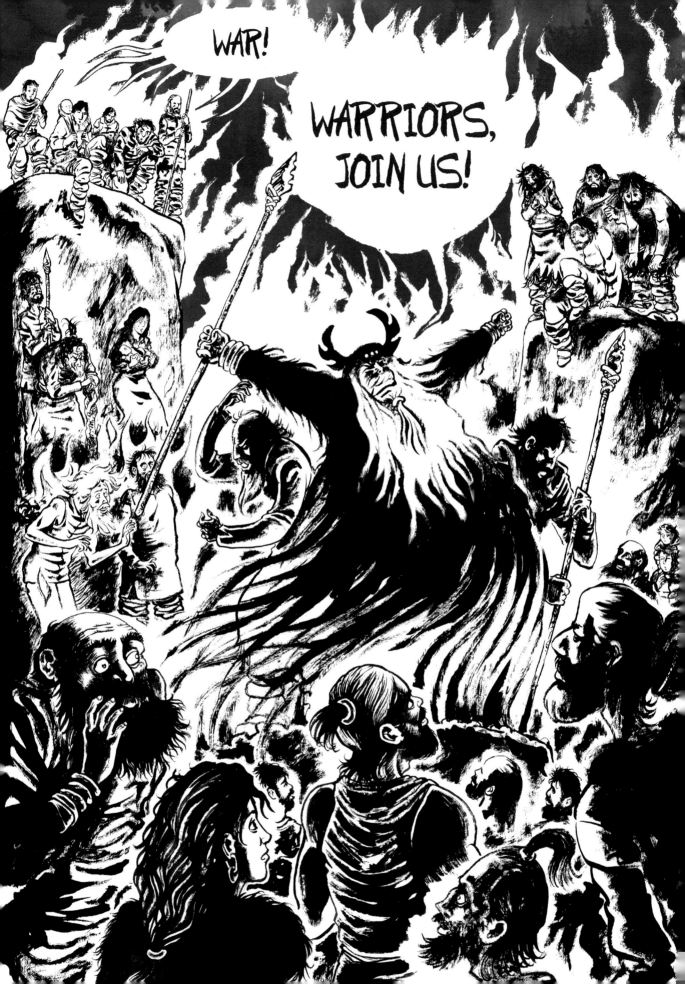

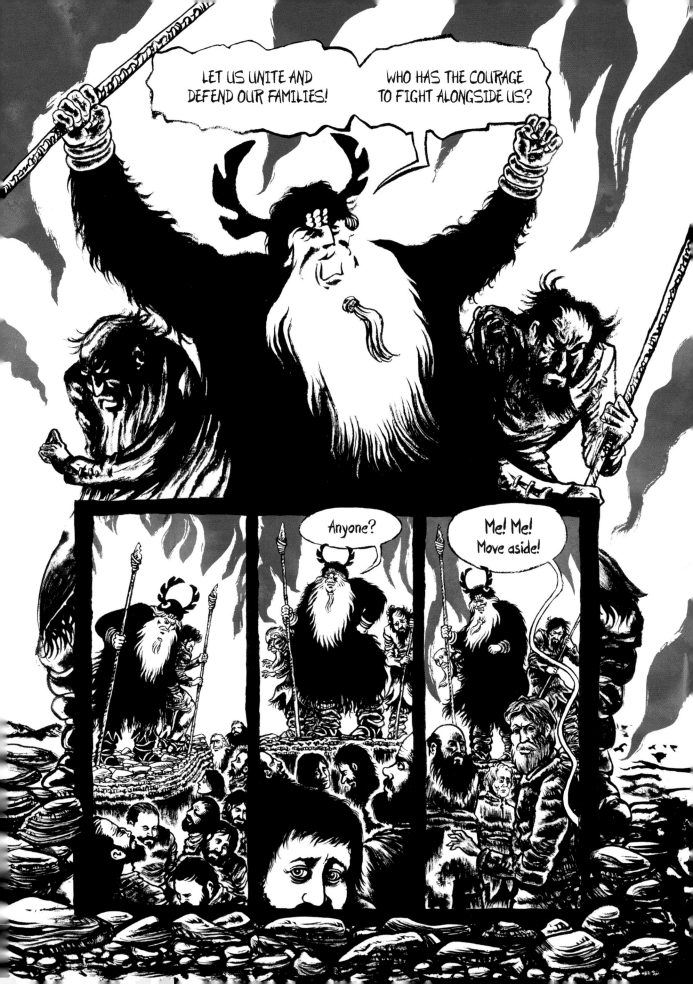

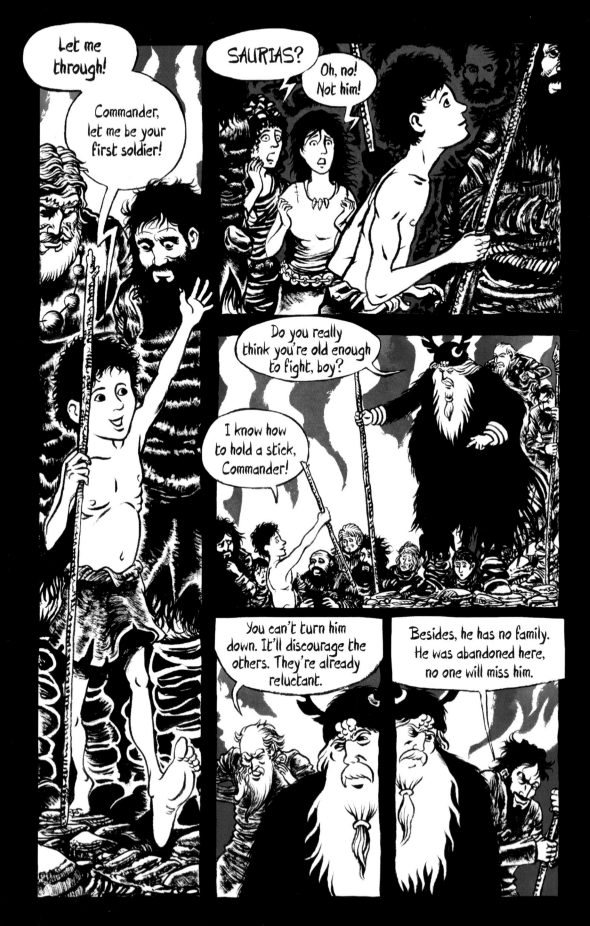

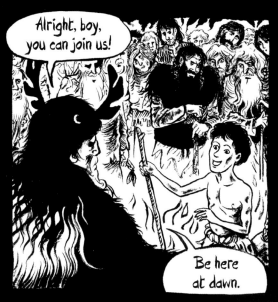

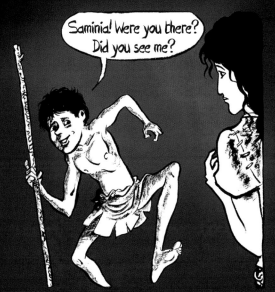

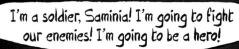

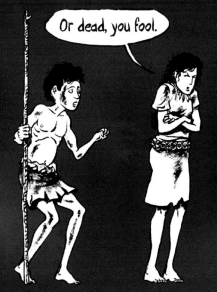

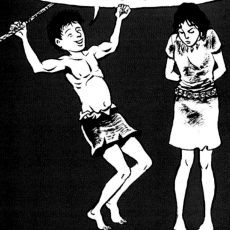

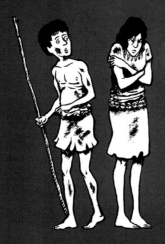

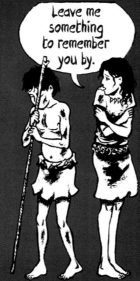

Leave me something to remember you by.

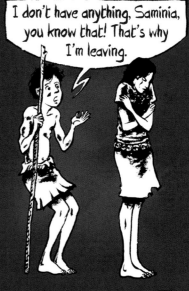

I don't have anything, Saminia, you know that! That's why I'm leaving.

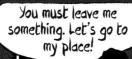
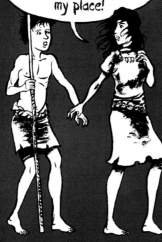

You must leave me something. Let's go to my place!

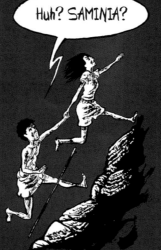

Huh? SAMINIA?

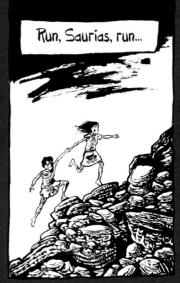

Run, Saurias, run...

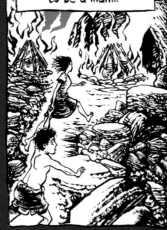

...since you claim to be a man...

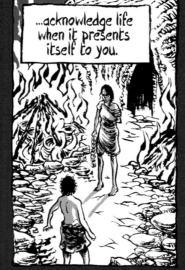

...acknowledge life when it presents itself to you.

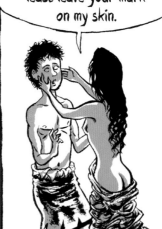

Come closer...at least leave your mark on my skin.

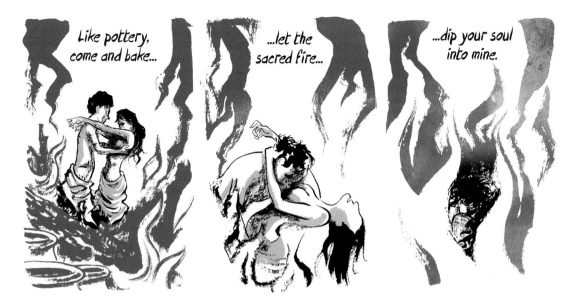

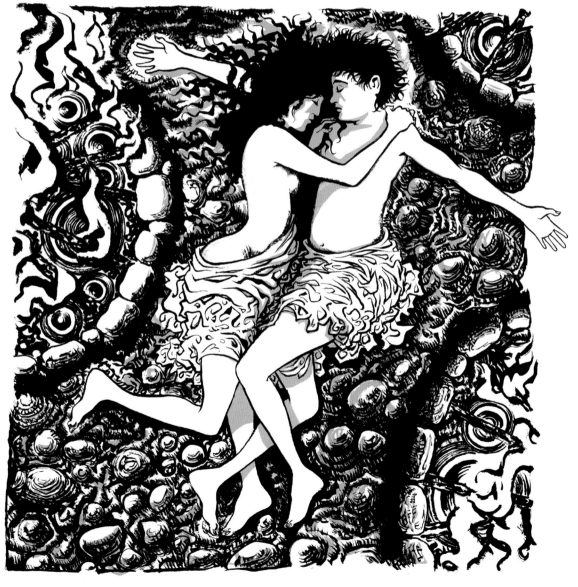

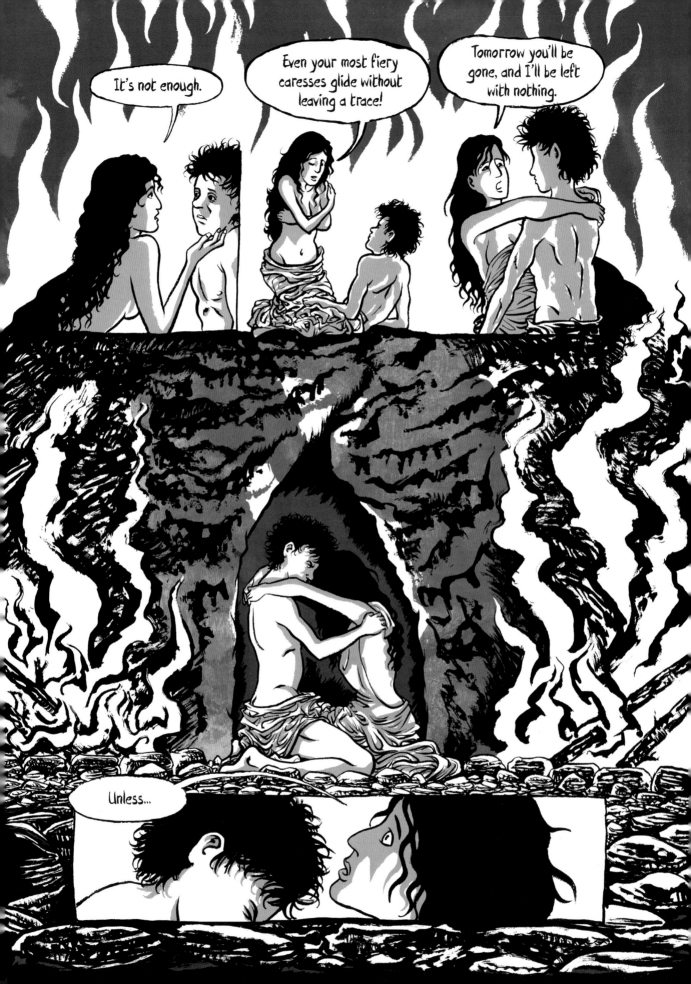

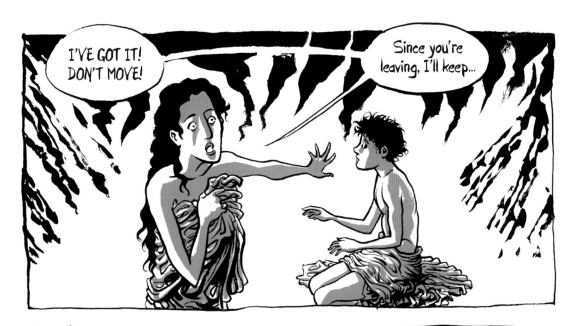

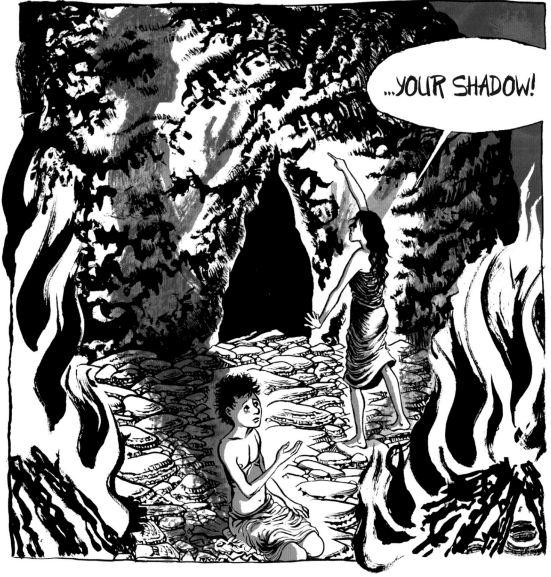

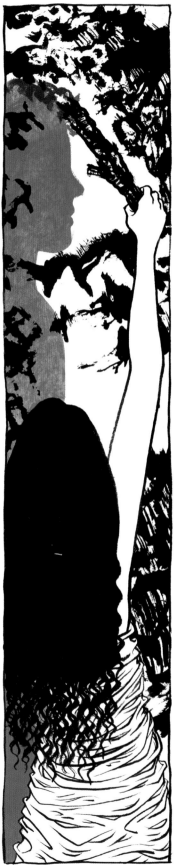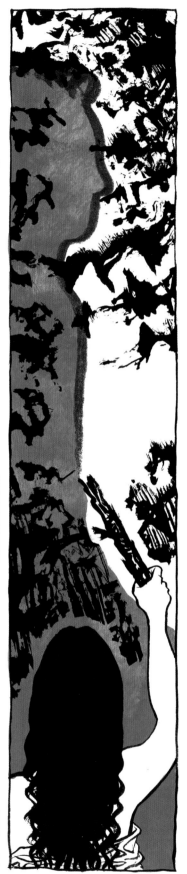

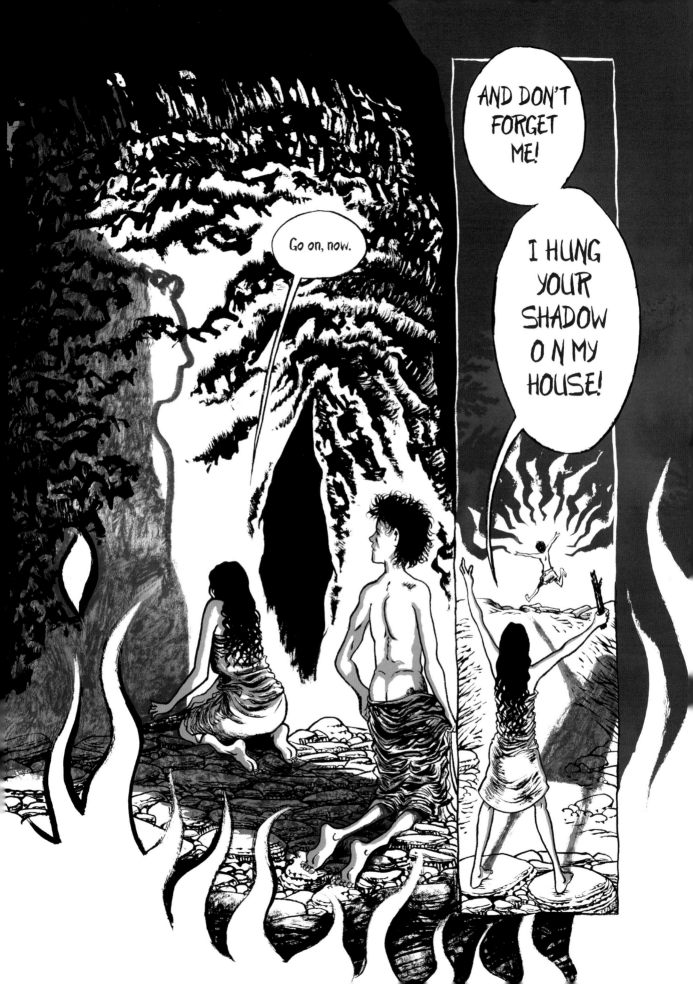

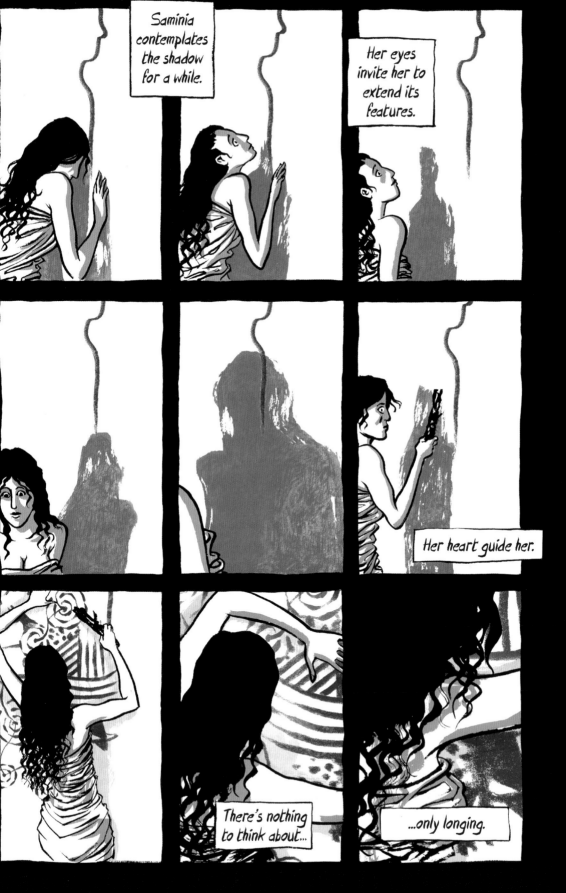

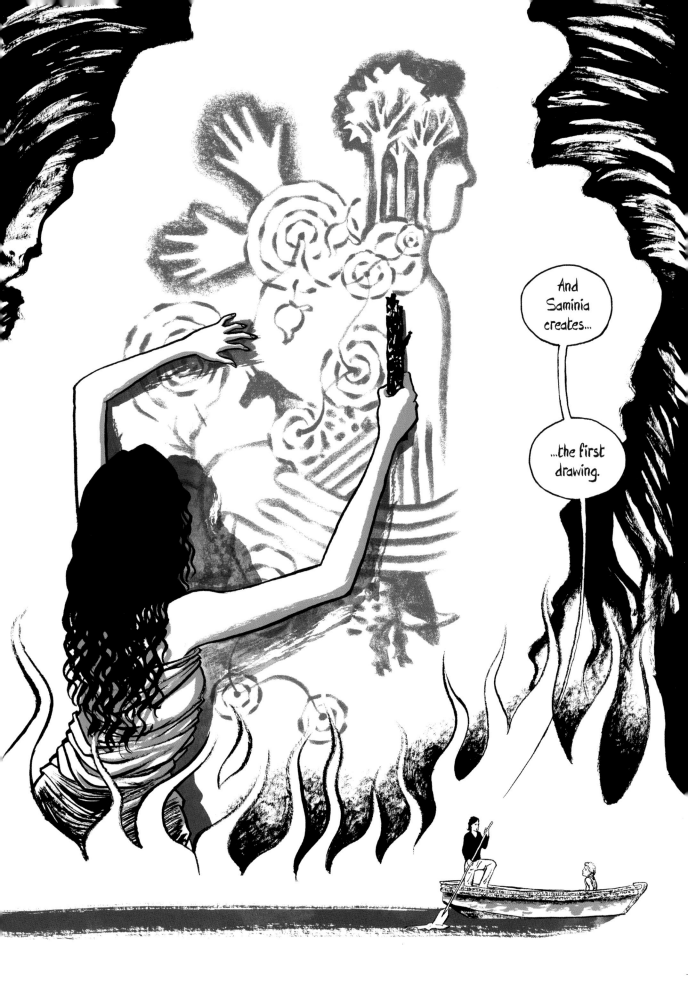

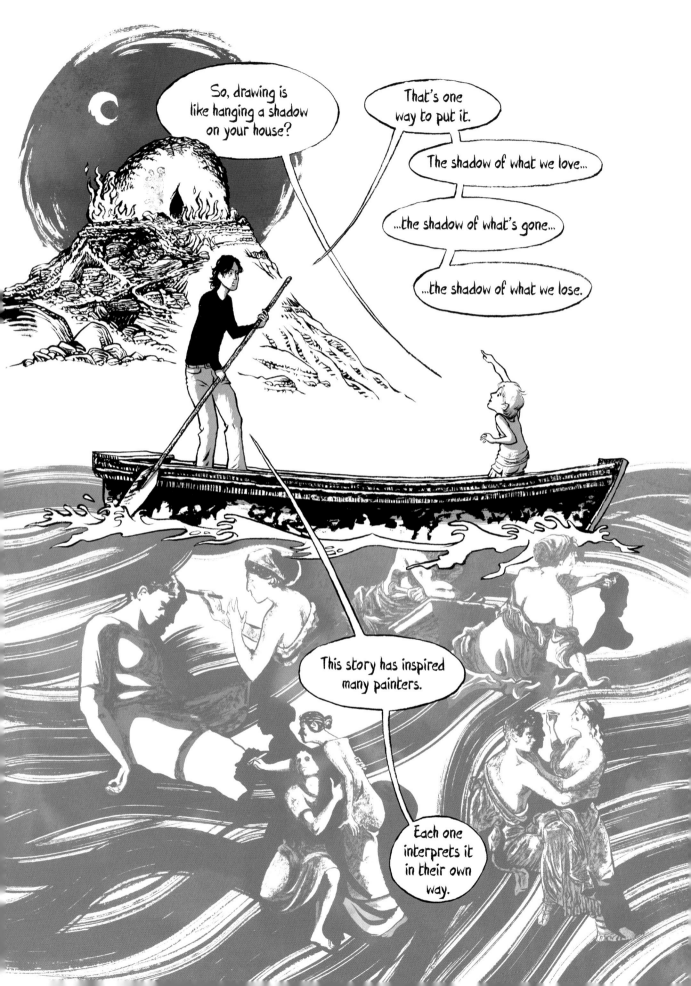

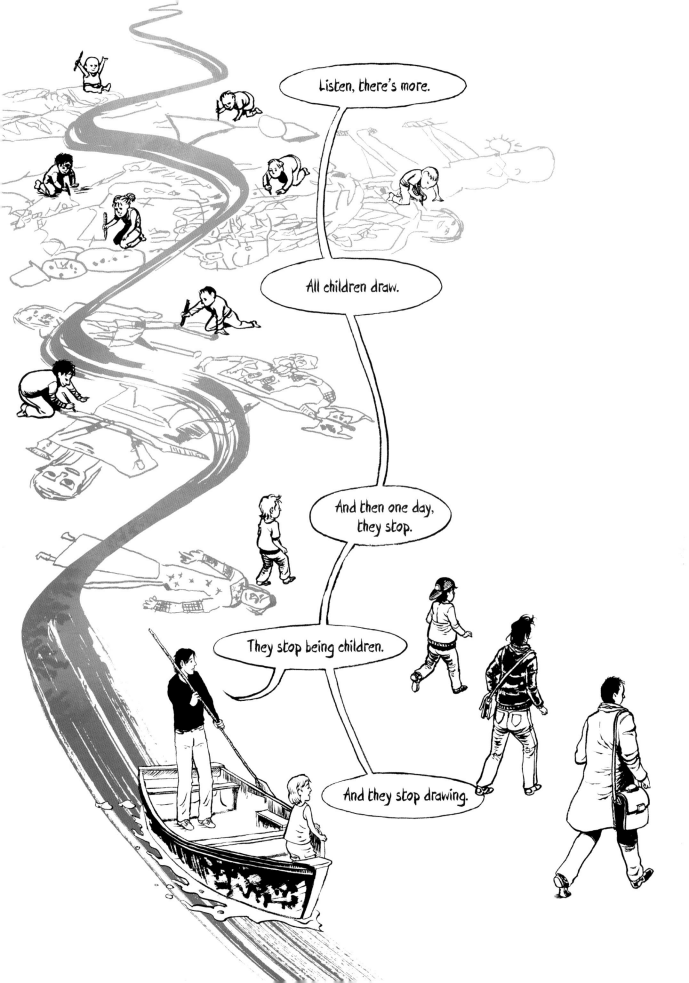

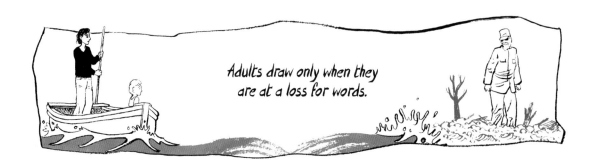

Adults draw only when they
are at a loss for words.

That's what happened to my great-grandfather, René, during the First World War.

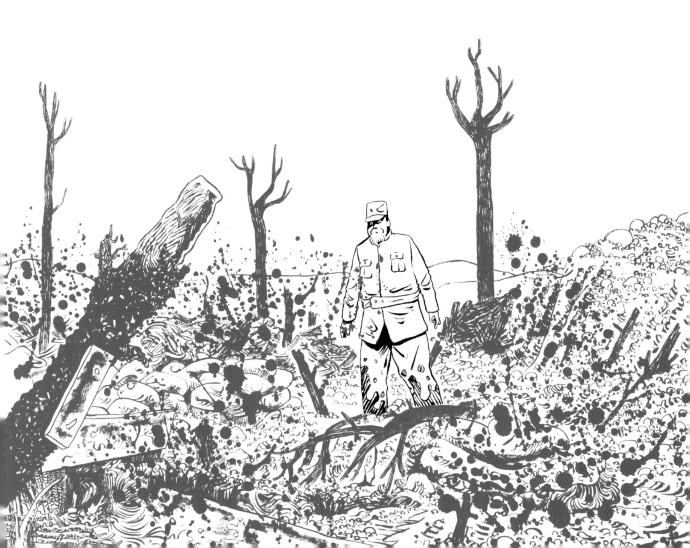

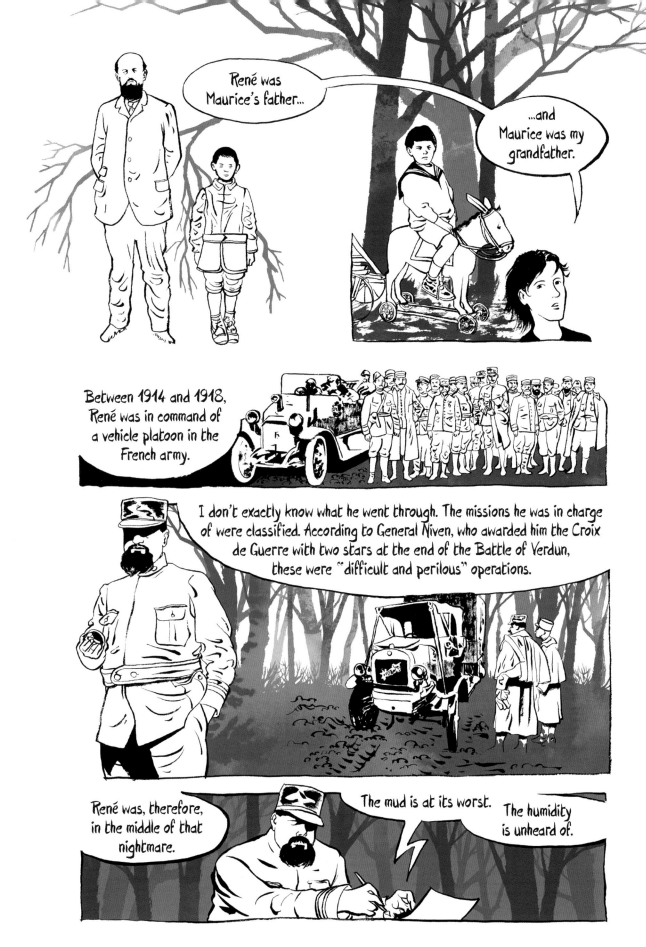

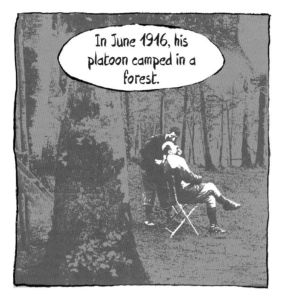

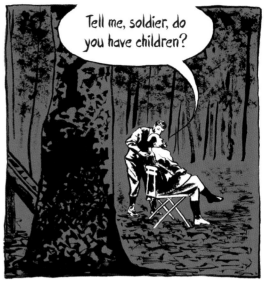

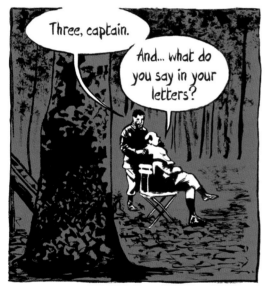

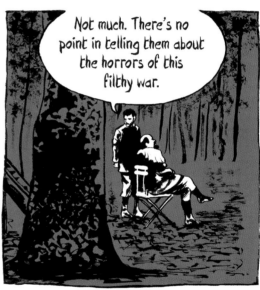

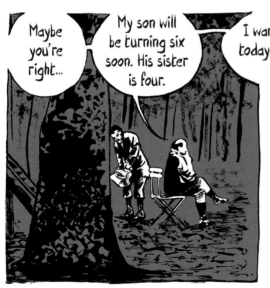

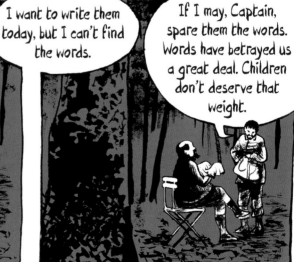

Besides, those are the rules: to say as little as possible!

Look, it's written on this official correspondence form, clear as day.

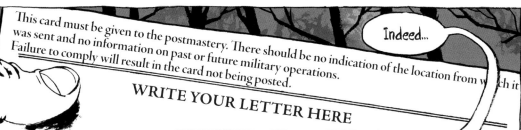

This card must be given to the postmastery. There should be no indication of the location from which it was sent and no information on past or future military operations. Failure to comply will result in the card not being posted.

WRITE YOUR LETTER HERE

Indeed...

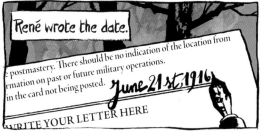

René wrote the date.

e postmastery. There should be no indication of the location from rmation on past or future military operations. in the card not being posted. *June 21st, 1916*

WRITE YOUR LETTER HERE

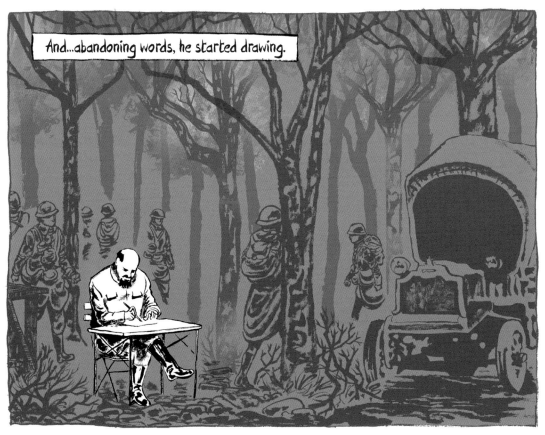

And...abandoning words, he started drawing.

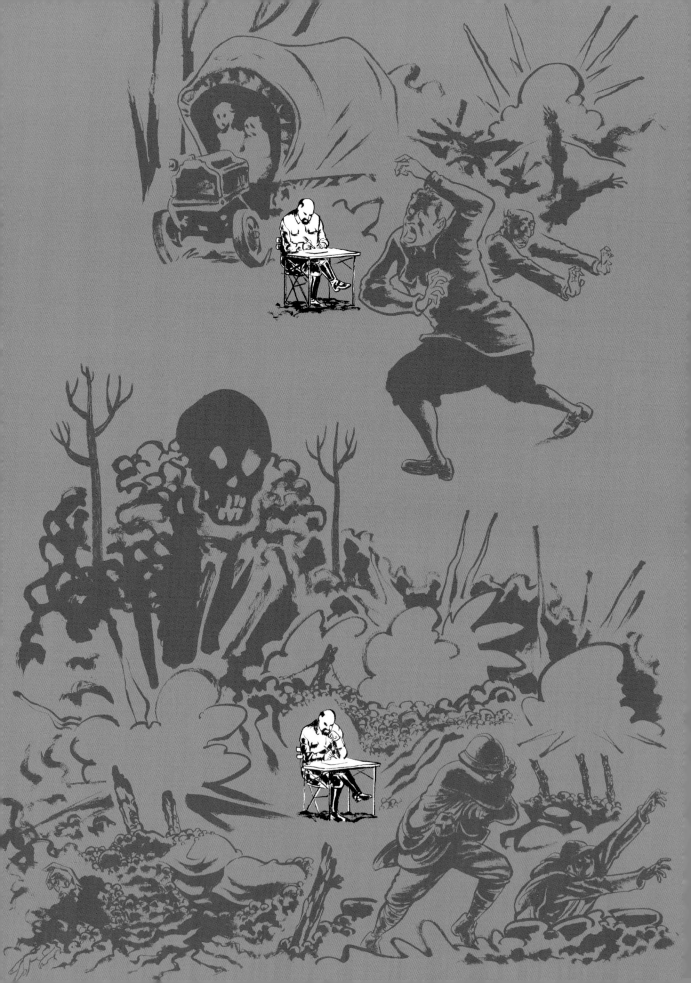

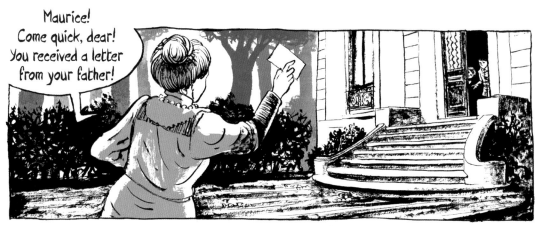

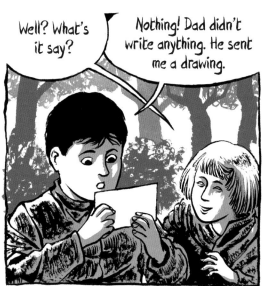

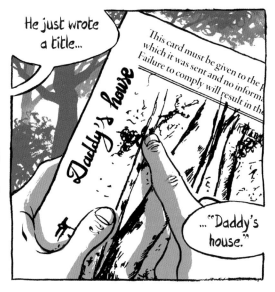

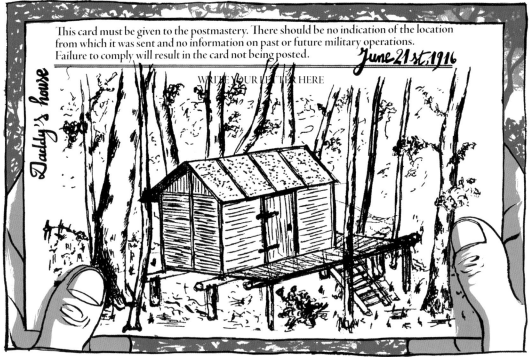

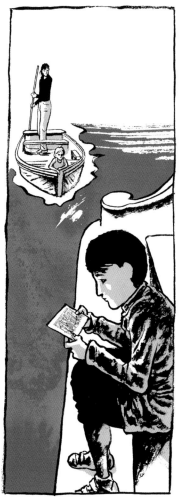

I often wondered how little Maurice, my grandfather, reacted when he got that letter.

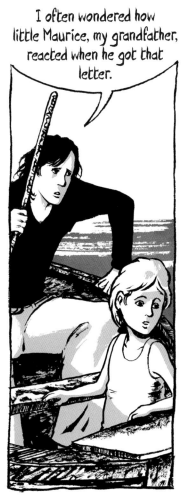

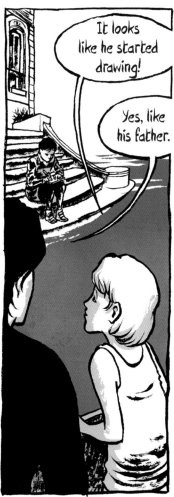

It looks like he started drawing!

Yes, like his father.

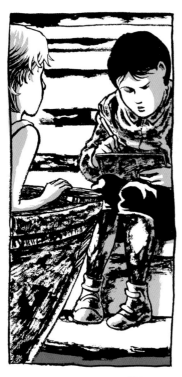

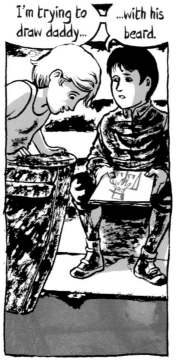

I'm trying to draw daddy... ...with his beard.

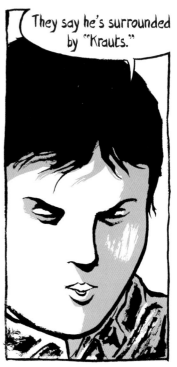

They say he's surrounded by "Krauts."

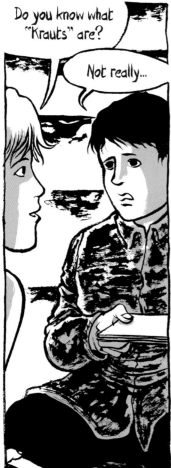

Do you know what "Krauts" are?

Not really...

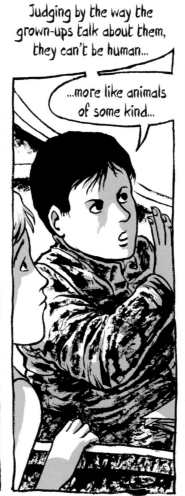

Judging by the way the grown-ups talk about them, they can't be human...

...more like animals of some kind...

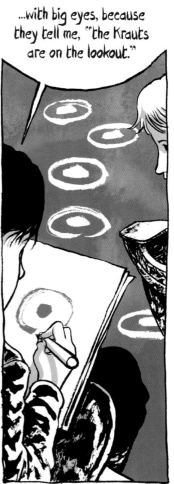

...with big eyes, because they tell me, "the Krauts are on the lookout."

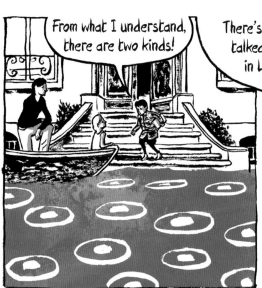

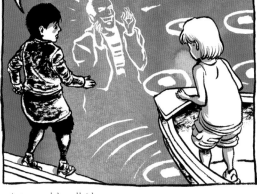

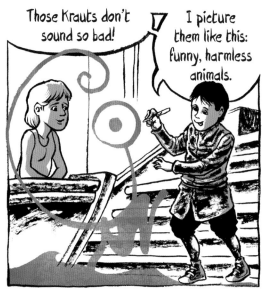

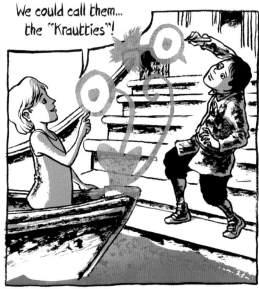

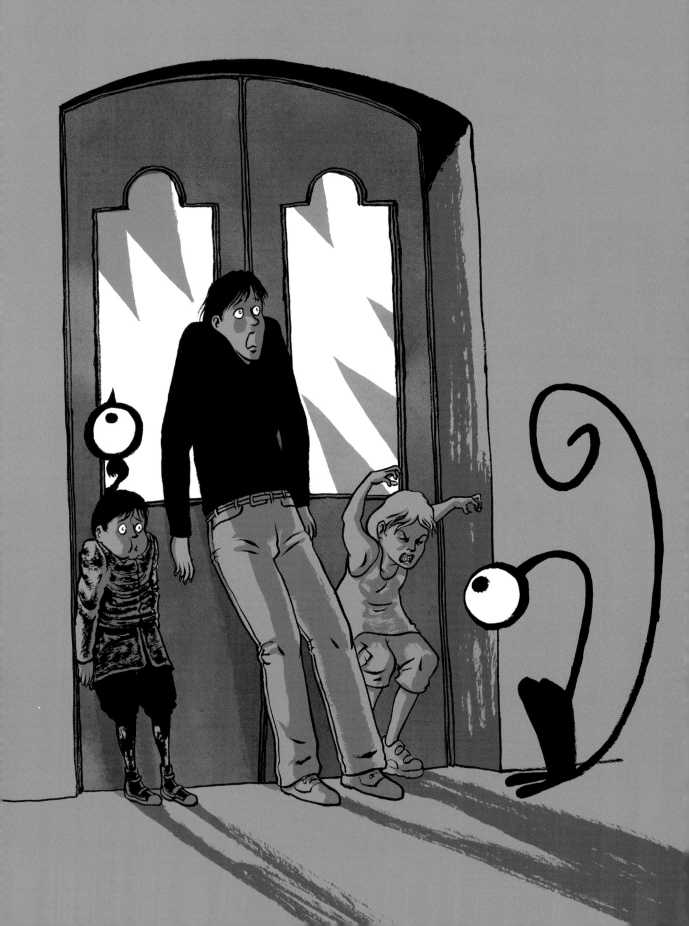

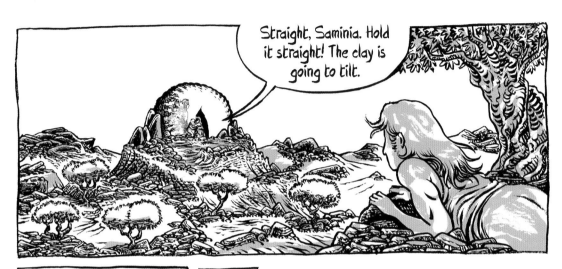

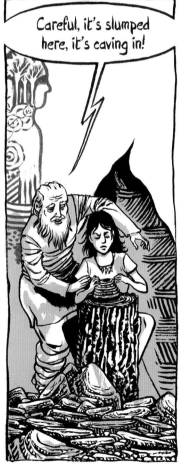

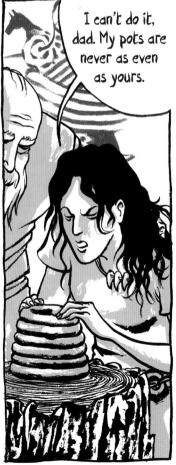

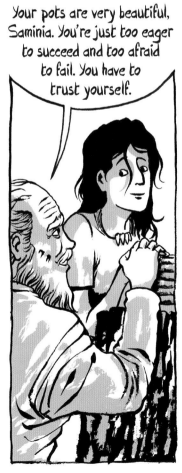

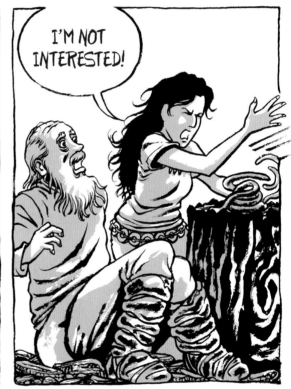

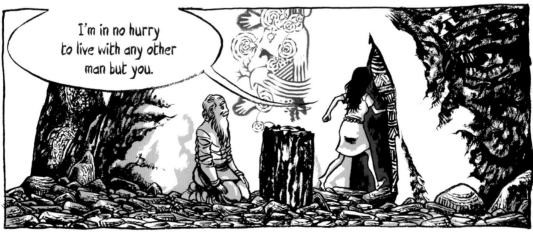

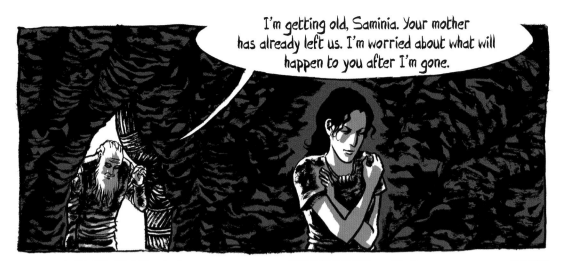

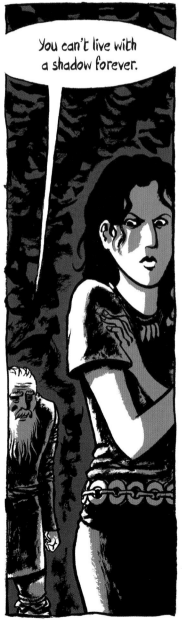

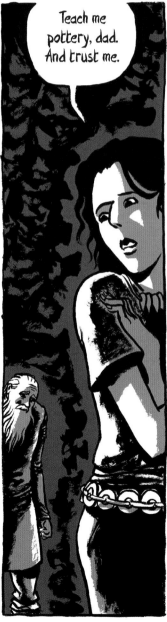

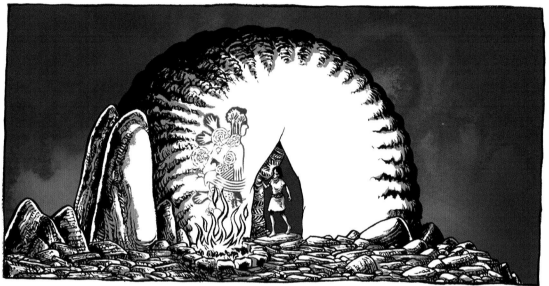

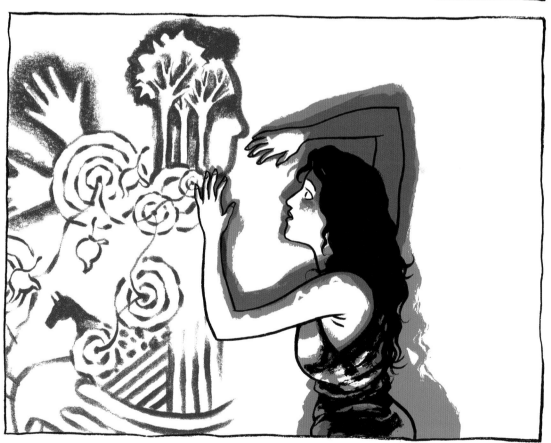

Saurias! Step on it!

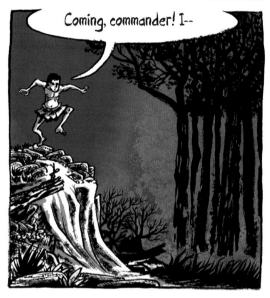

Coming, commander! I--

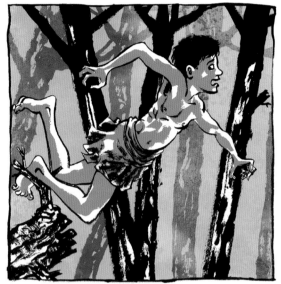

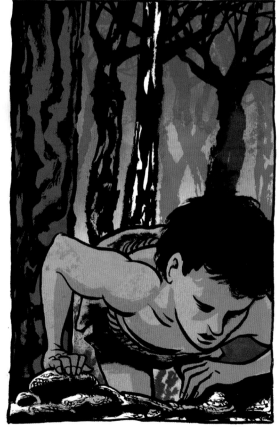

41

CRACK

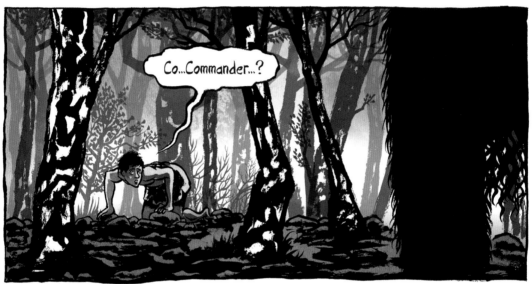

Co...Commander...?

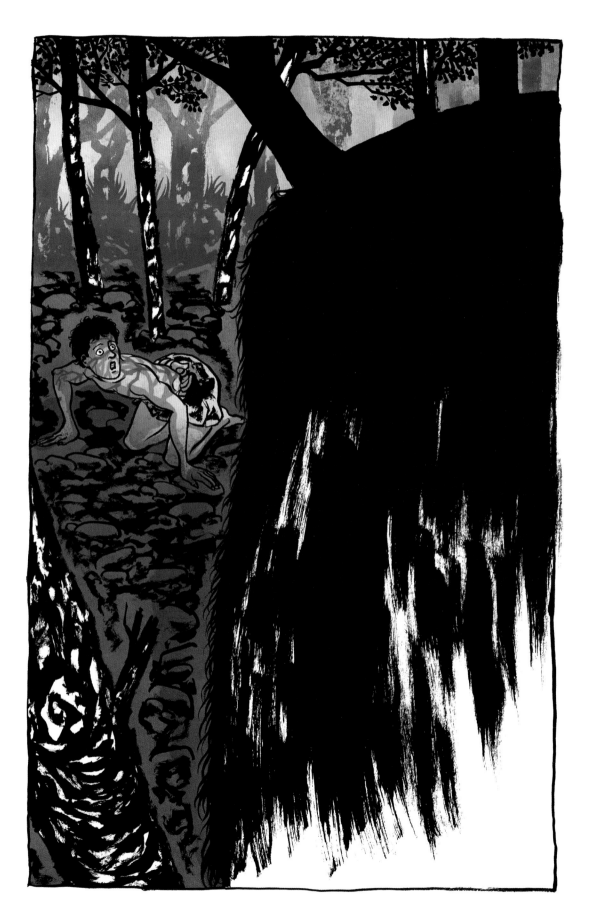

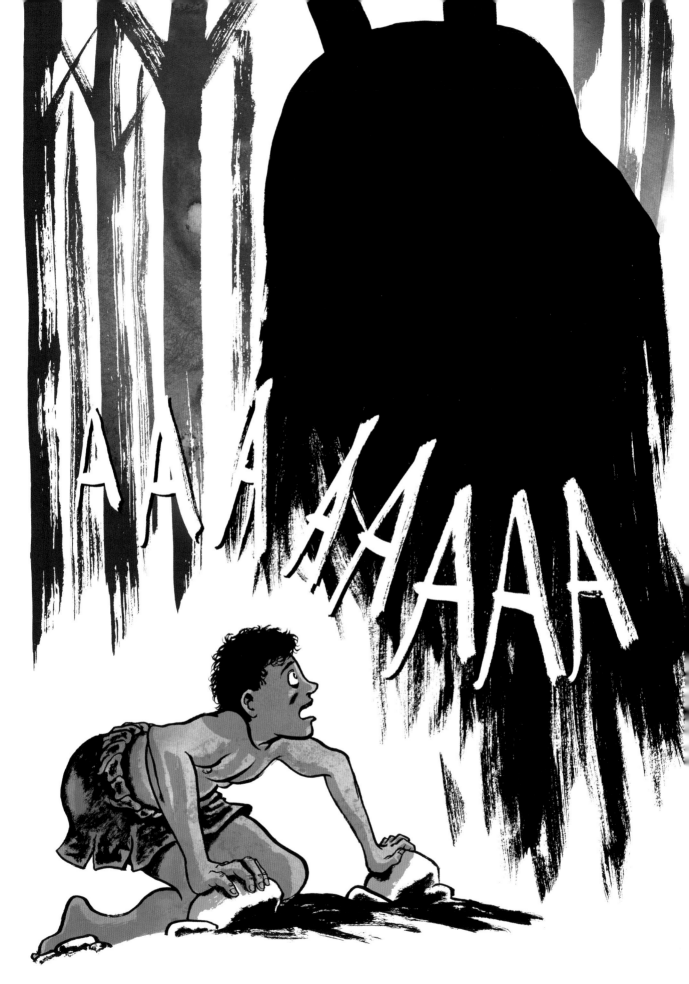

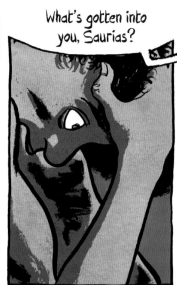

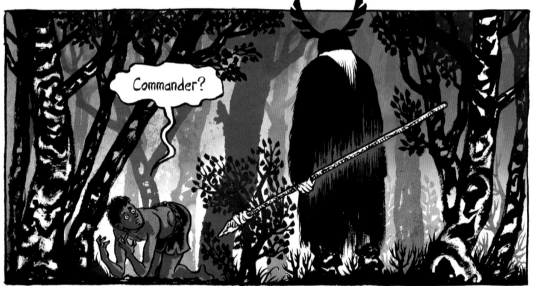

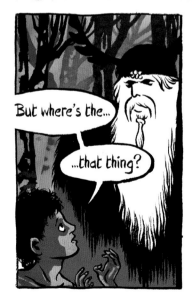

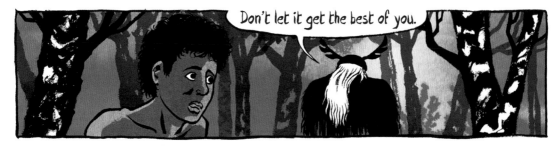

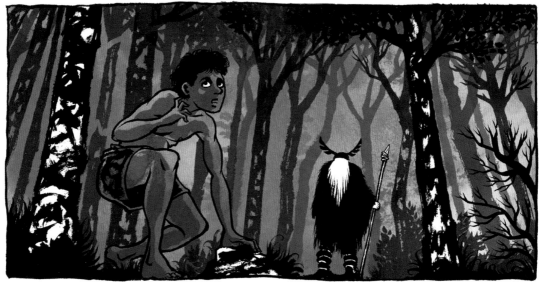

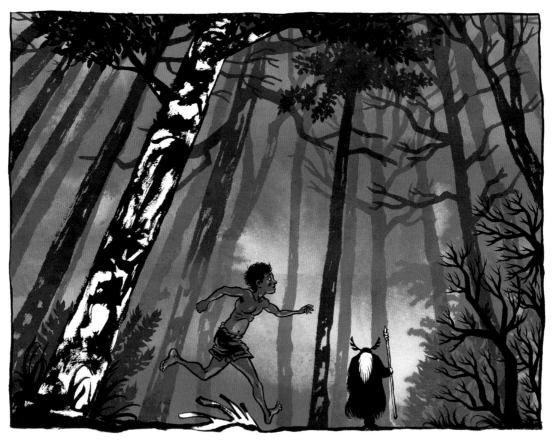

Phew...

It looks like we lost them.

Where are we?

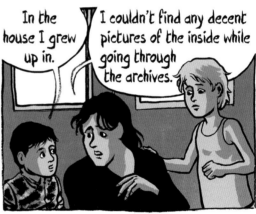

In the house I grew up in.

I couldn't find any decent pictures of the inside while going through the archives.

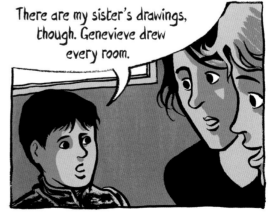

There are my sister's drawings, though. Genevieve drew every room.

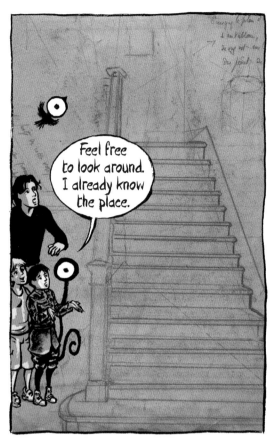

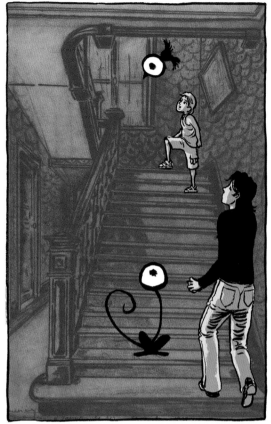

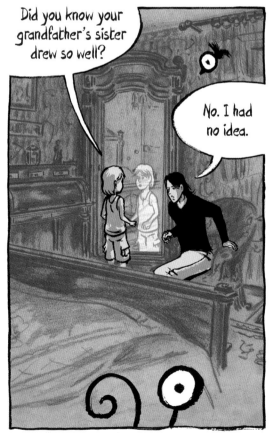

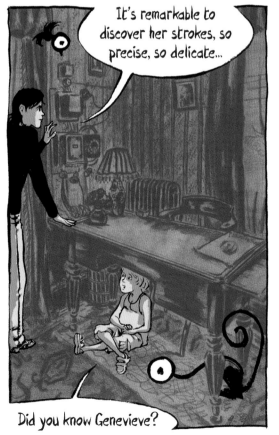

No. We wouldn't talk about her at home. Maybe I wasn't listening?

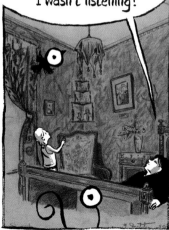

She spent most of her life in a psychiatric hospital. I don't really know why.

But whatever our family's memory omitted, she evoked in her drawings. With modesty. Look...

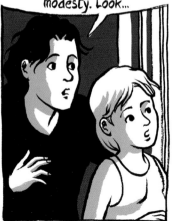

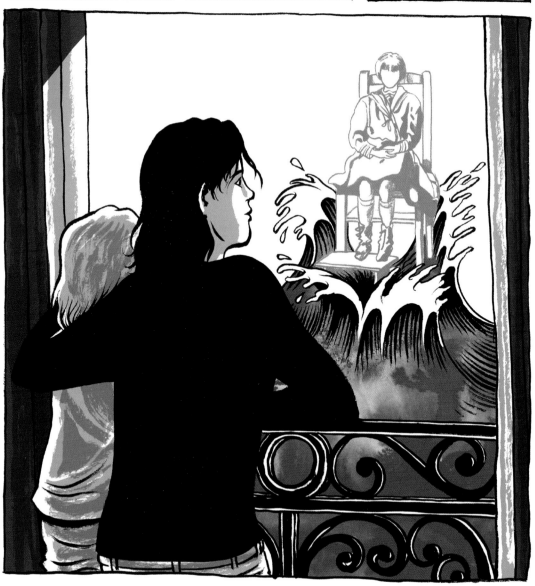

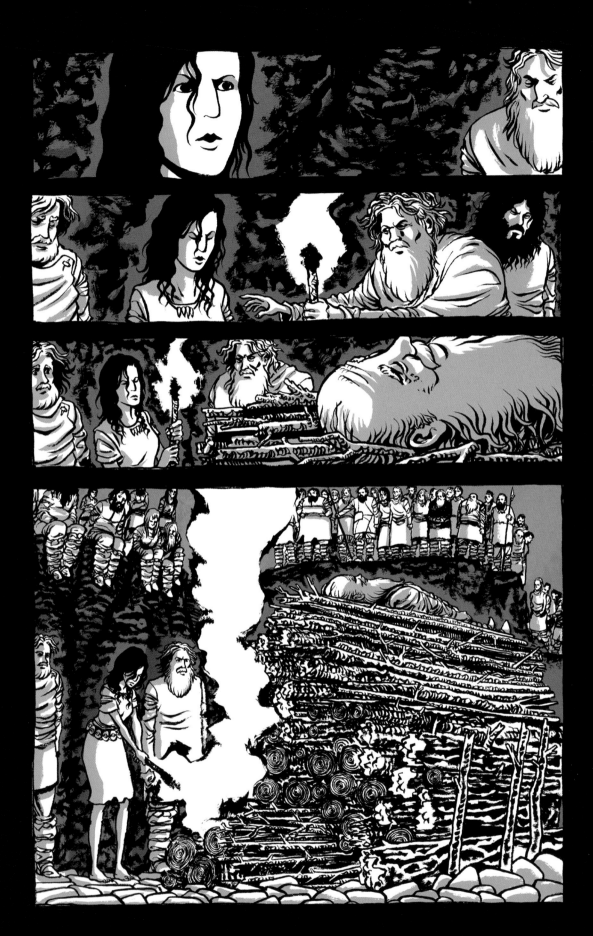

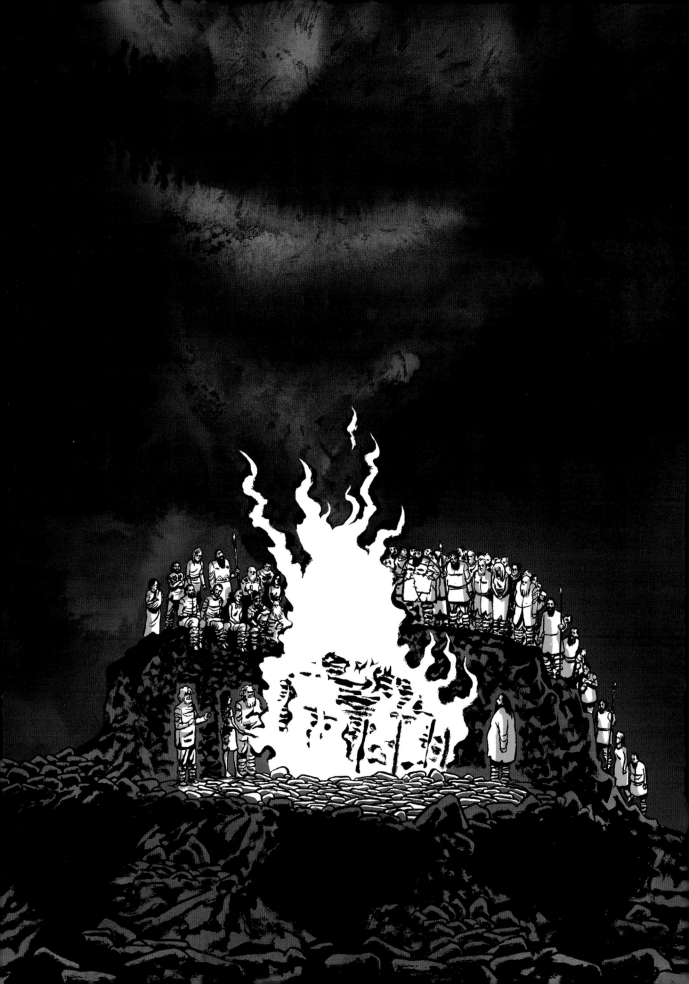

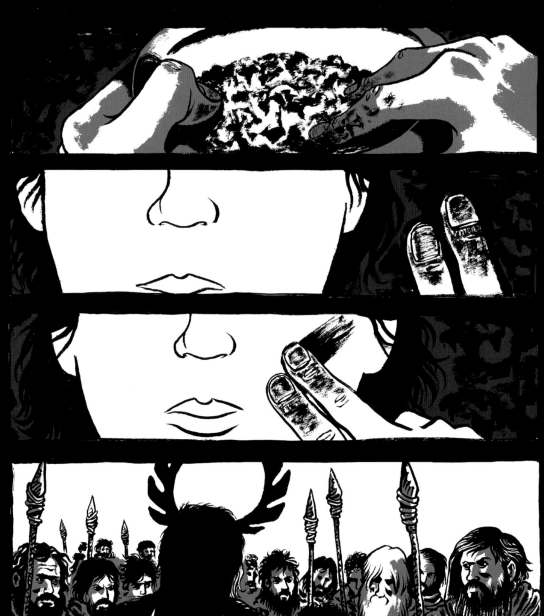
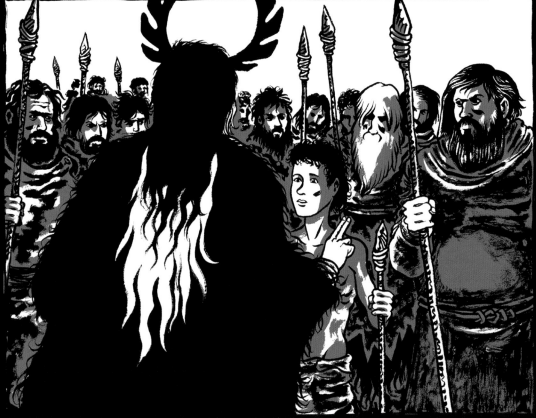

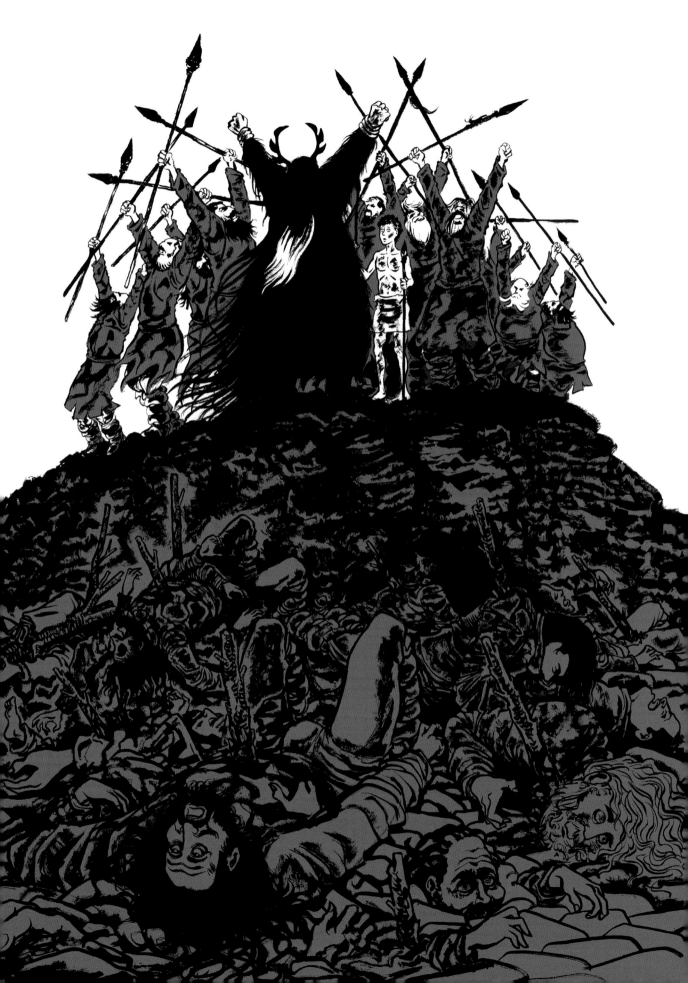

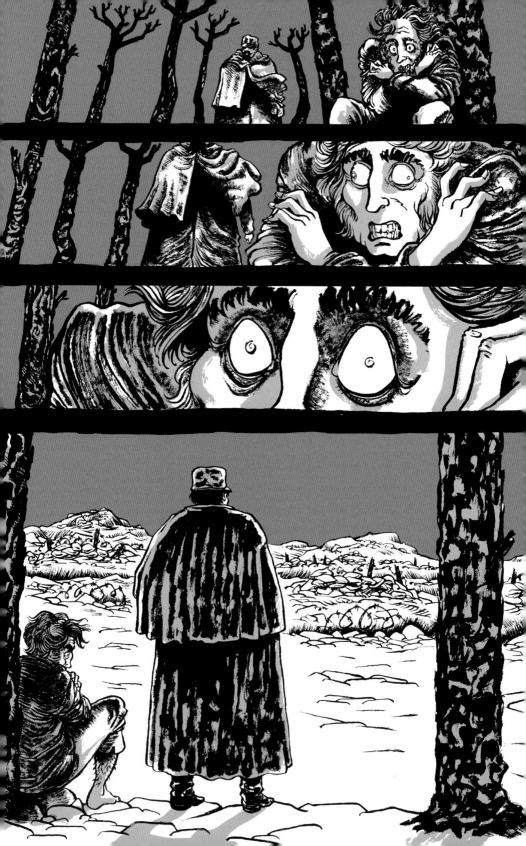

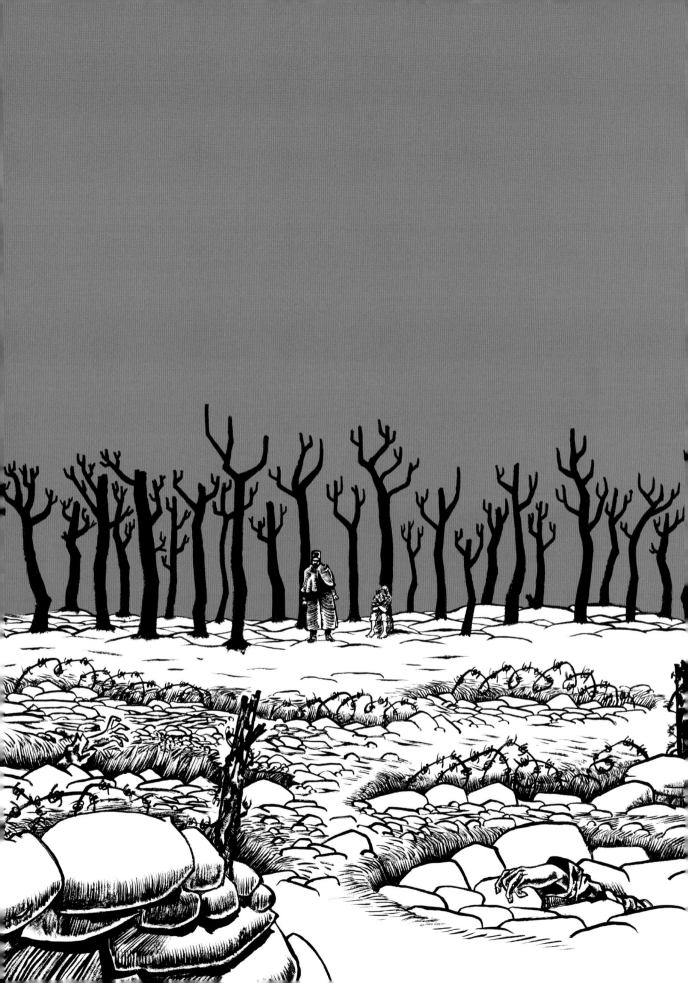

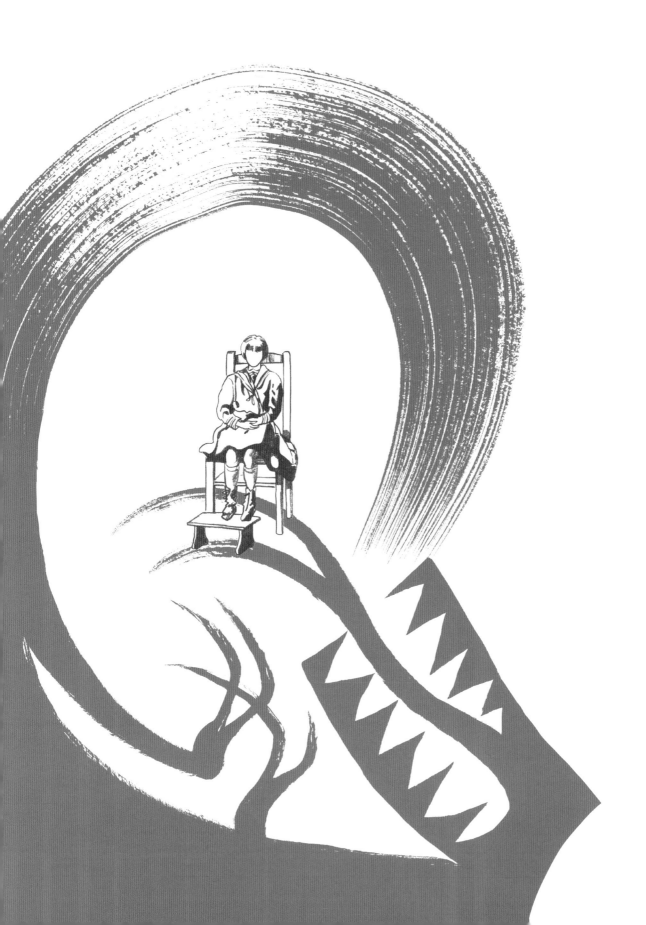

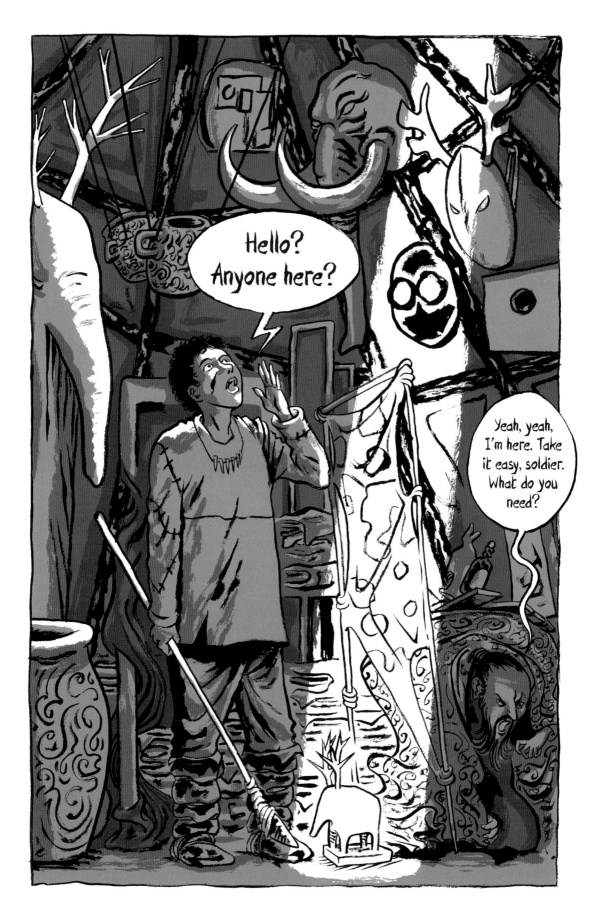

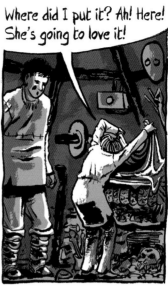

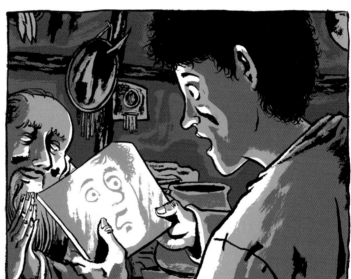

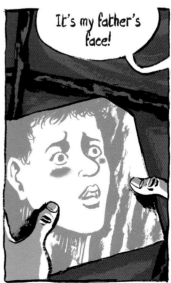

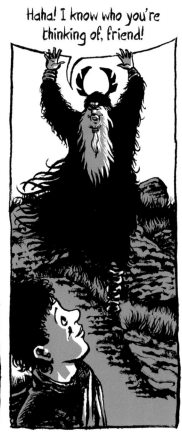

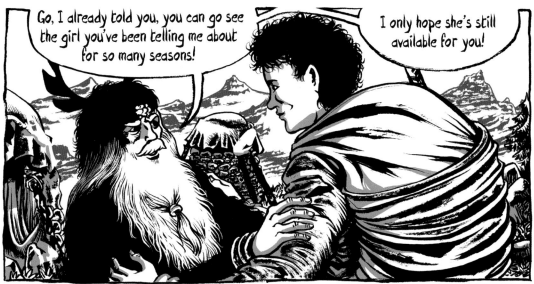

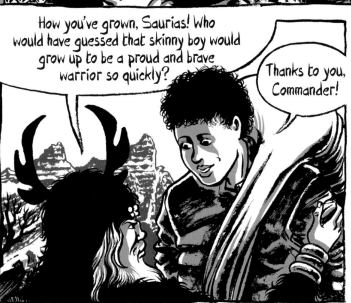

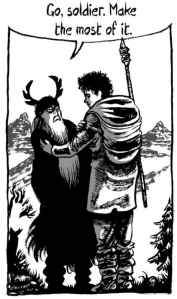

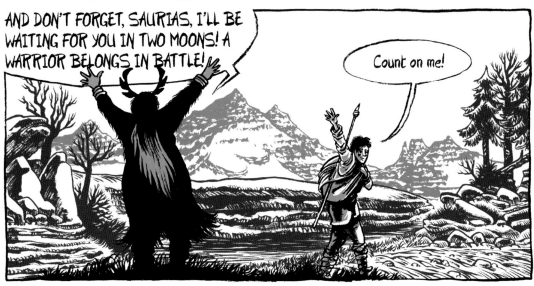

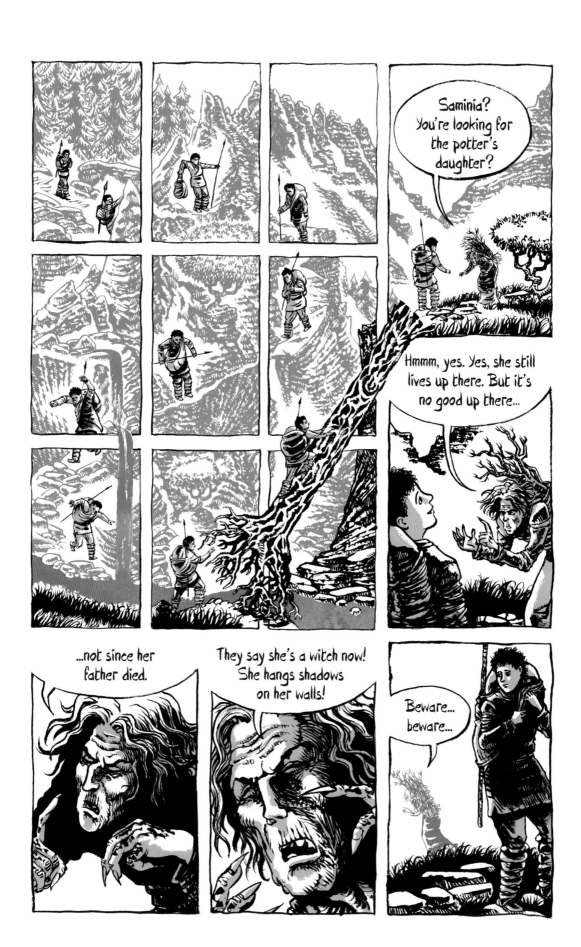

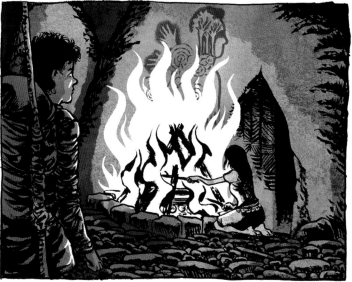

Forgive me for not turning around, stranger. I have to keep an eye on the pottery. At this stage of the firing process, the slightest crack can ruin them.

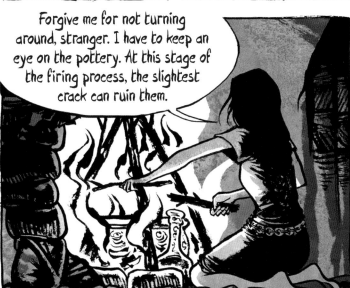

But feel free to watch! I made these pots with the skills my father taught me.

I didn't come here to admire pottery.

I left something here, a long time ago.

I left my shadow.

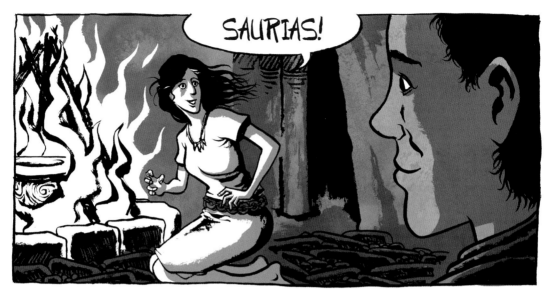

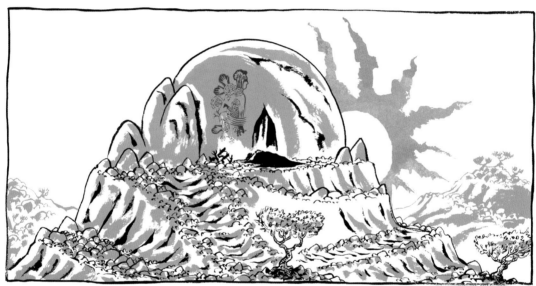

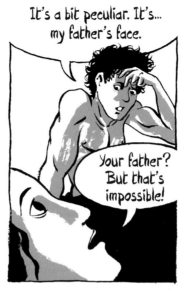

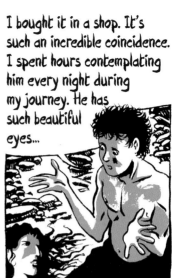

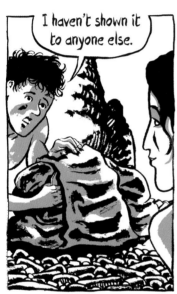

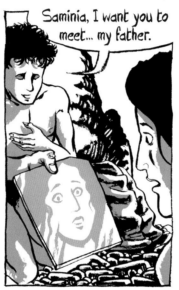

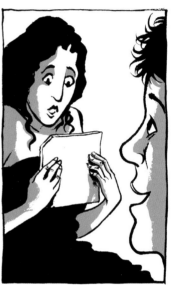

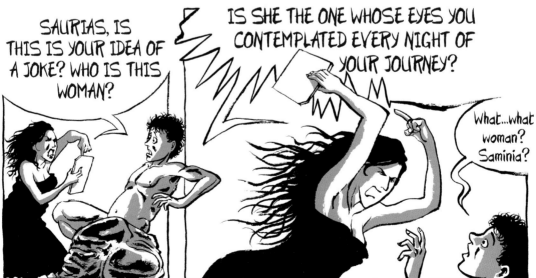

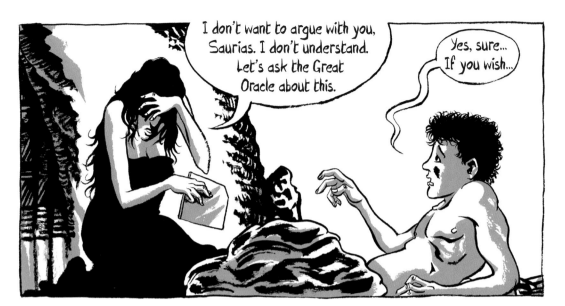

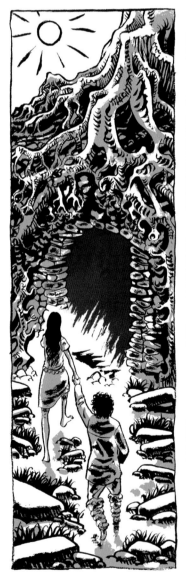

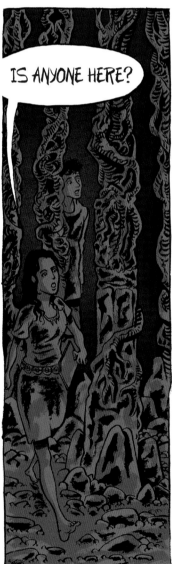

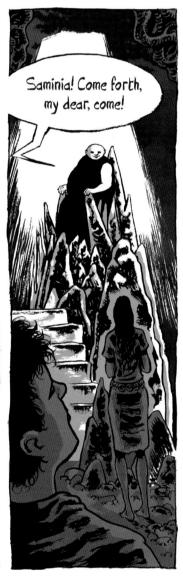

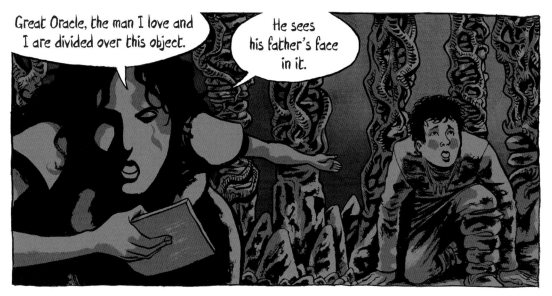

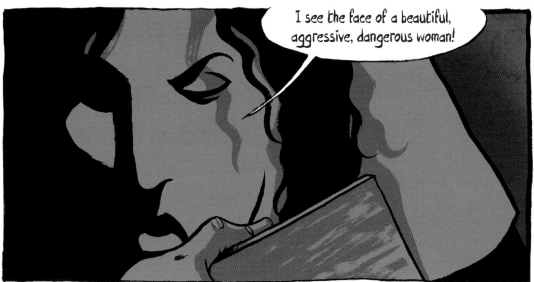

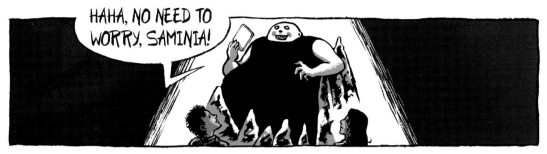

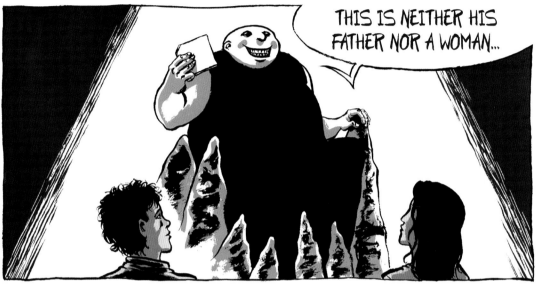

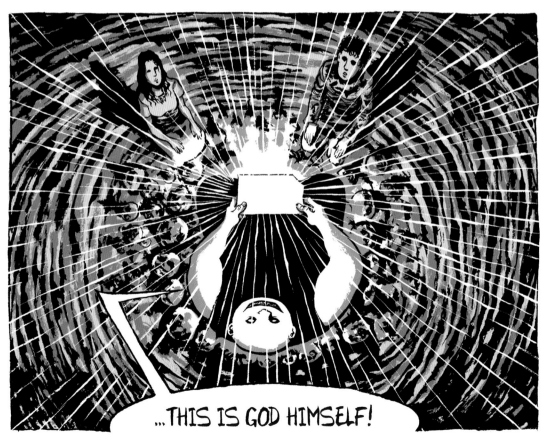

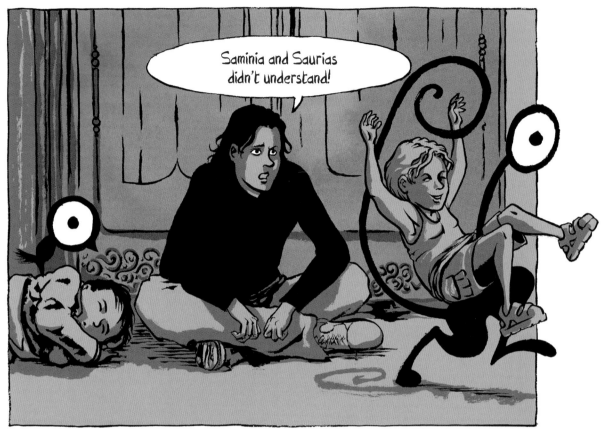

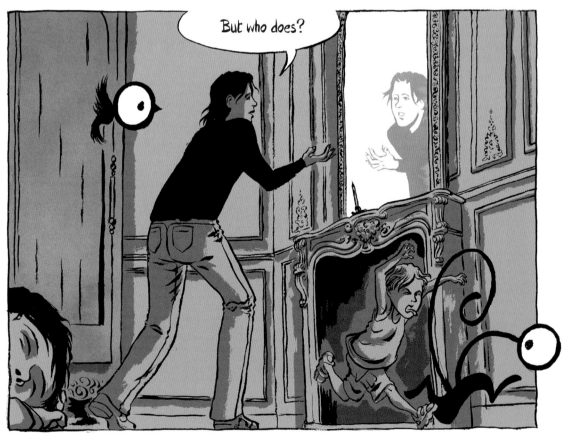

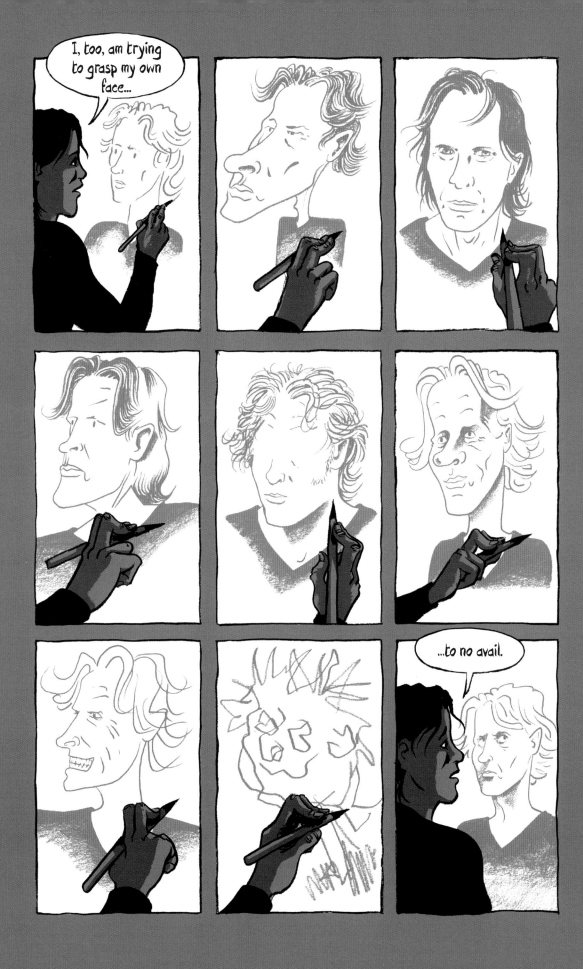

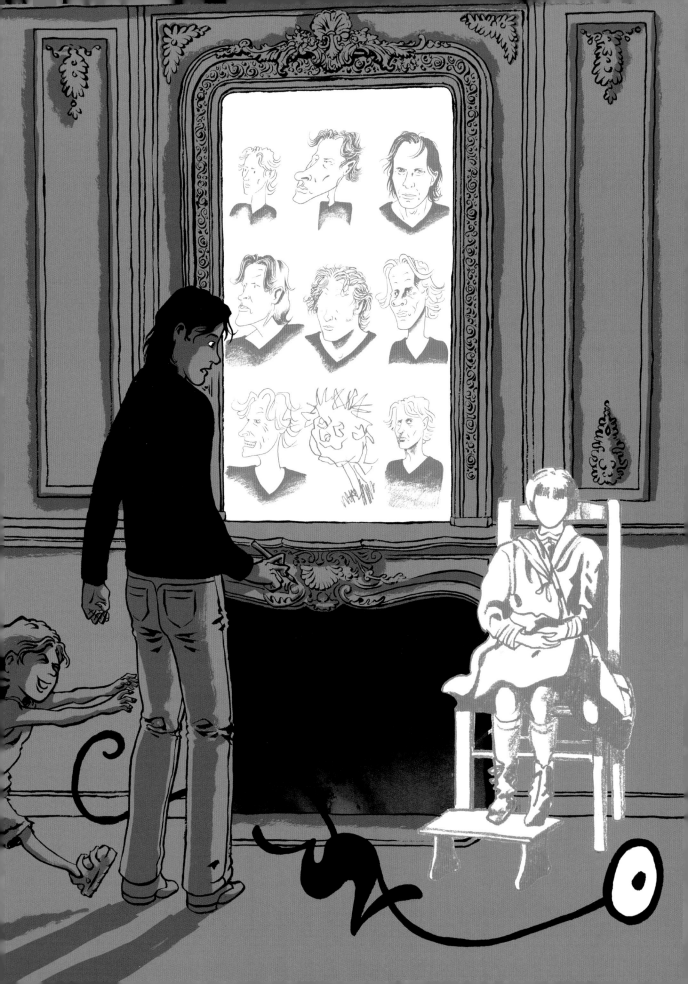

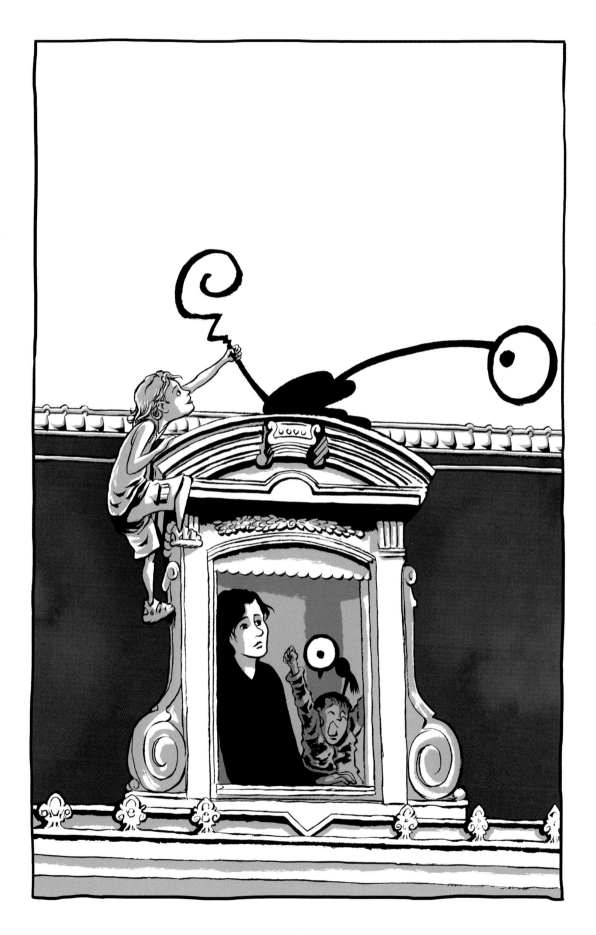

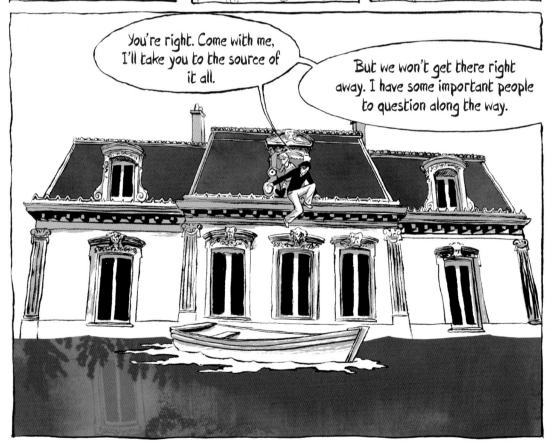

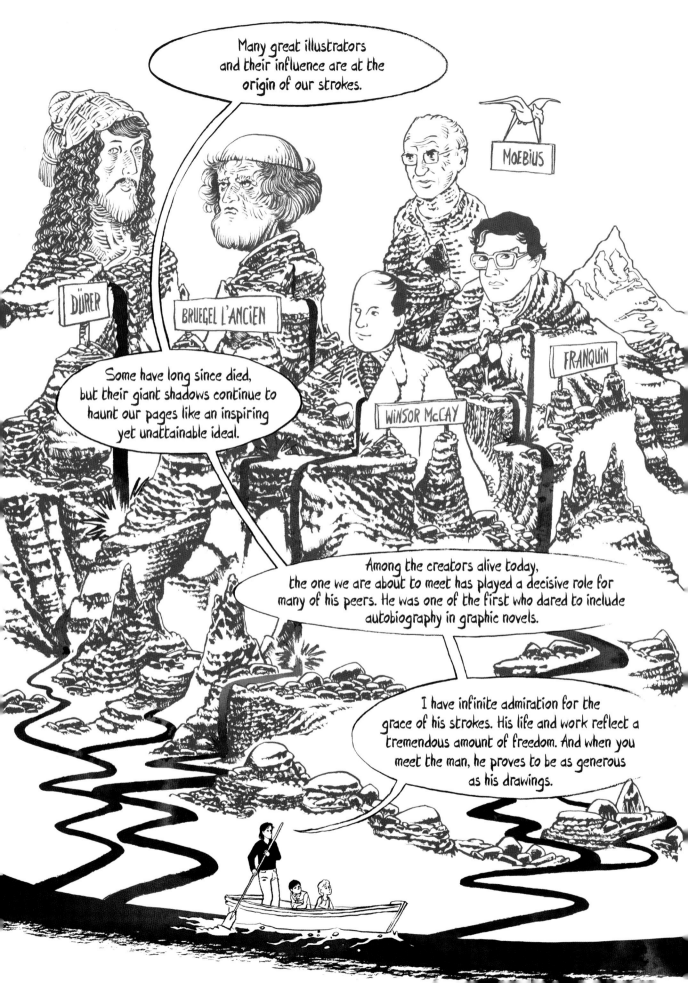

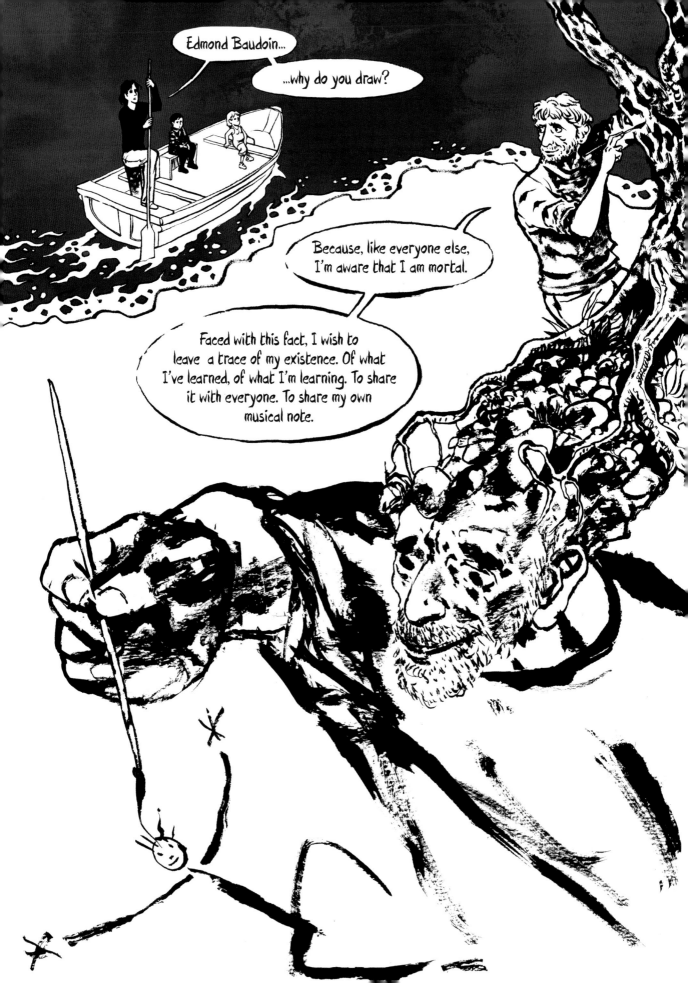

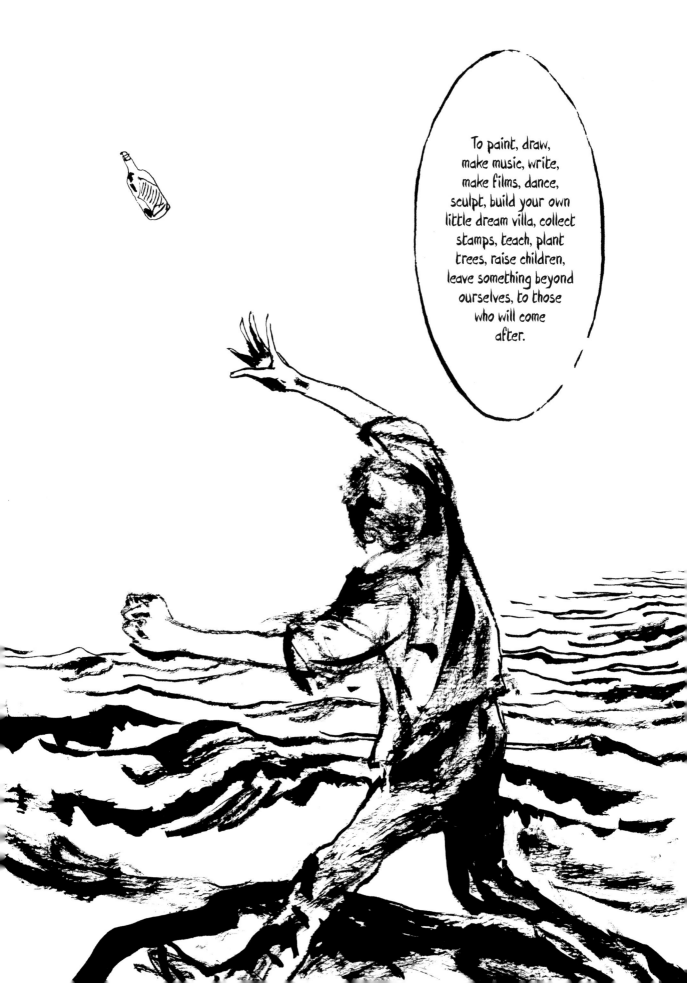

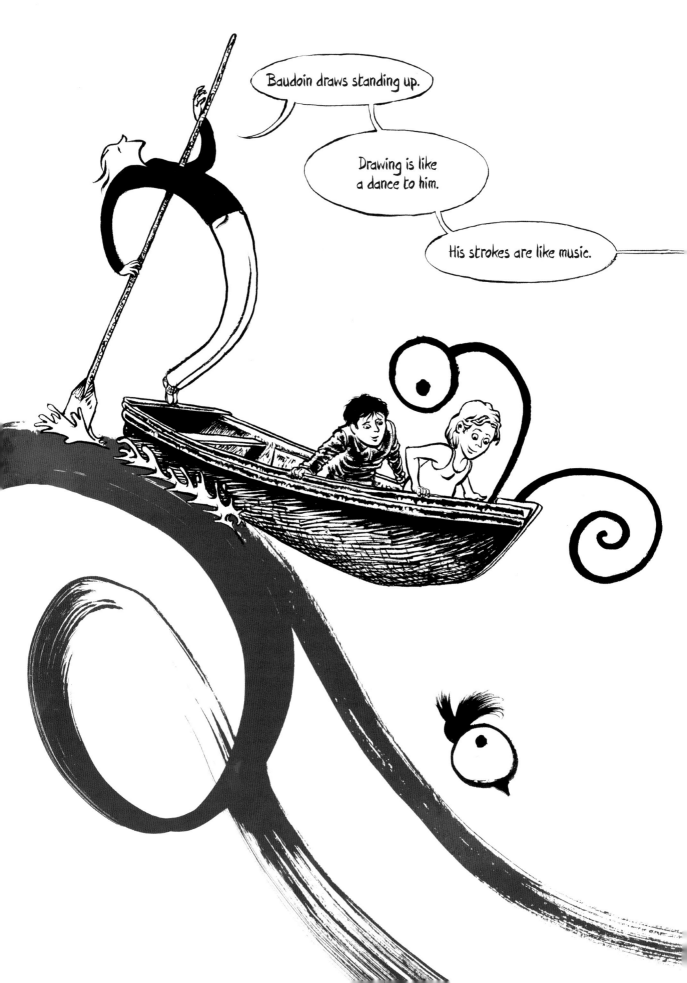

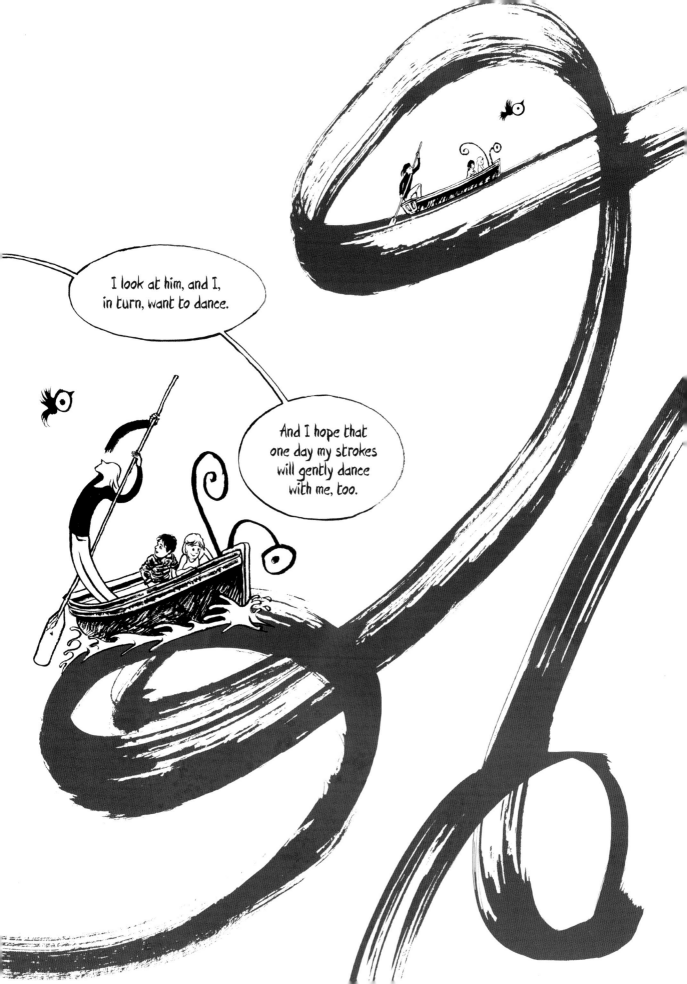

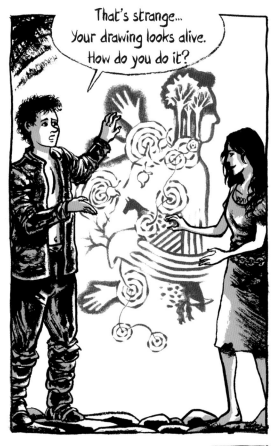

That's strange... Your drawing looks alive. How do you do it?

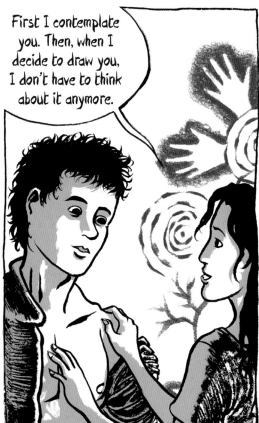

First I contemplate you. Then, when I decide to draw you, I don't have to think about it anymore.

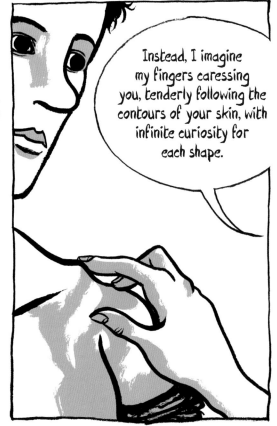

Instead, I imagine my fingers caressing you, tenderly following the contours of your skin, with infinite curiosity for each shape.

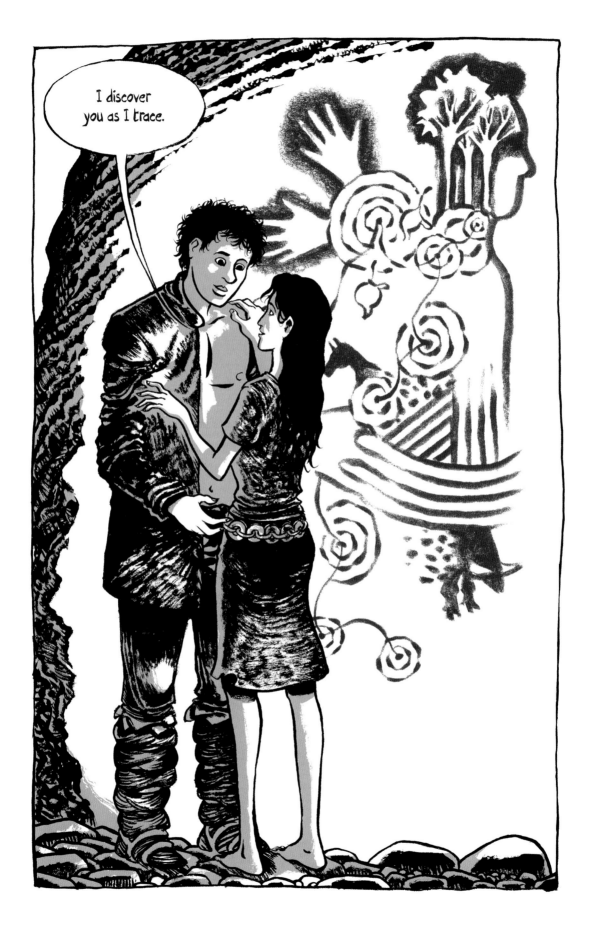

We're approaching the temple of another master of illustration.

In my opinion, he is not only one of the greatest masters of the graphic novel...

...but one of the few for whom life and art are inseparable.

Very few authors approach creation from such a vast, intimate, and profound perspective.

This is the kind of artist I shrink before.

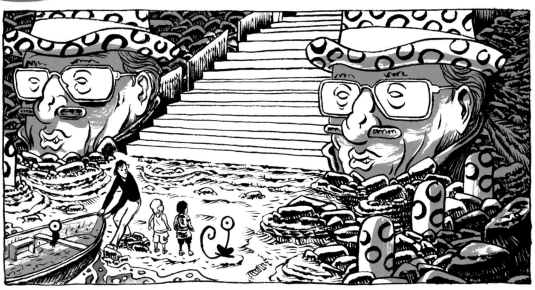

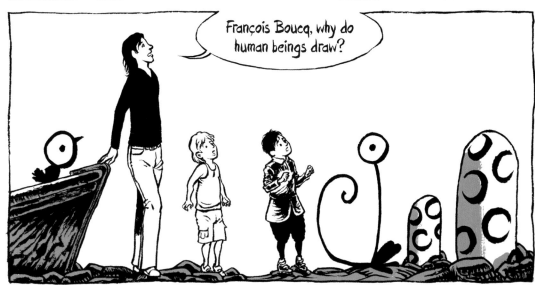

François Boucq, why do human beings draw?

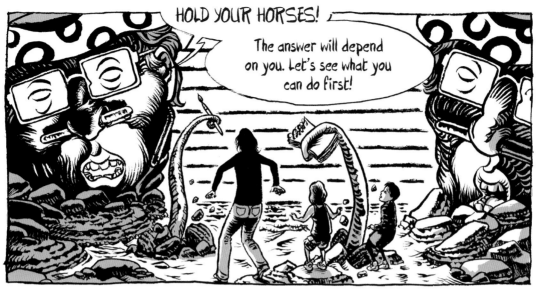

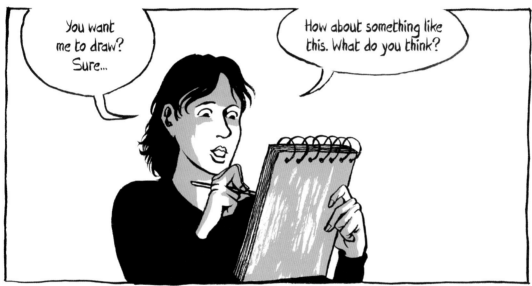

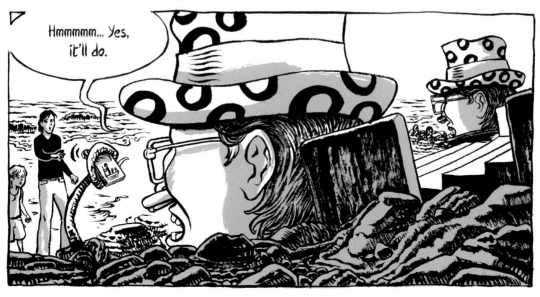

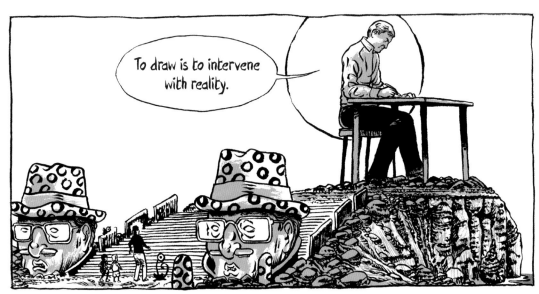

As long as an intention remains vague, its power is limited, like a ghostly, diffused, and evanescent energetic entity.

But if I draw it, it becomes real.

It's an act of magic.

Intentions become real as soon as we give shape to them.

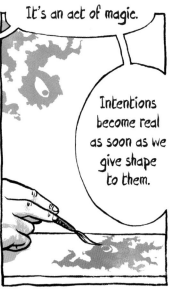

Most religions have forbidden the visual representation of any living being. They know that we can influence beings through their representations.

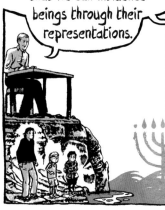

In general, Judaism and Islam allow only geometric representations.

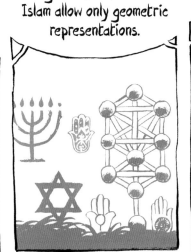

Christianity is different due to Veronica.

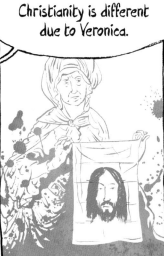

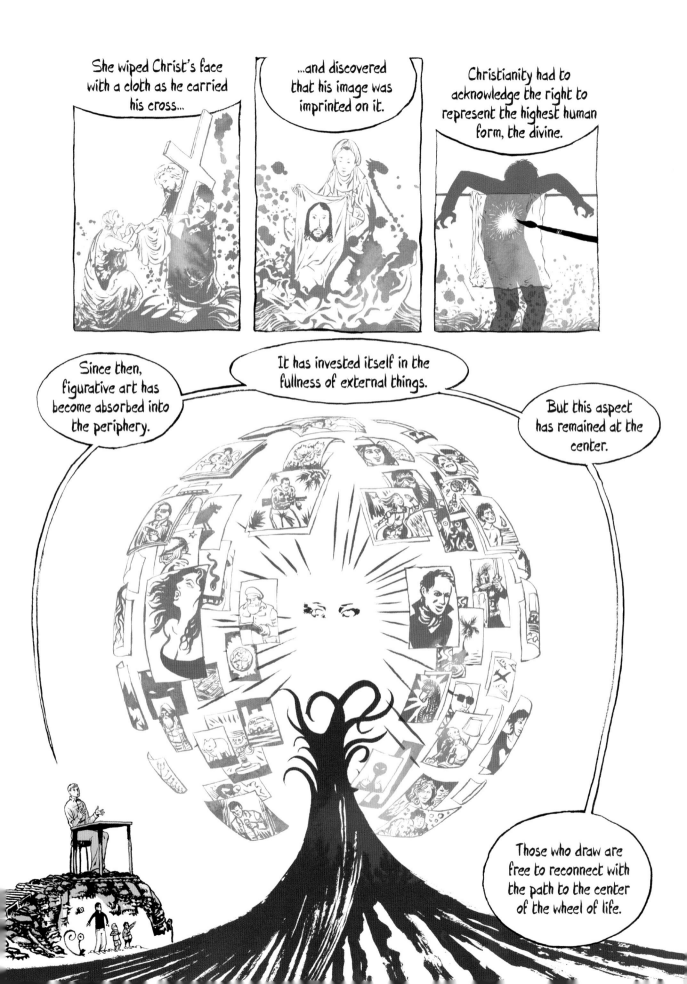

 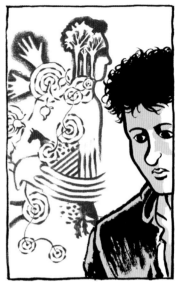

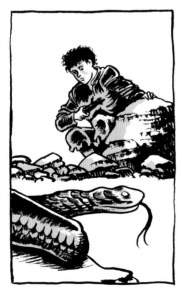 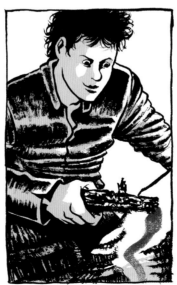

Did you catch the shadow fever, too, Saurias?

ORPHEUS! OLD FRIEND!

The Oracle said you were back!

Are you back for good, Saurias, or just for a while?

Unfortunately, I'll have to leave again soon. My life belongs to the Commander.

You're just like Saminia...

...obsessed with your shadows, you keenly observe the world...

...and yet, you see nothing.

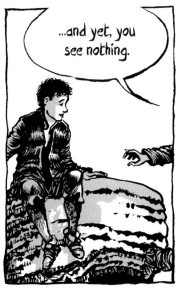

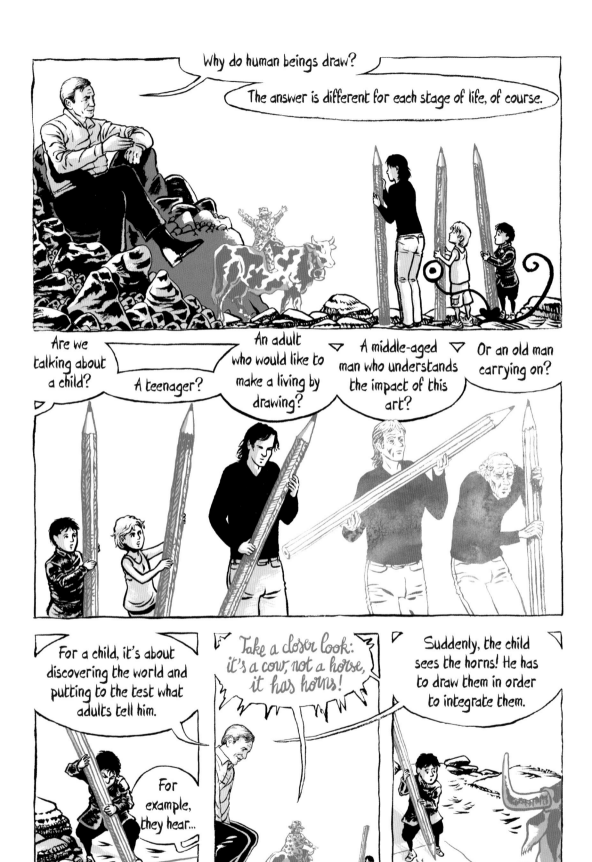

Why do human beings draw?

The answer is different for each stage of life, of course.

Are we talking about a child?

A teenager?

An adult who would like to make a living by drawing?

A middle-aged man who understands the impact of this art?

Or an old man carrying on?

For a child, it's about discovering the world and putting to the test what adults tell him.

For example, they hear...

Take a closer look: it's a cow, not a horse, it has horns!

Suddenly, the child sees the horns! He has to draw them in order to integrate them.

He looks at the world with the intensity of someone who wants to integrate everything.

Drawing the shapes, he separates them, individualizes them.

With the same intelligence, he learns to see his family no longer as an indivisible whole but as a set of separate individuals: his father, mother, and himself.

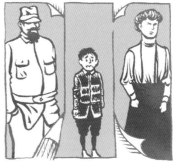

And yet, the stroke that separates also creates a connection in the same movement.

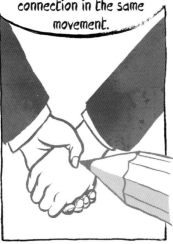

The stroke is the border, the skin through which I feel both the other and my limits.

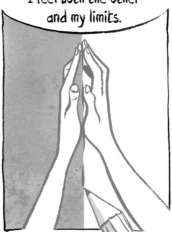

Touch is the most fundamental of a human being's senses. Sound touches my eardrum. Taste touches my taste buds. Light touches my eye.

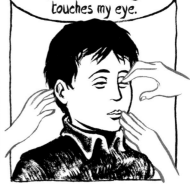

Sight is the last sense a baby develops. It sums up all the others.

The sight of a flame can make me feel heat.

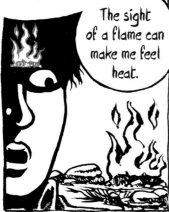

That's why the eye is the symbol of reflection. It allows the world to be reflected in me.

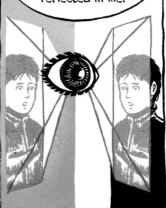

We draw to integrate the world.

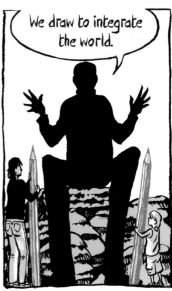

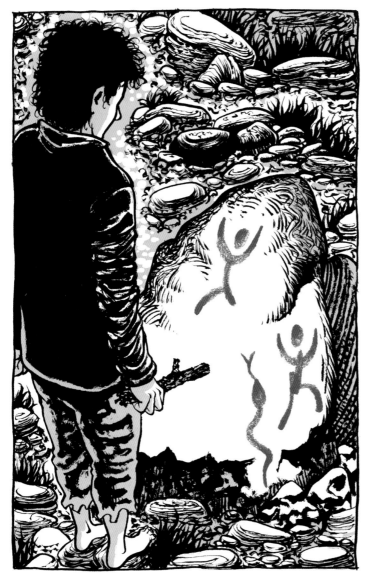

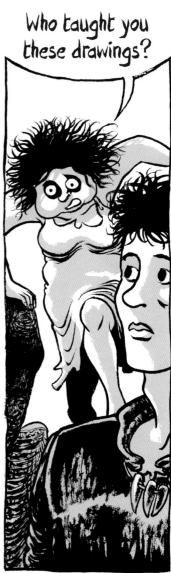

Who taught you these drawings?

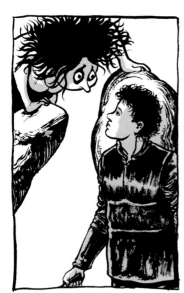

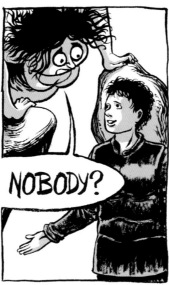

NOBODY?

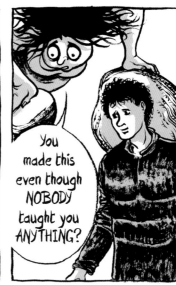

You made this even though NOBODY taught you ANYTHING?

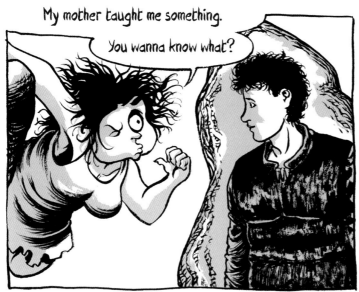

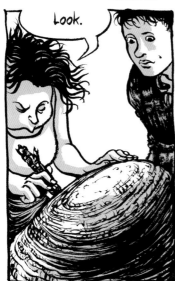

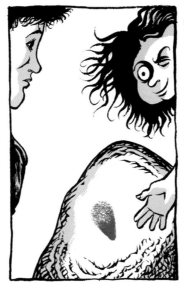

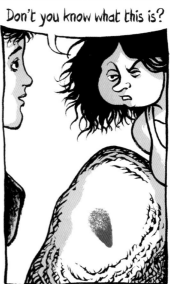

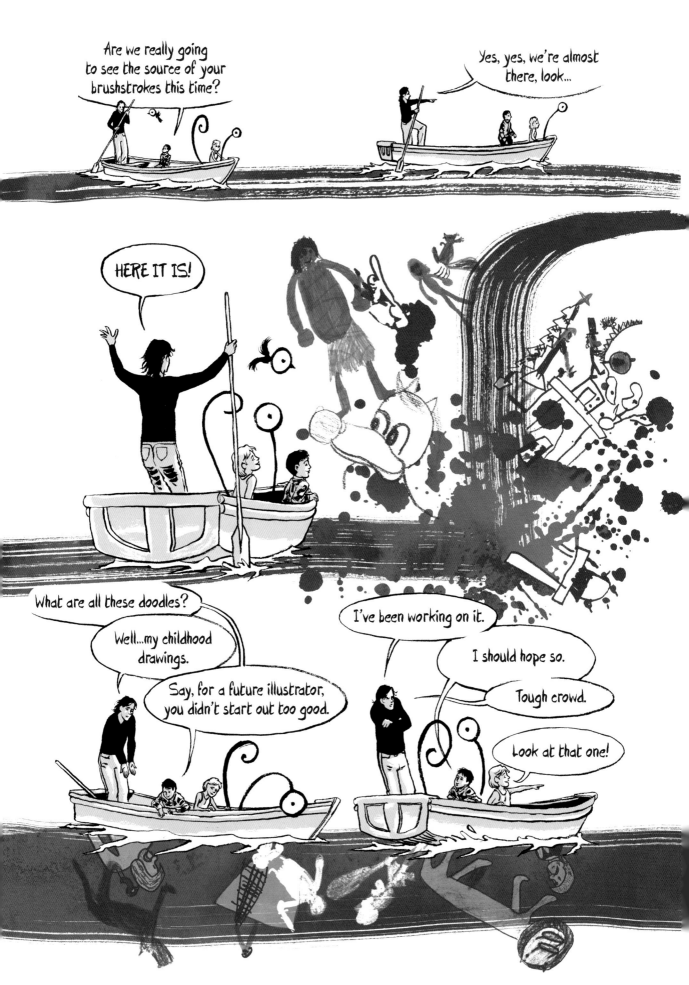

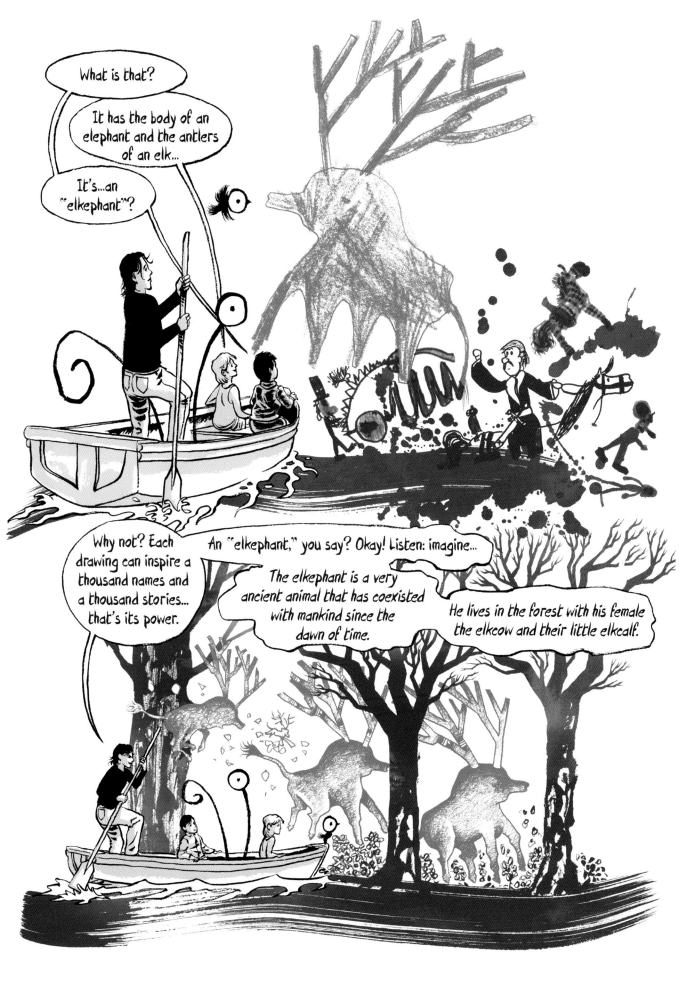

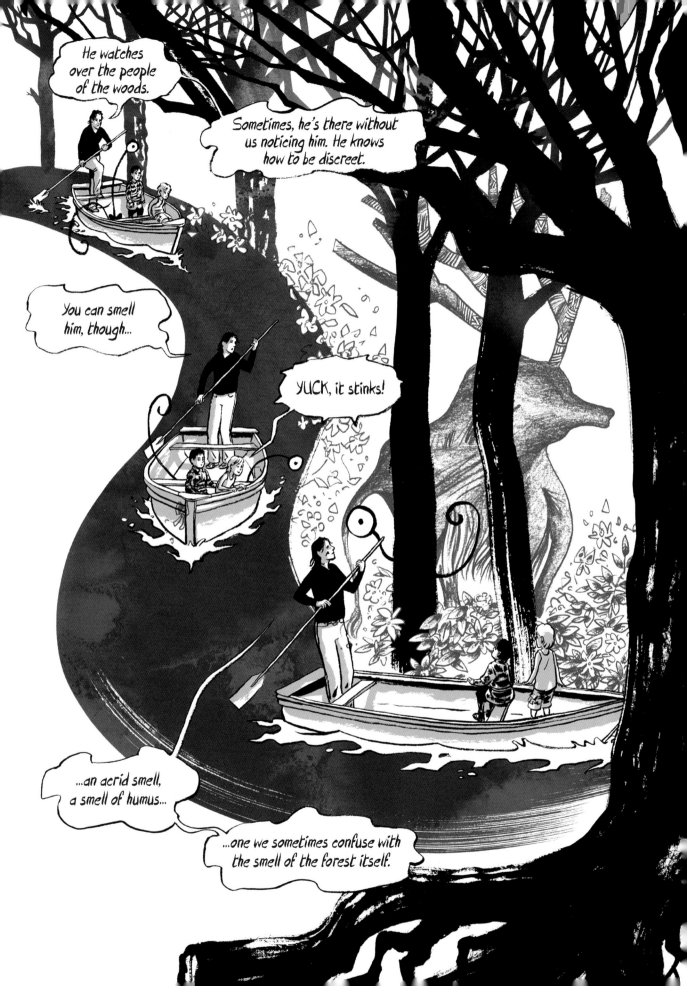

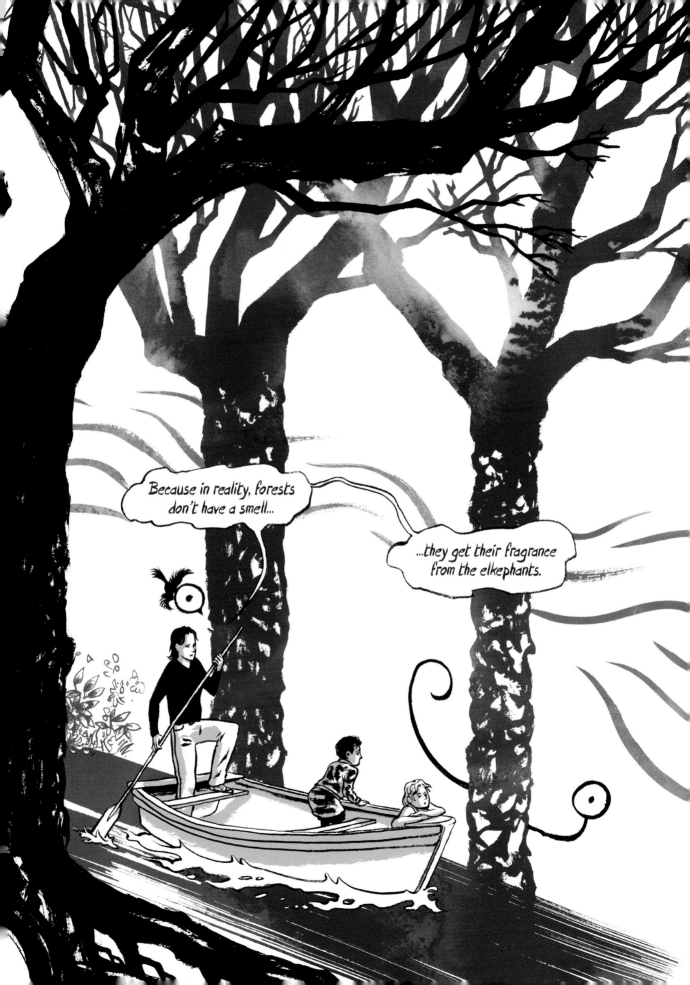

Are you okay?

I'm thinking about my dad, far away...

I'd like there to be an elkephant...

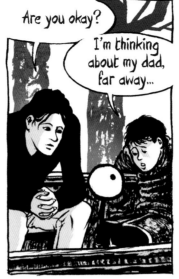

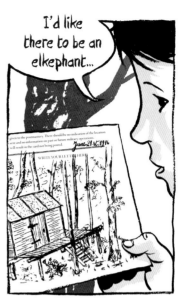

...watching over him in his forest...

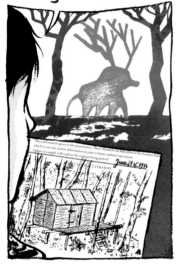

...every time he leaves his house.

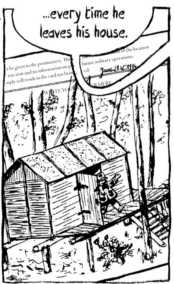

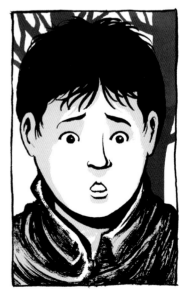

I don't get why daddy has to stay there.

Neither do I. That's the way it is. The front holds on to its soldiers.

Saurias, too, has to return to battle after the two moons spent by Saminia's side.

Saminia never really forgave him for what she saw in the mirror.

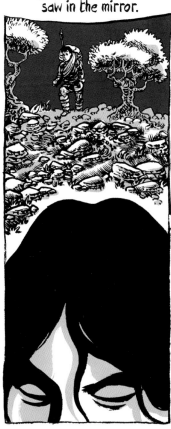

Despite what the oracle said, she's still suspicious.

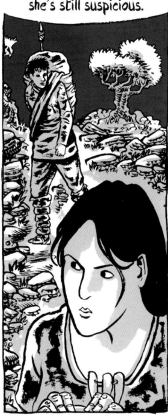

But when she realizes that Saurias is going away...

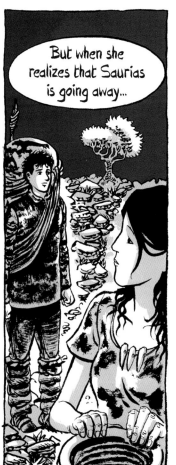

Oh, no...wait, come!

Just for a moment! Please...

...not like this!

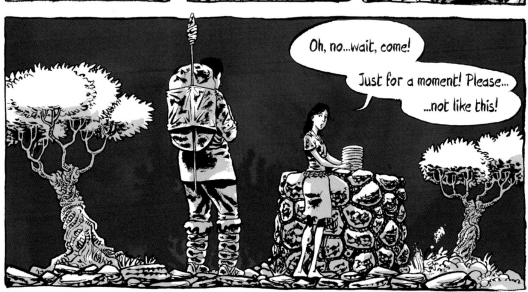

97

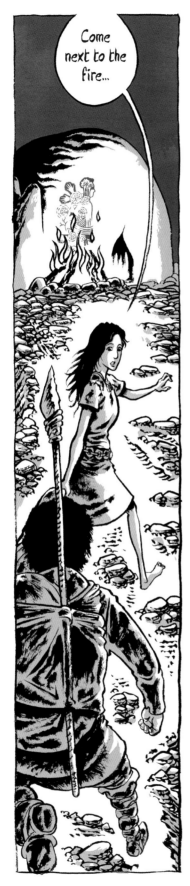

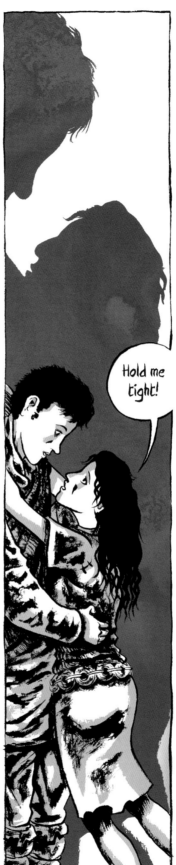

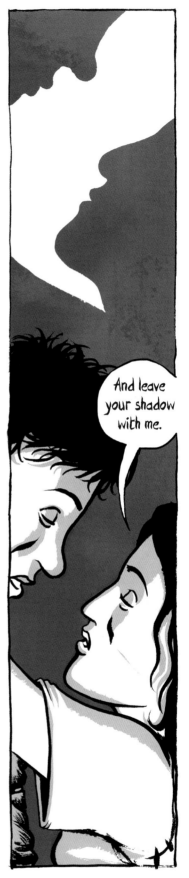

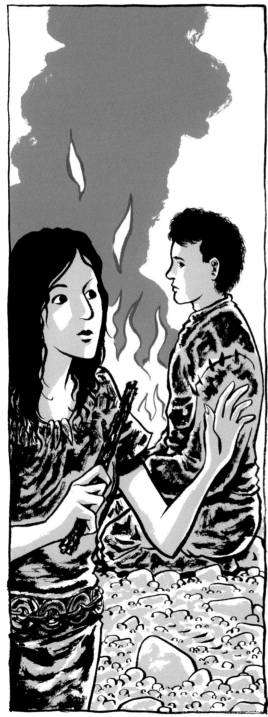

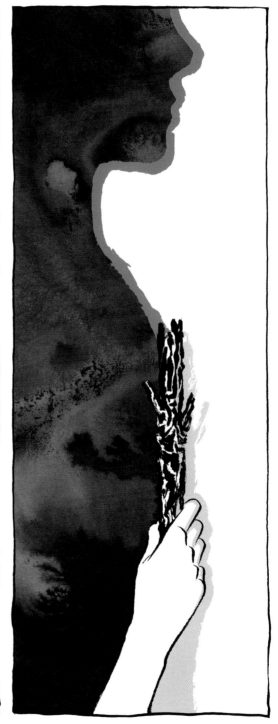

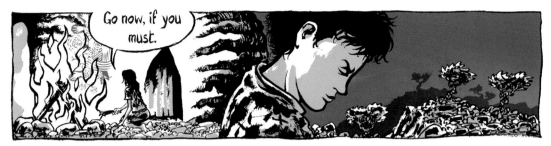

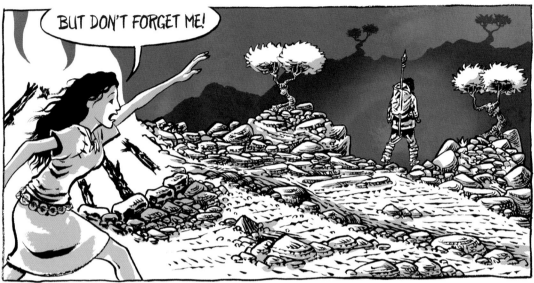

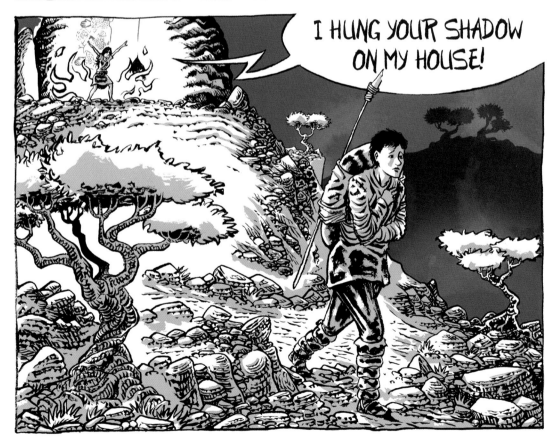

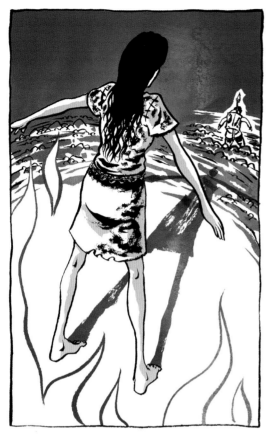
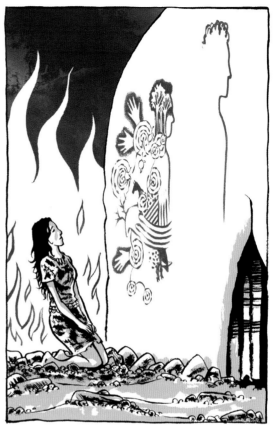

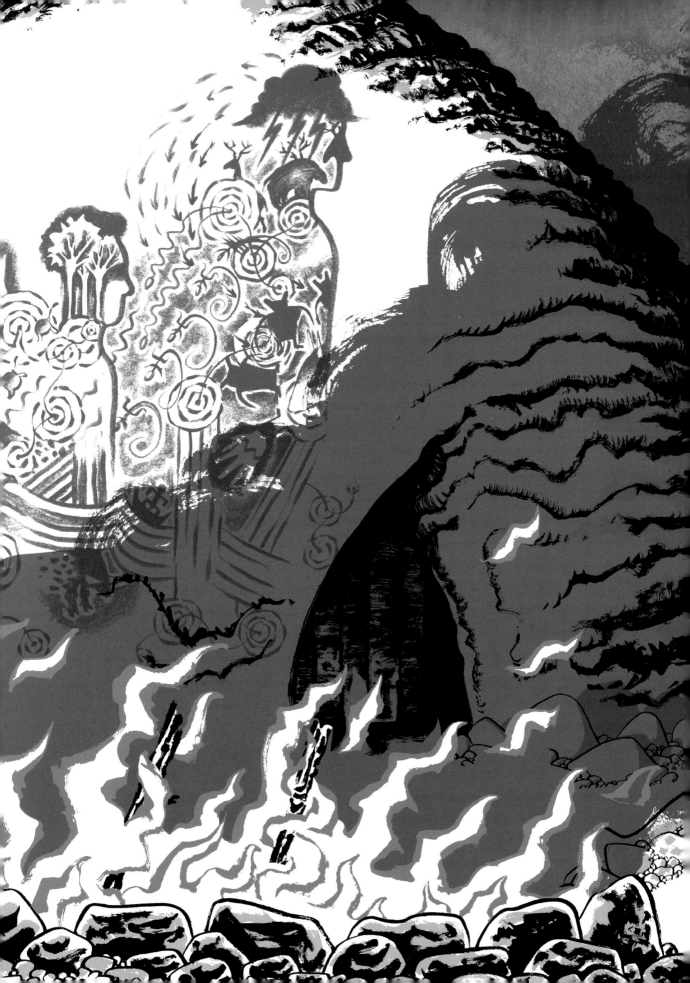

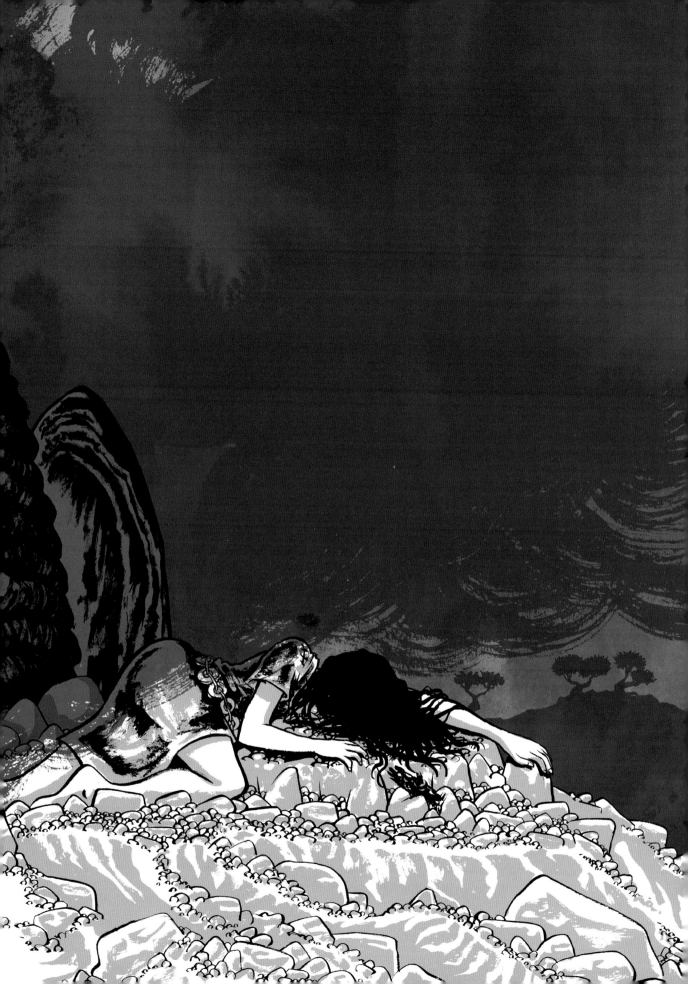

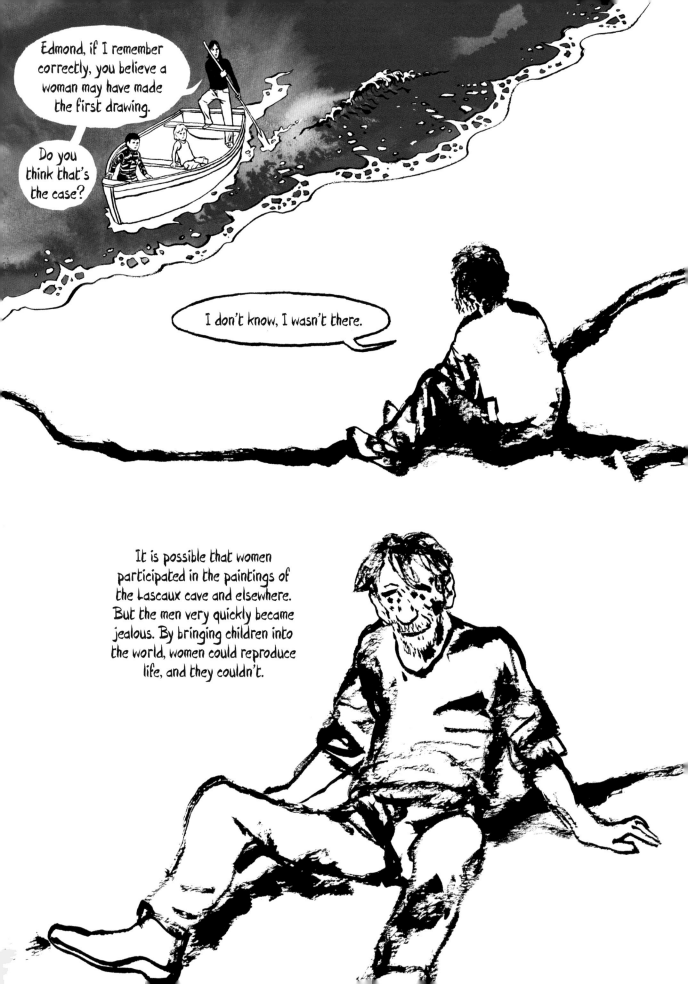

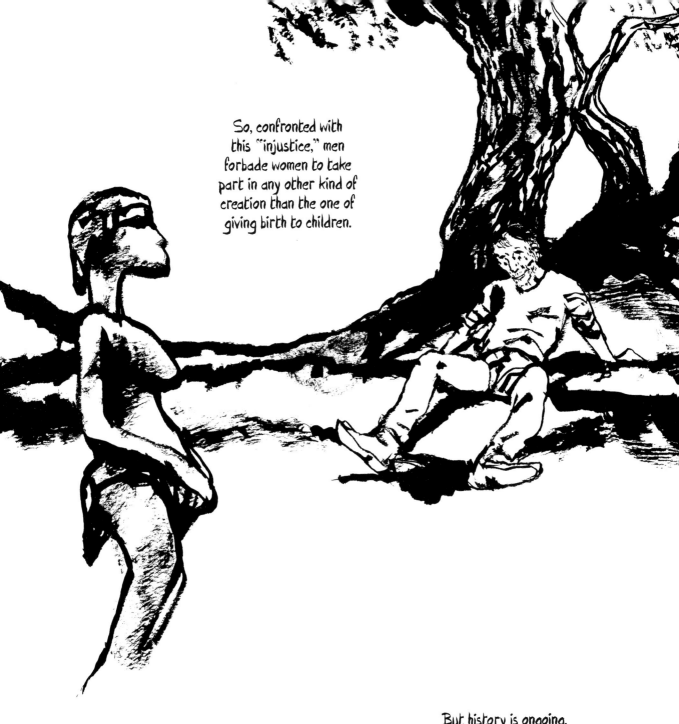

So, confronted with this "injustice," men forbade women to take part in any other kind of creation than the one of giving birth to children.

But history is ongoing. And that's its strength and beauty.

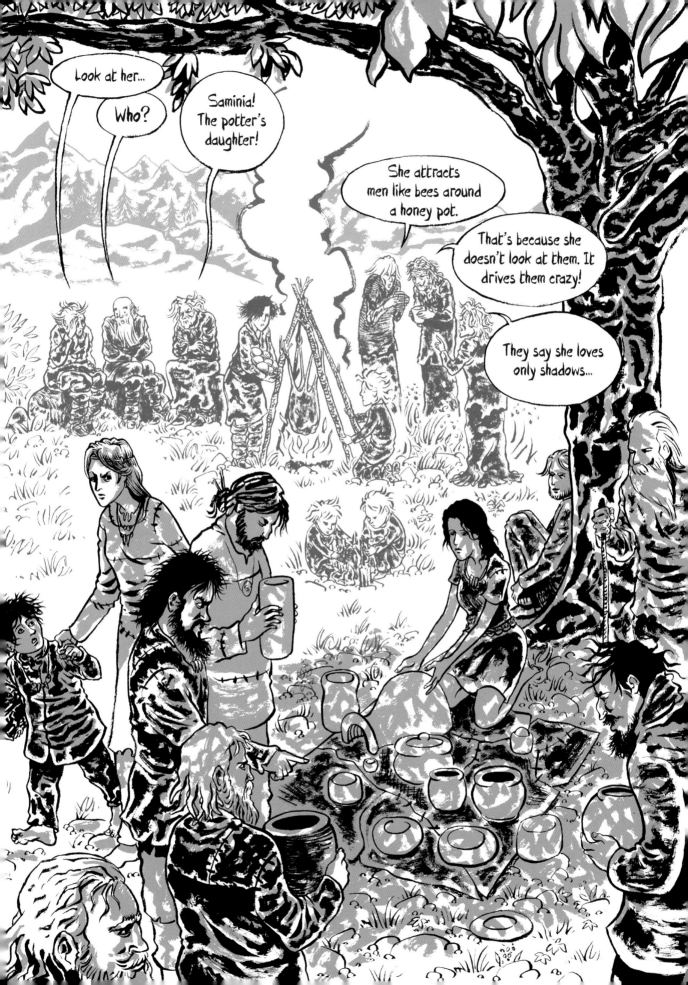

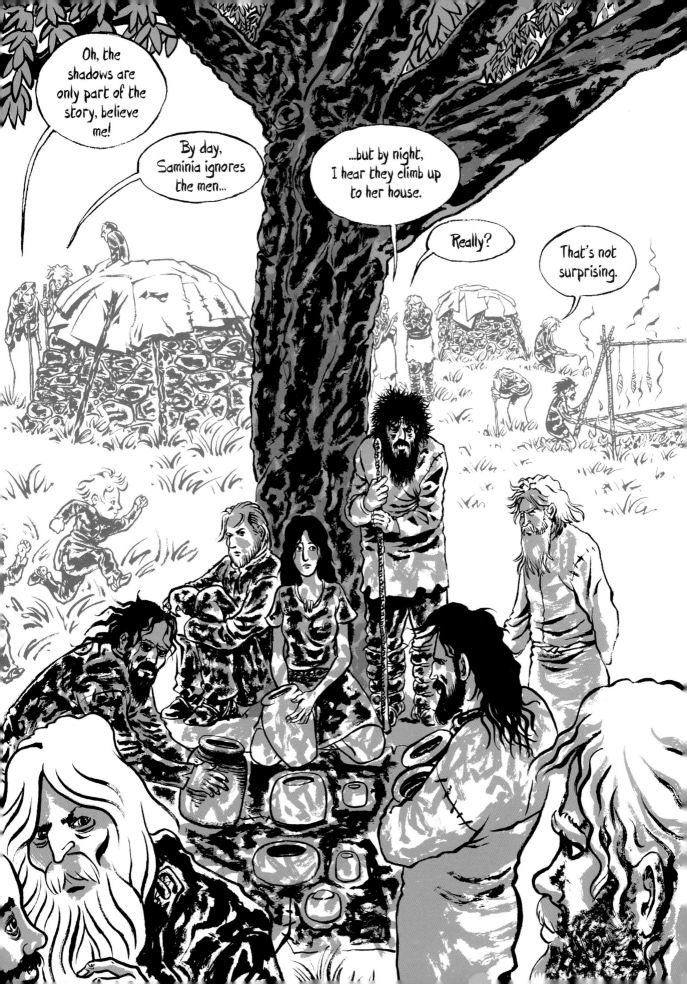

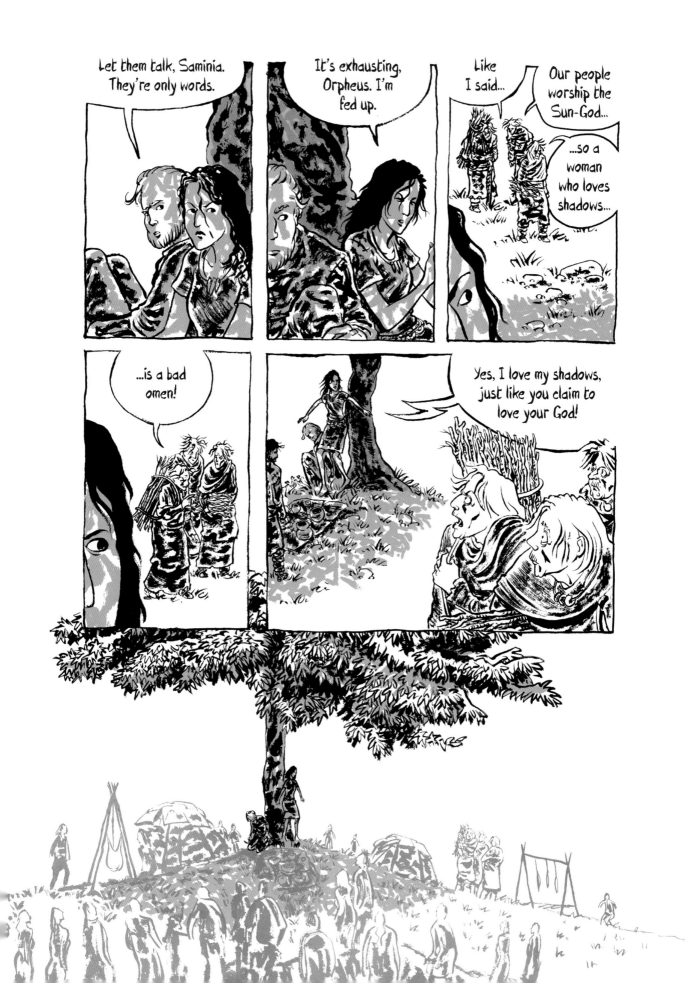

Drawing gives teenagers a space for affirmation, without compromise.

Drawing allows you to escape from the world, no longer subjected to the pressure of others.

Drawing teaches you to assert your way of seeing reality without being contradicted.

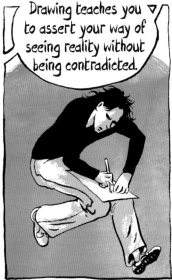

To me, this is an ear!

But before reaching that point, a child treats drawing like a decorative art.

WHOA! What's happening to me?

A child wants to be loved. He'll do anything to please others...

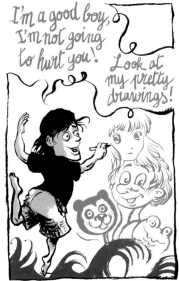

I'm a good boy, I'm not going to hurt you!

Look at my pretty drawings!

...to the point of sometimes looking for approval from those who would take advantage.

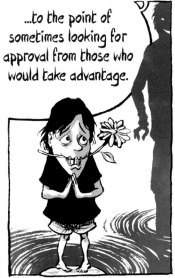

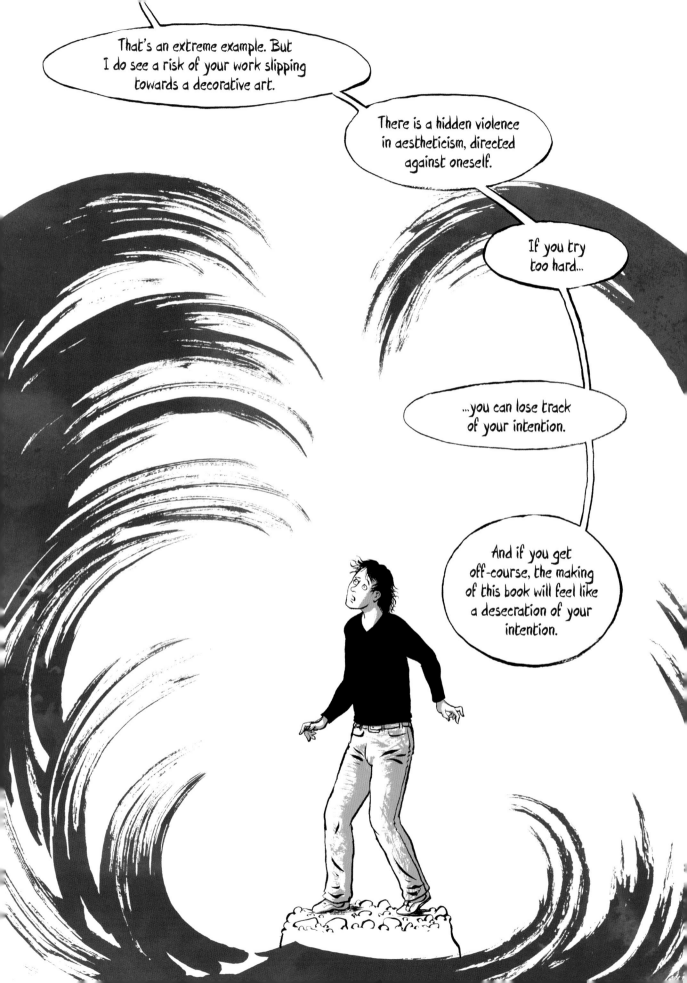

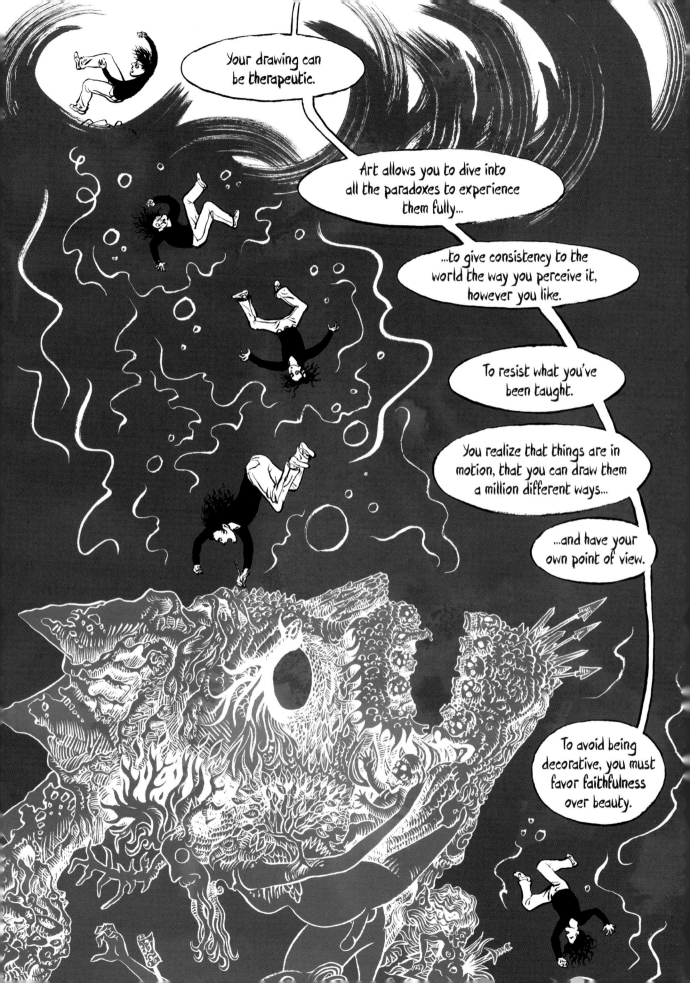

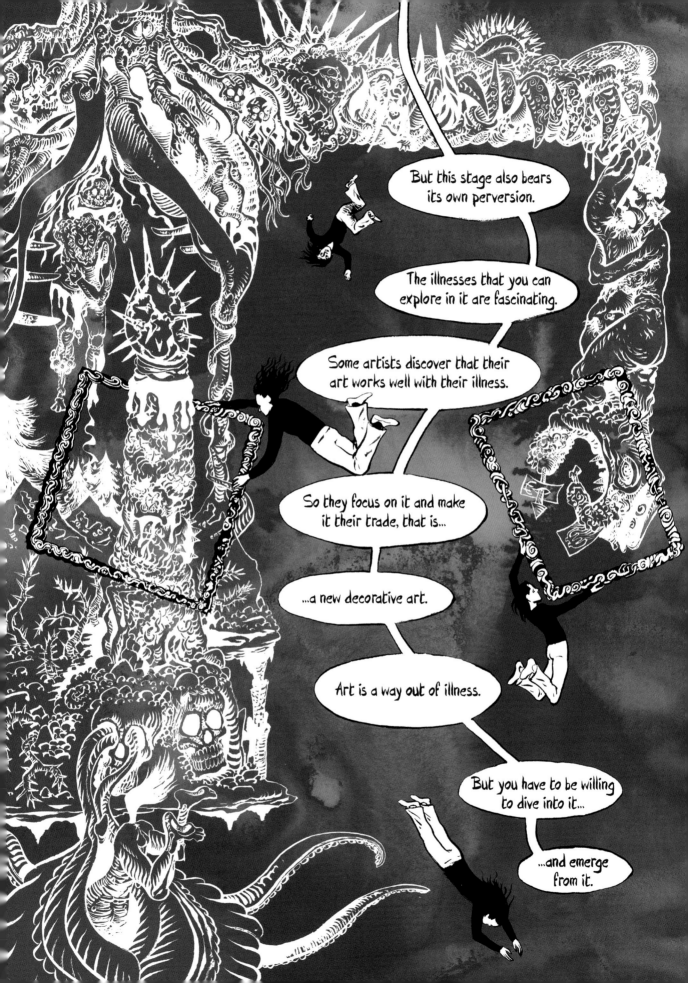

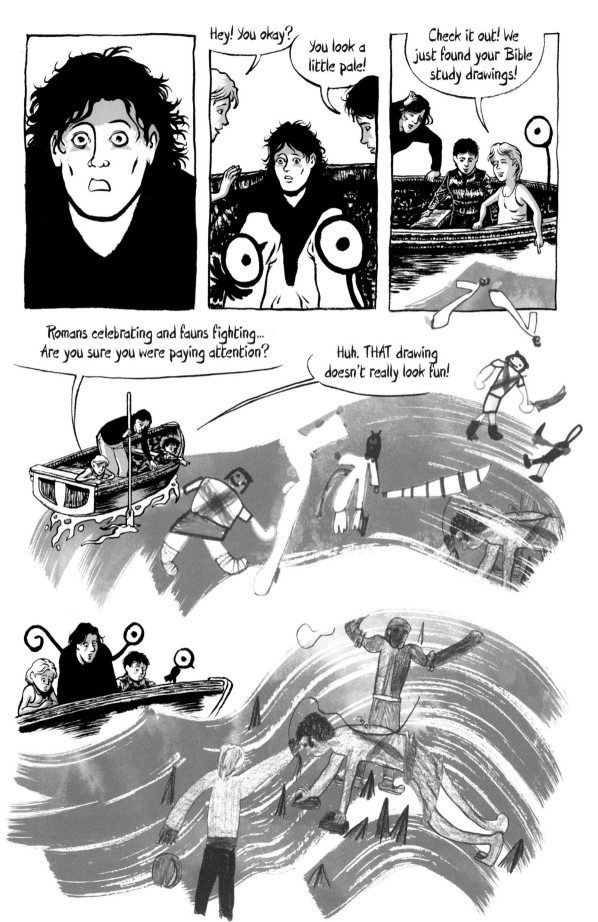

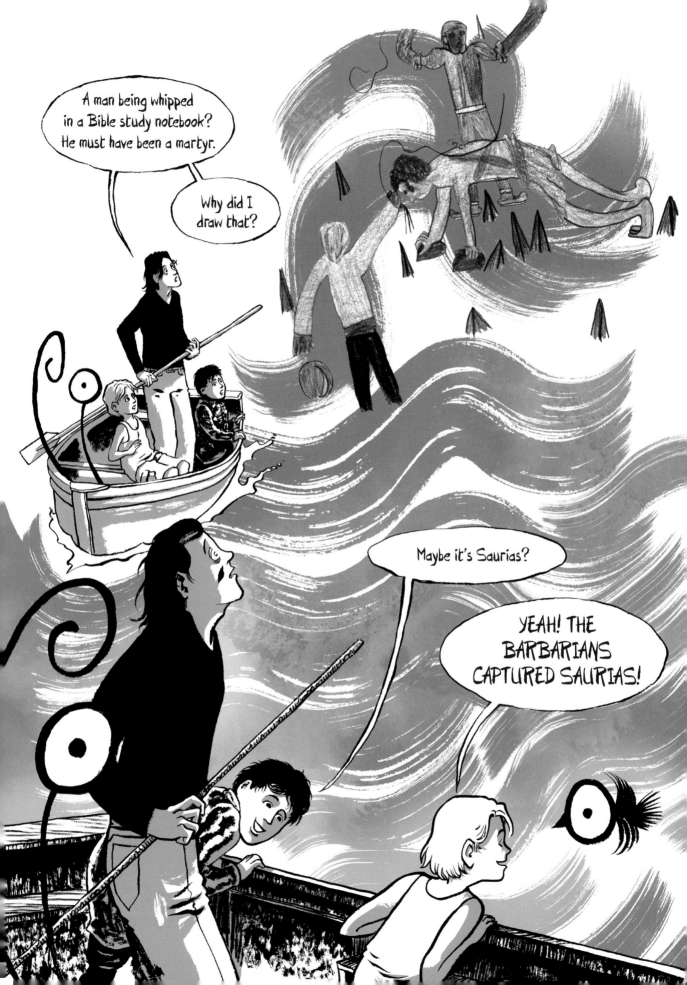

After leaving Saminia, he set off for the Commander's camp.

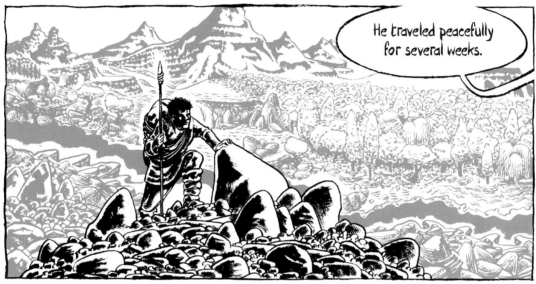

He traveled peacefully for several weeks.

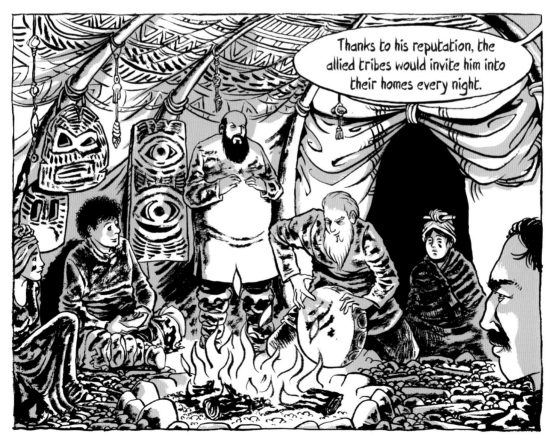

Thanks to his reputation, the allied tribes would invite him into their homes every night.

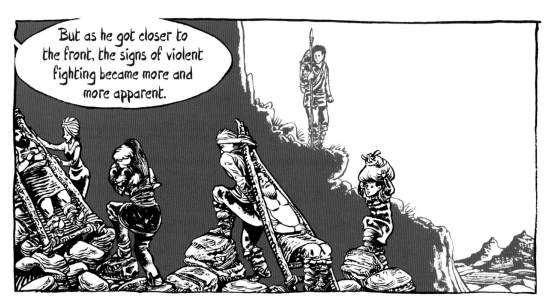

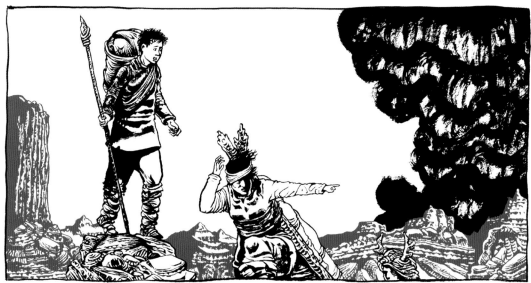

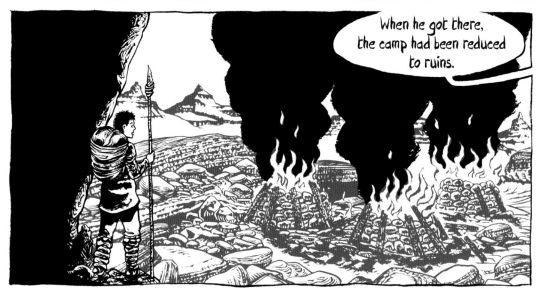

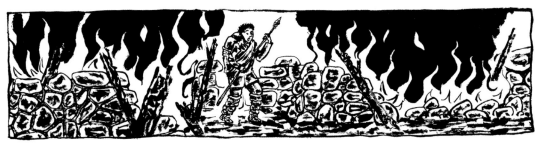

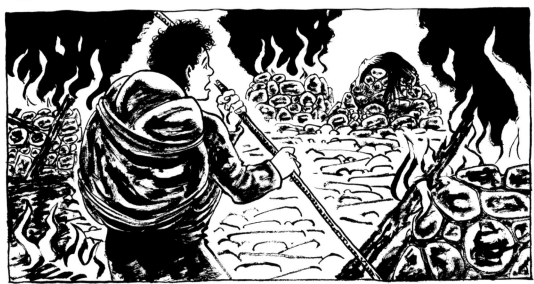

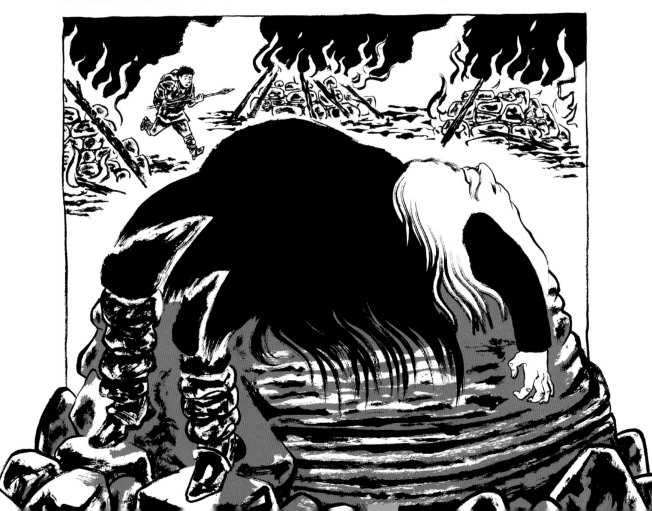

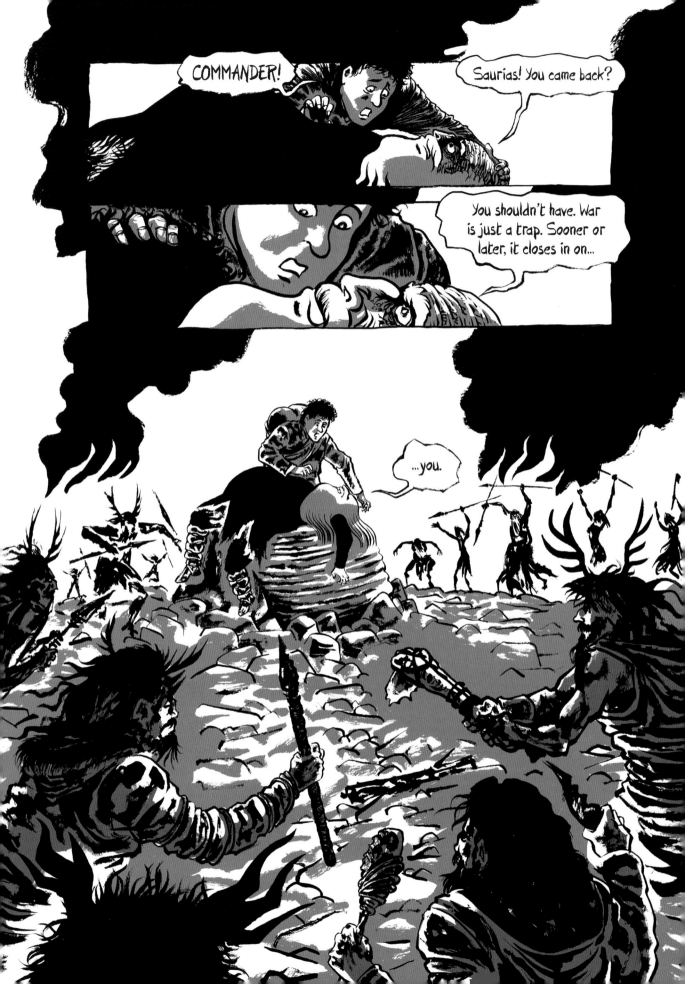

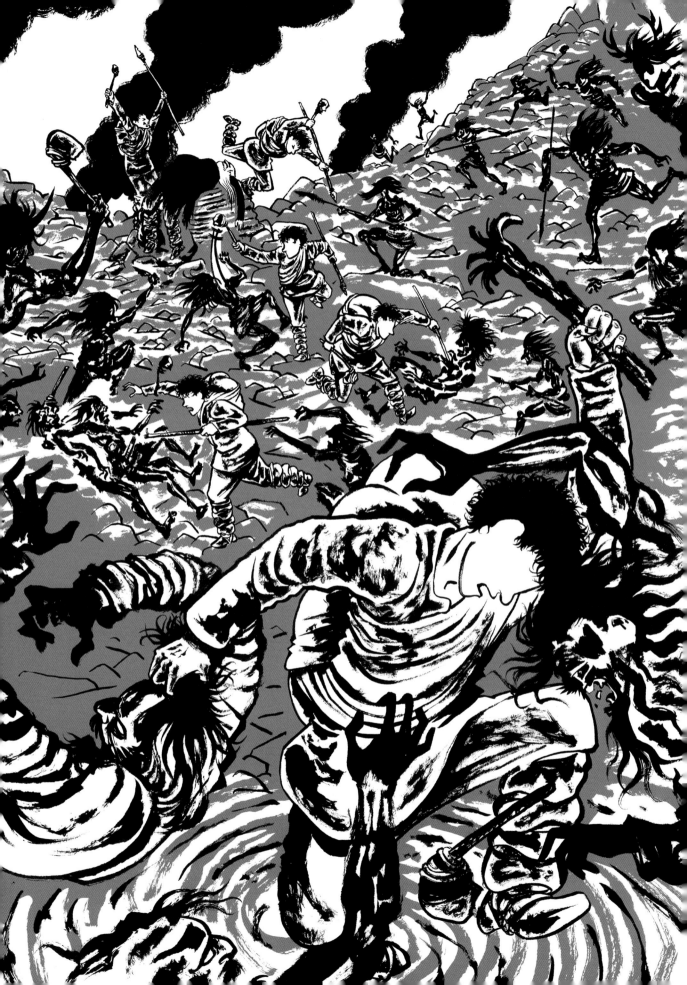

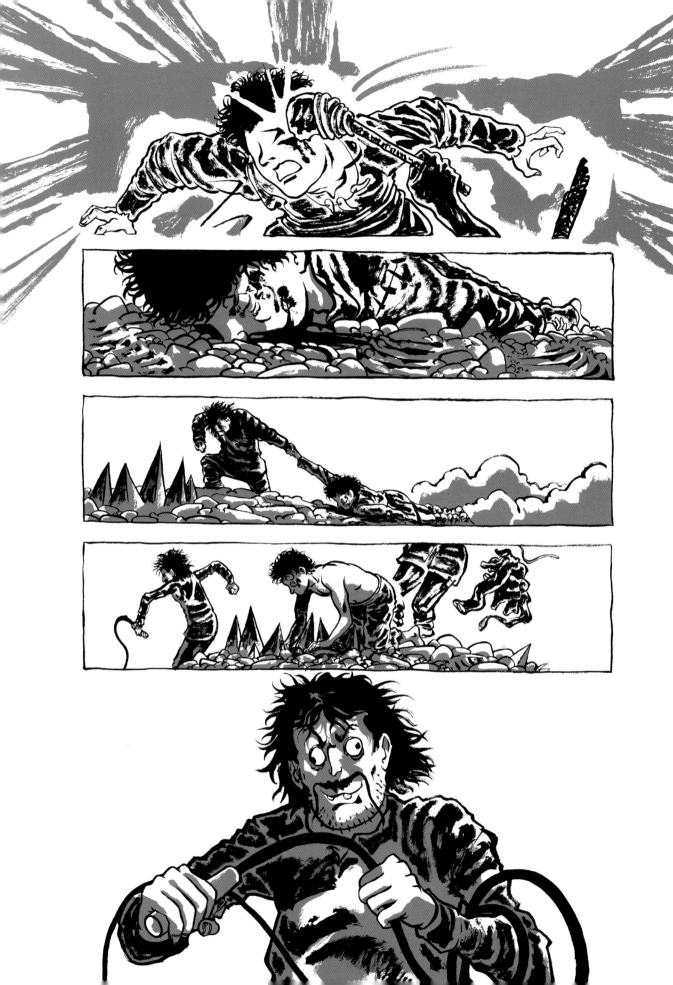

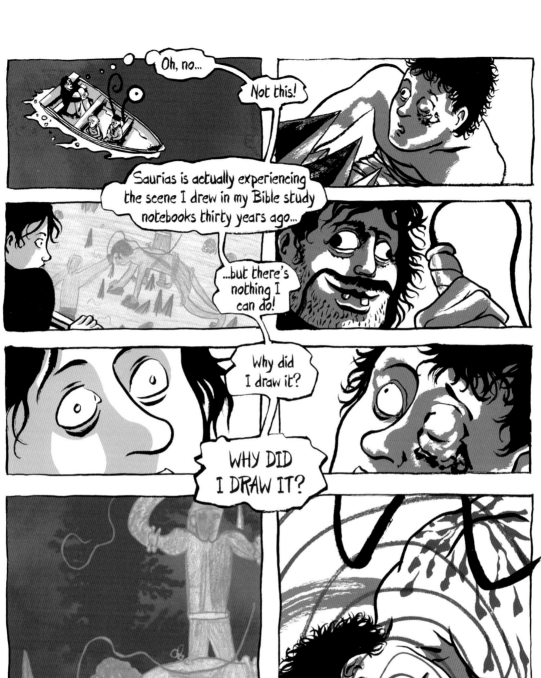

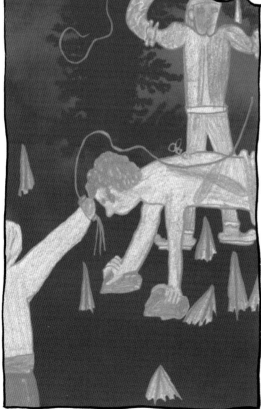

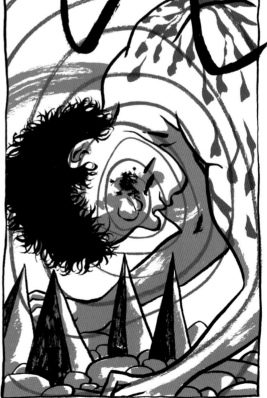

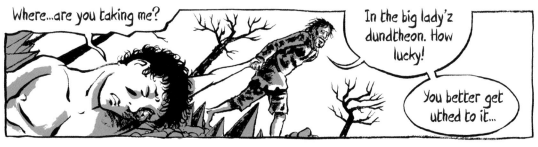

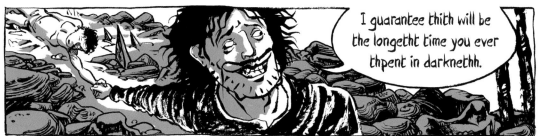

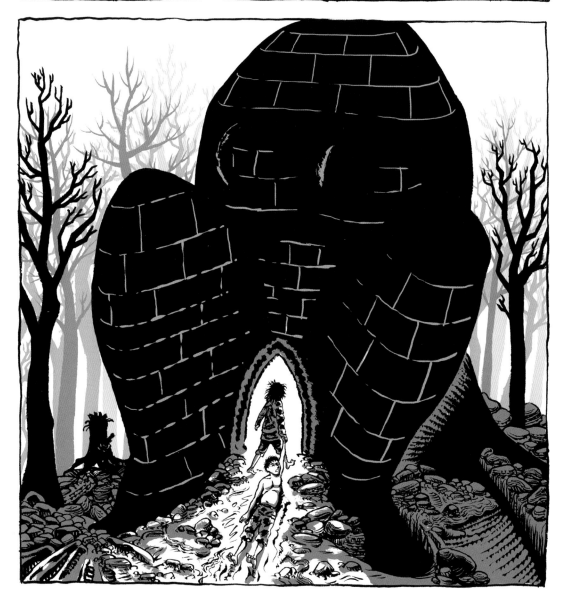

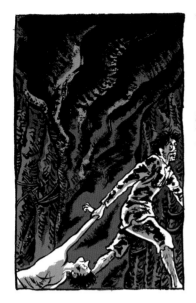

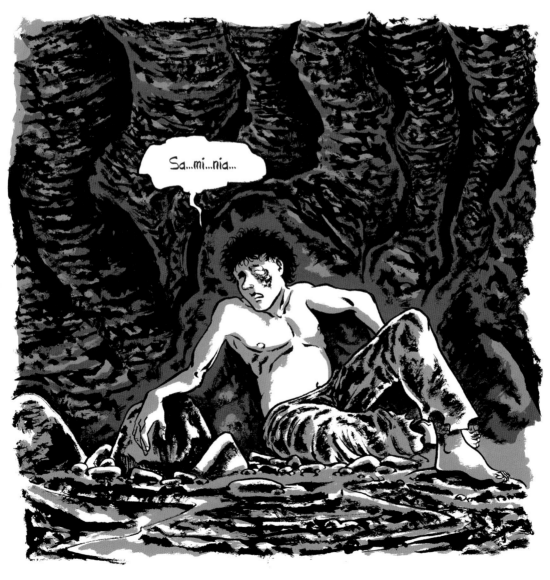

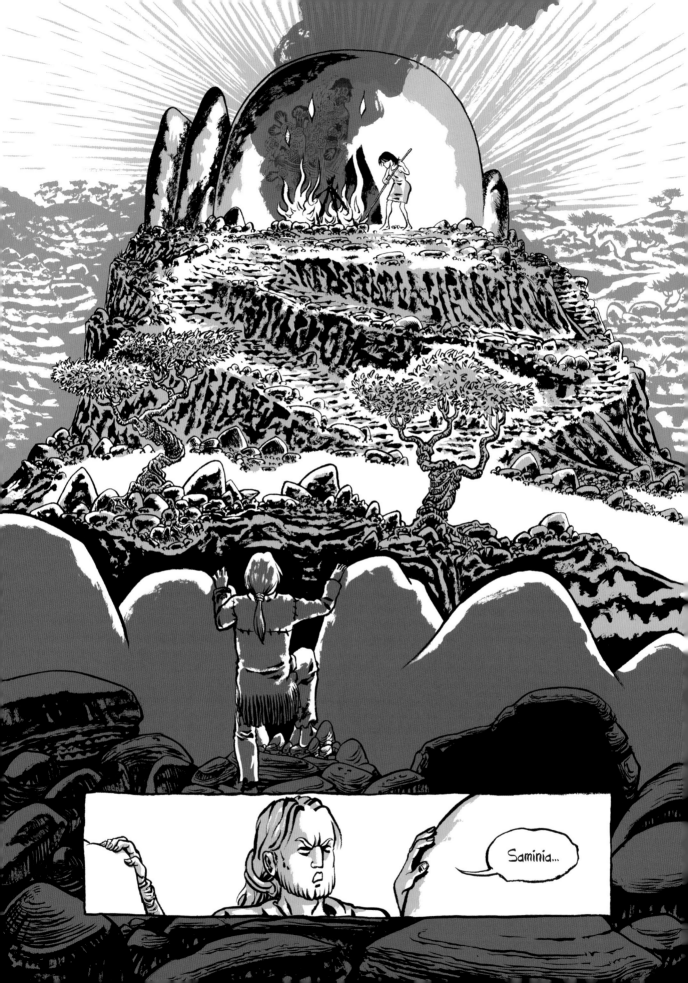

Saminia...

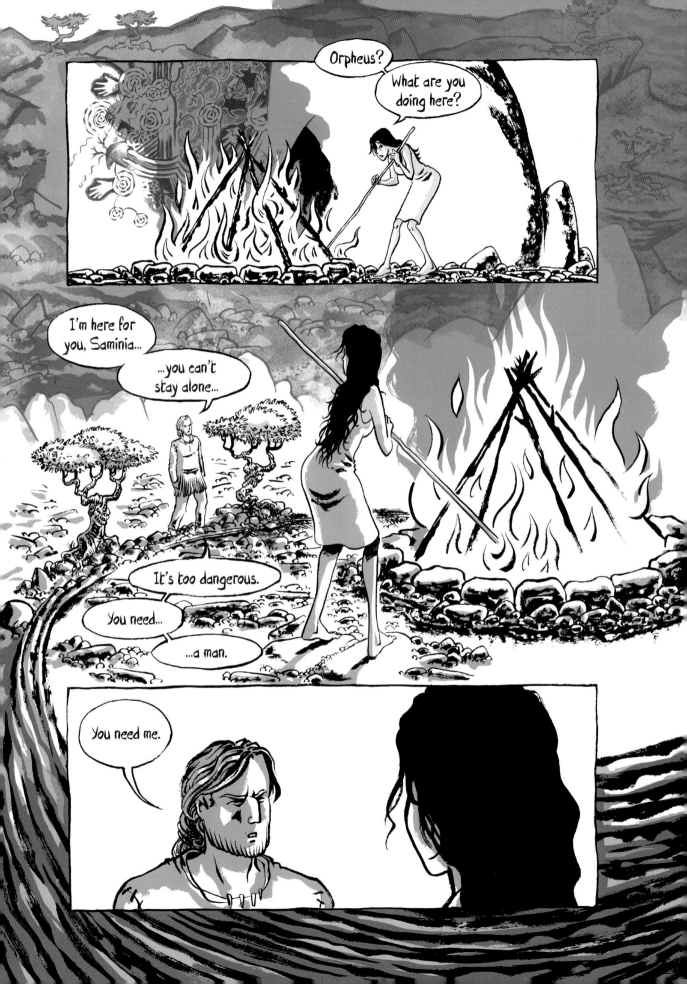

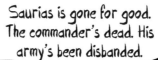

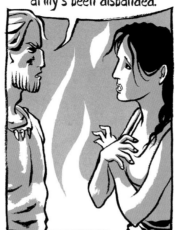

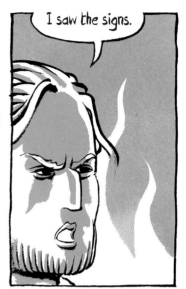

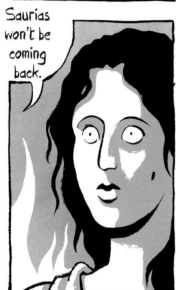

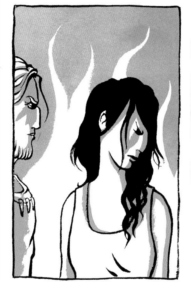

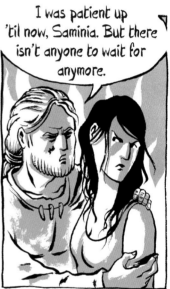

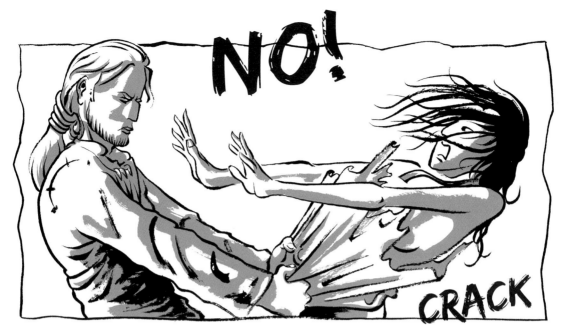

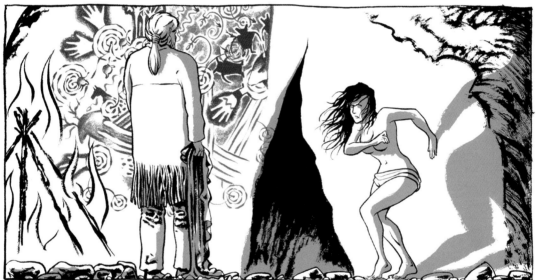

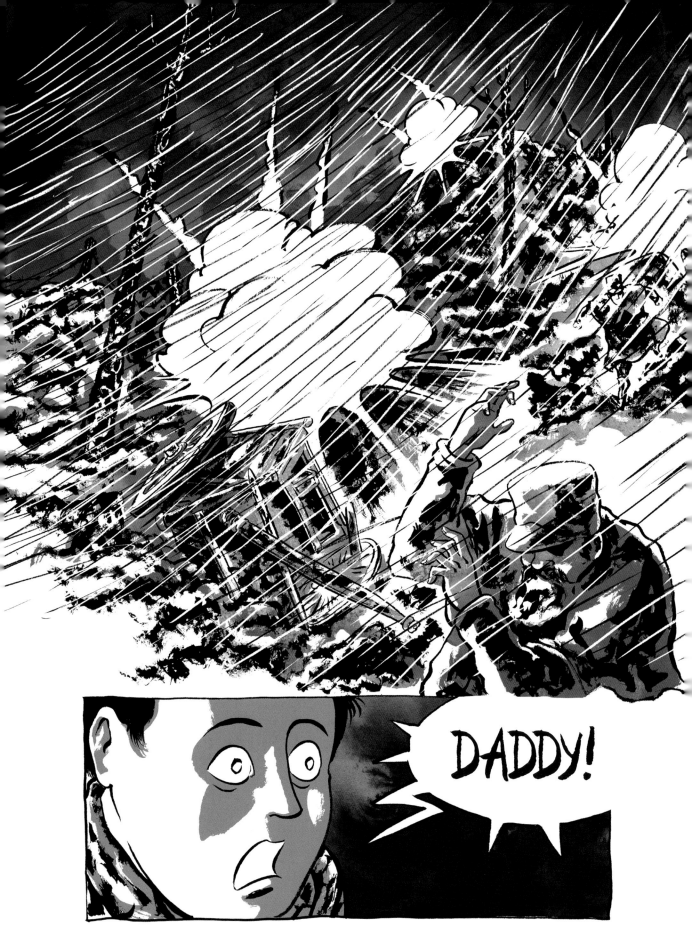

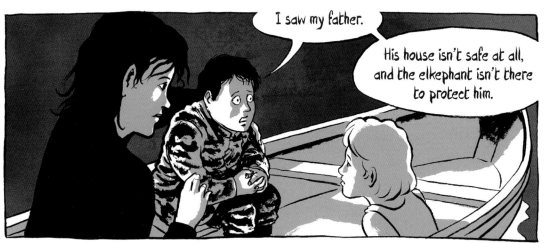

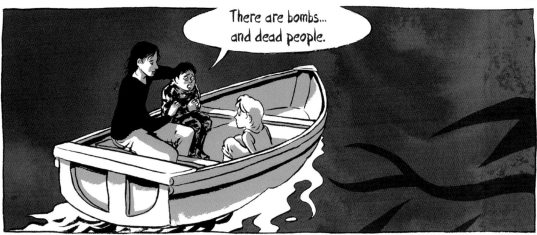

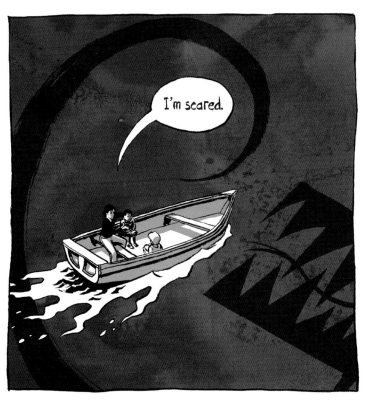

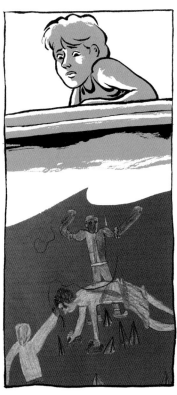

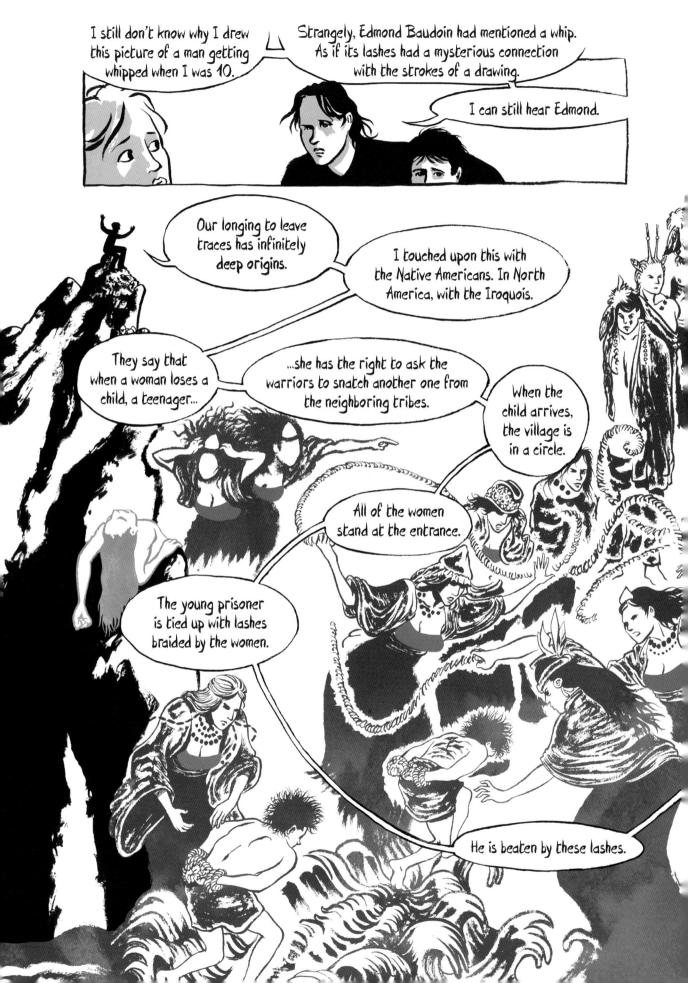

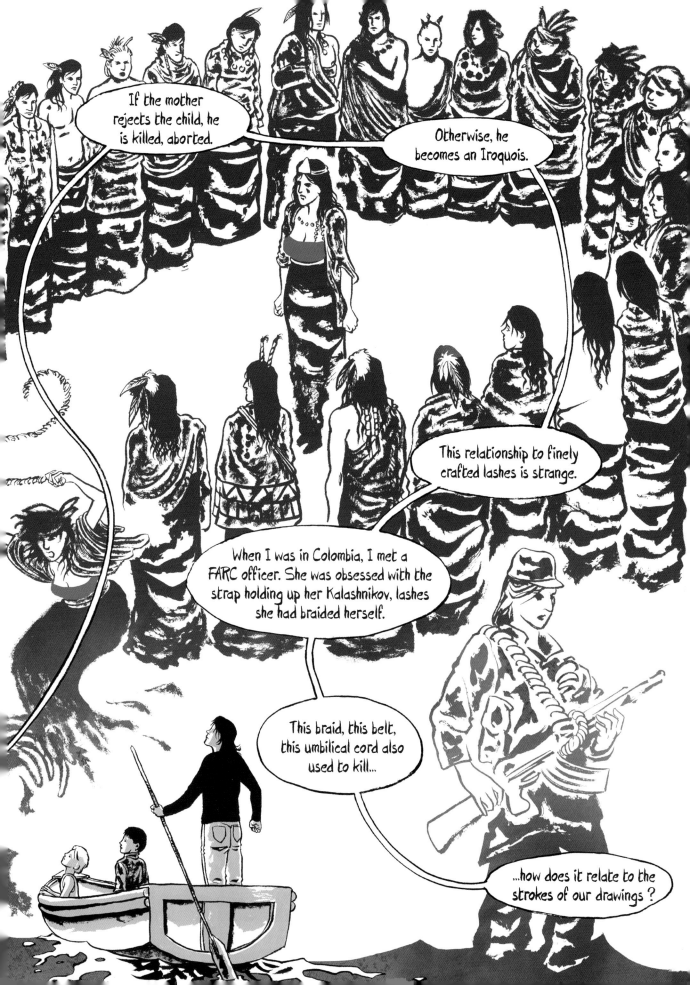

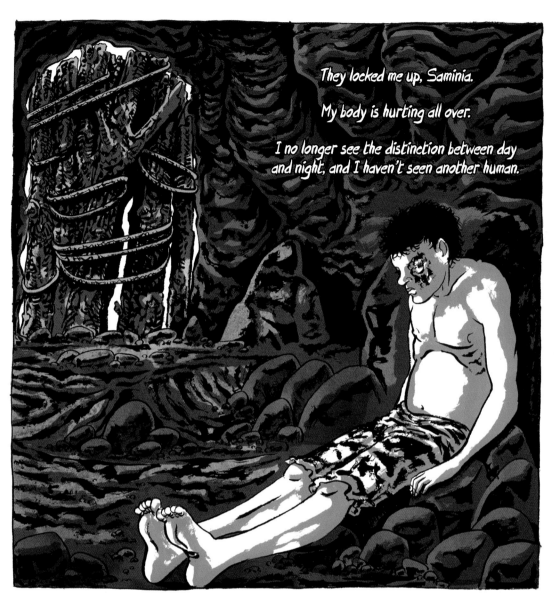

They locked me up, Saminia.

My body is hurting all over.

I no longer see the distinction between day and night, and I haven't seen another human.

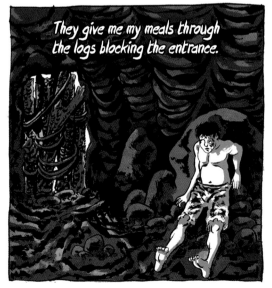

They give me my meals through the logs blocking the entrance.

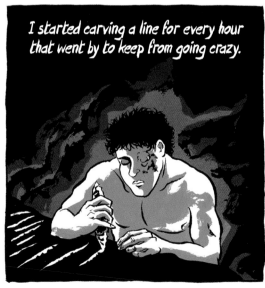

I started carving a line for every hour that went by to keep from going crazy.

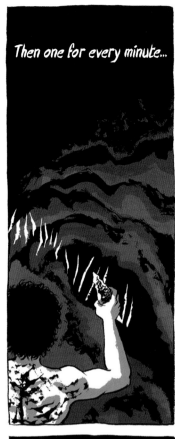

Then one for every minute...

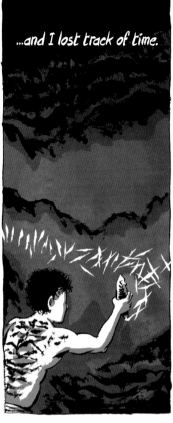

...and I lost track of time.

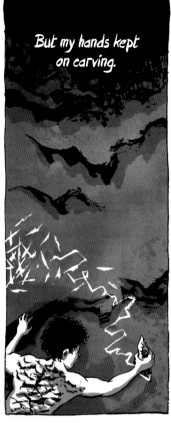

But my hands kept on carving.

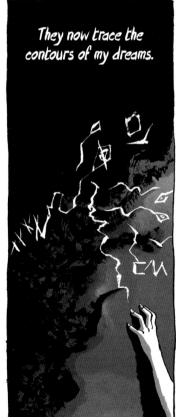

They now trace the contours of my dreams.

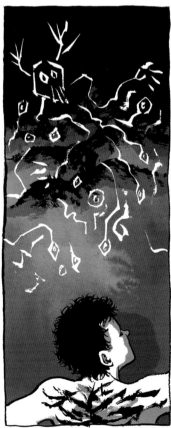

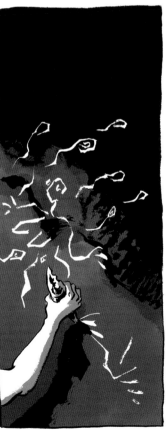

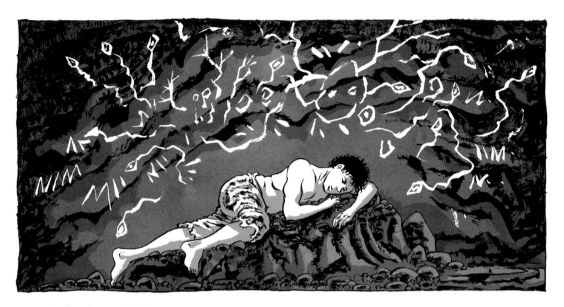

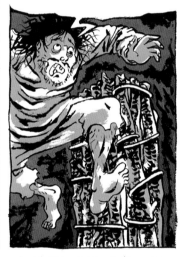

CHIEF! CHIEF!

THE PRITHONER! HE'Z A THORTHERER!

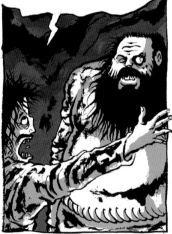

He'z drawing hideouth shapethz all over the wallthz! He'z thummoning demonthz!

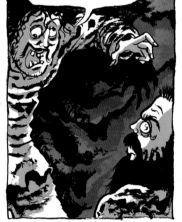

And latht night... I thaw his drawingthz thlither like a thouzand thnakes all around him... HE'Z A THORTHERER, I TELL YOU!

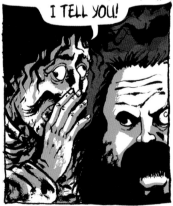

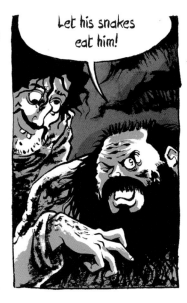

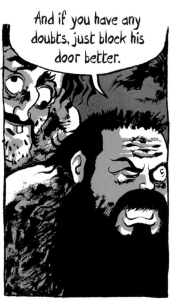

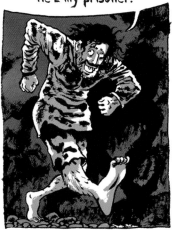

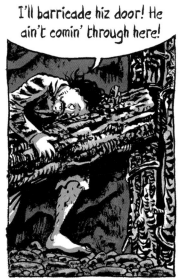

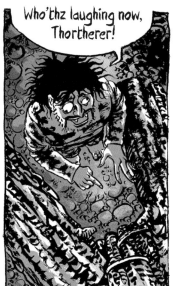

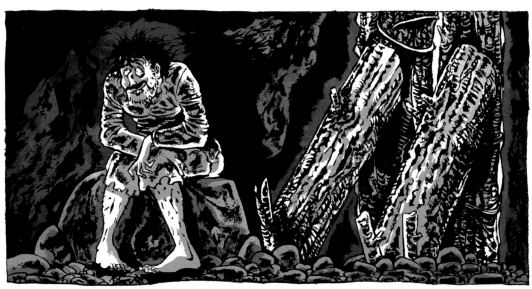

135

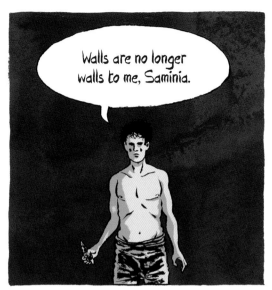

Walls are no longer walls to me, Saminia.

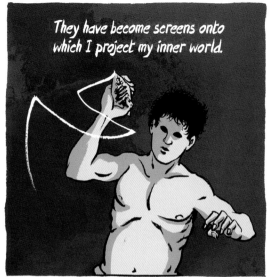

They have become screens onto which I project my inner world.

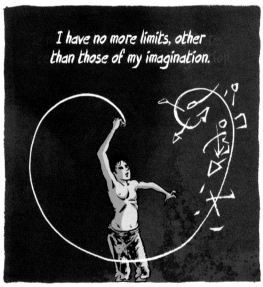

I have no more limits, other than those of my imagination.

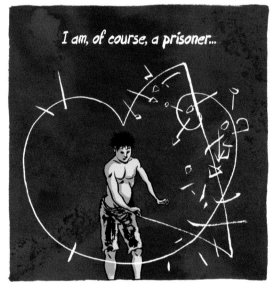

I am, of course, a prisoner...

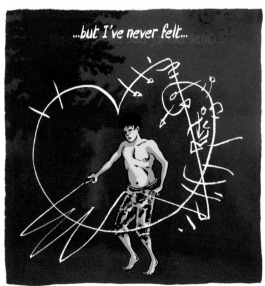

...but I've never felt...

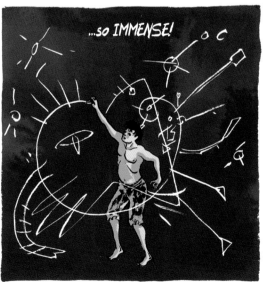

...so IMMENSE!

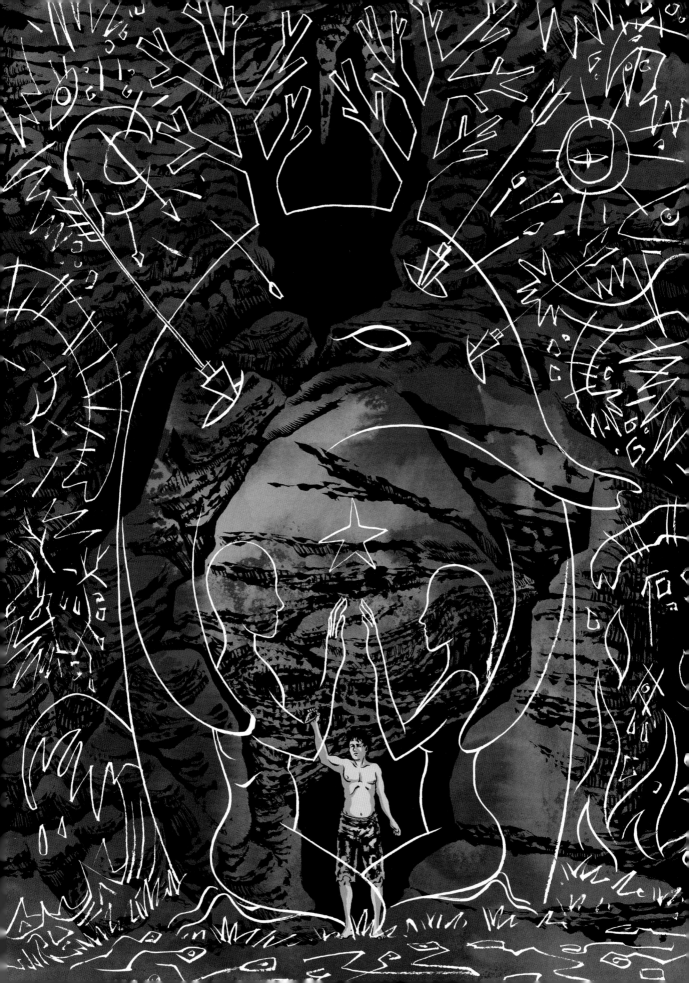

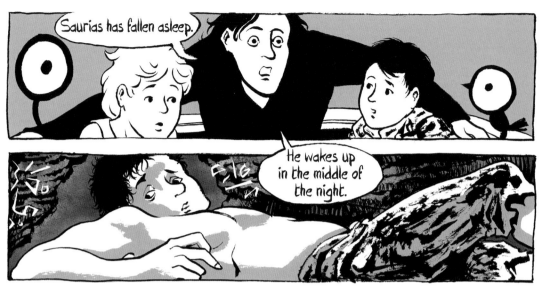

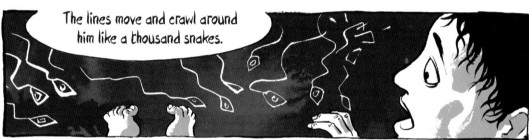

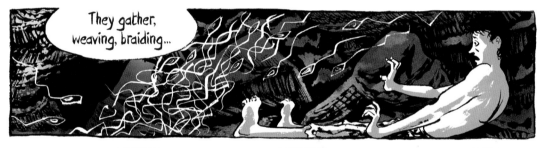

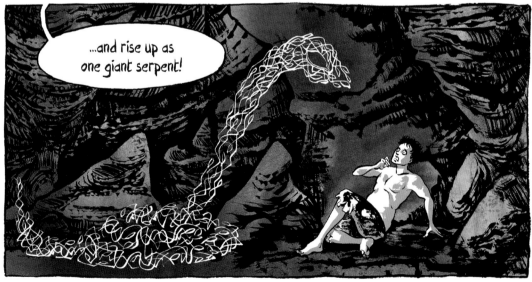

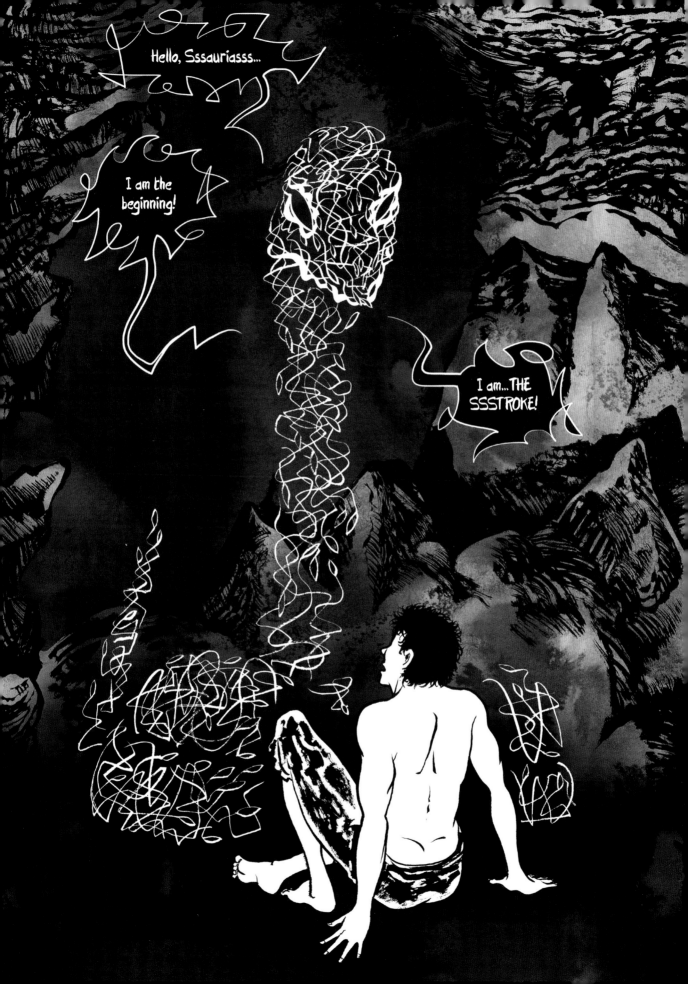

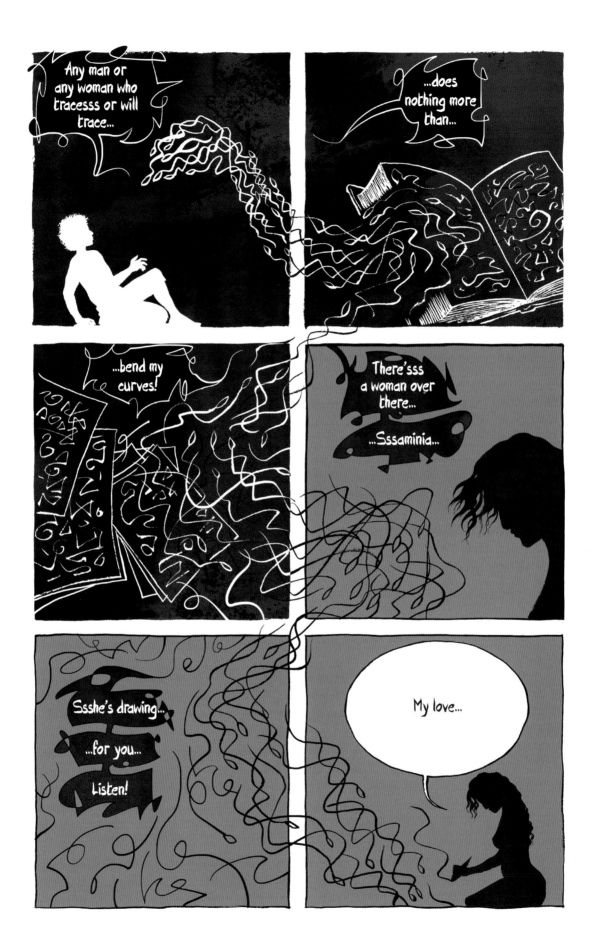

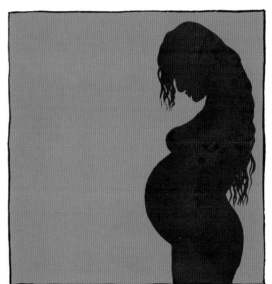
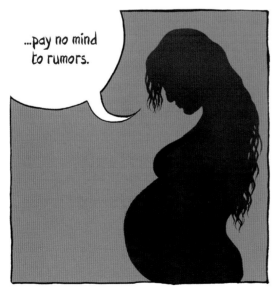
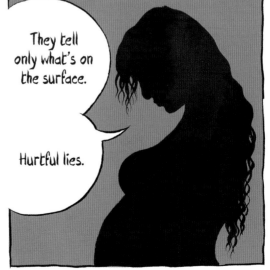

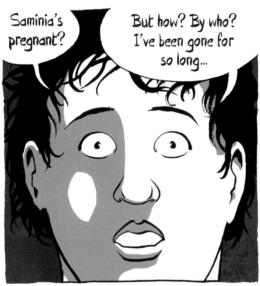

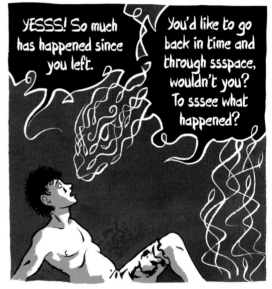

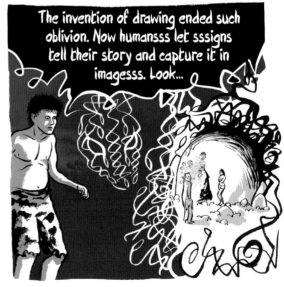

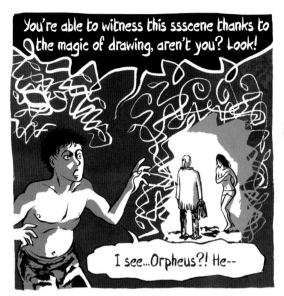

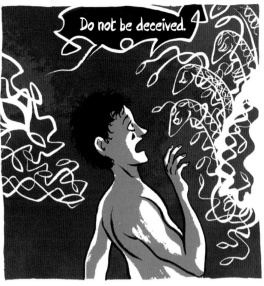

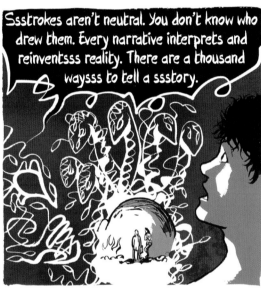

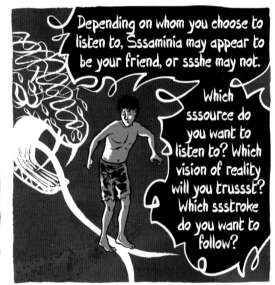

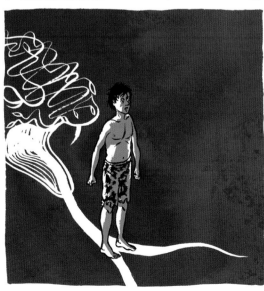

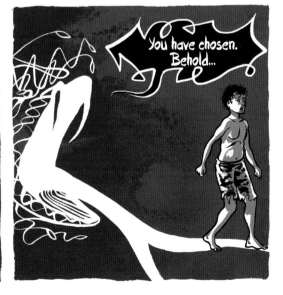

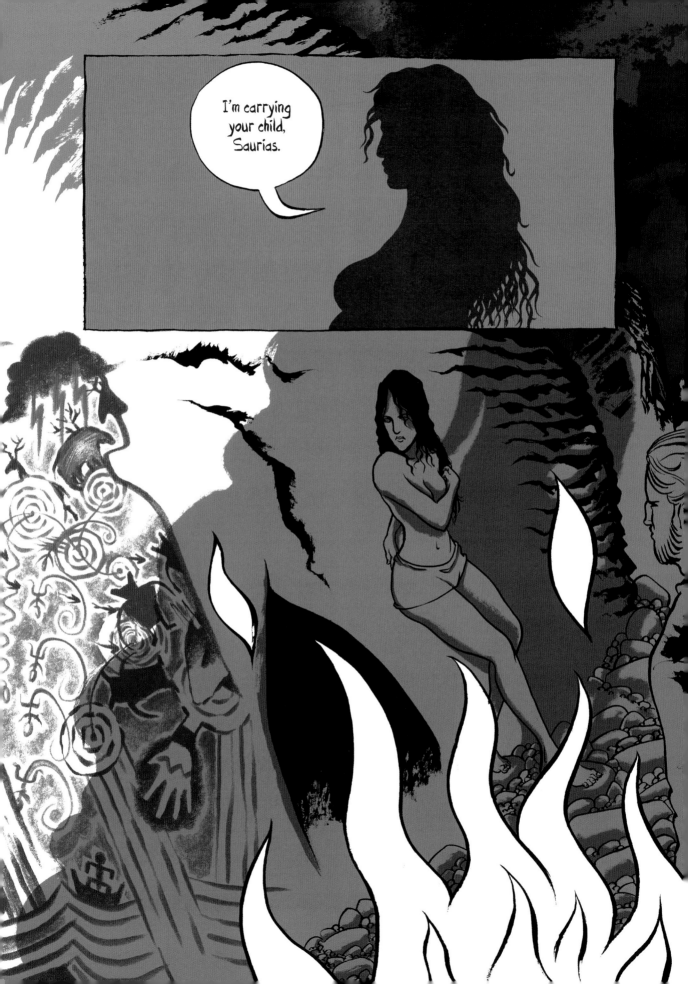

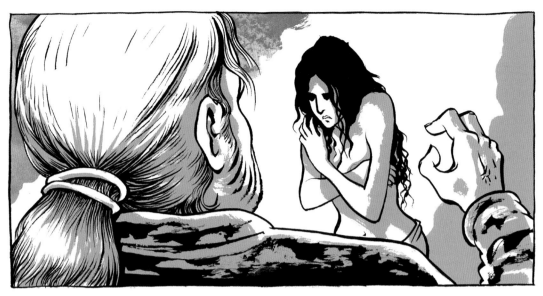

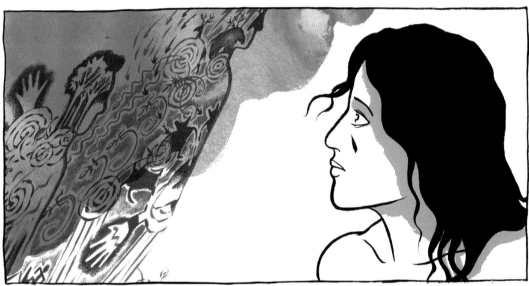

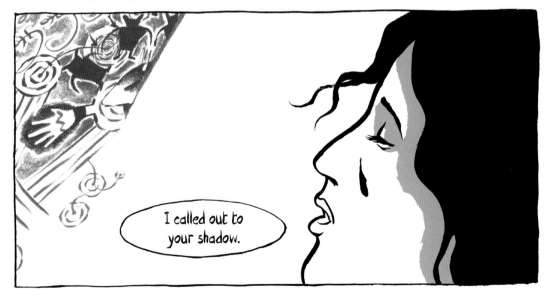

I called out to
your shadow.

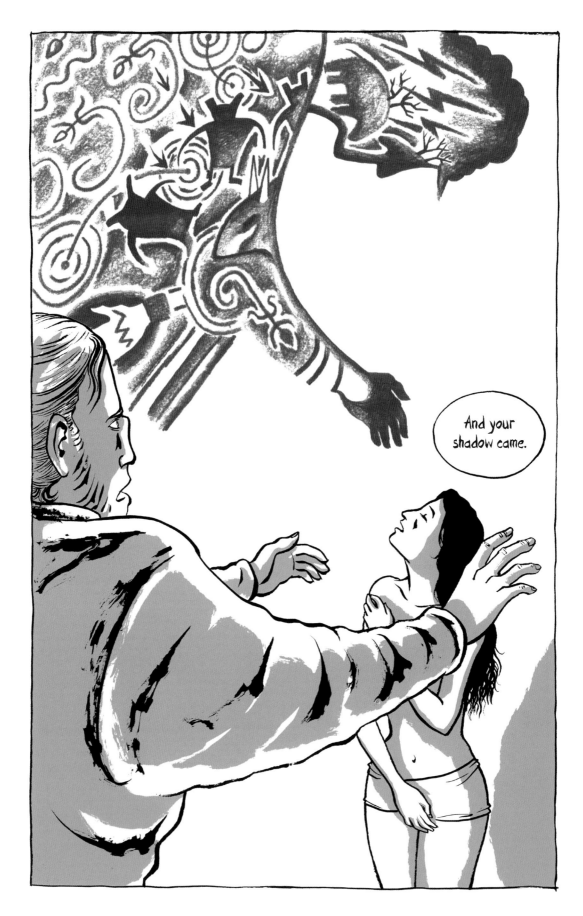

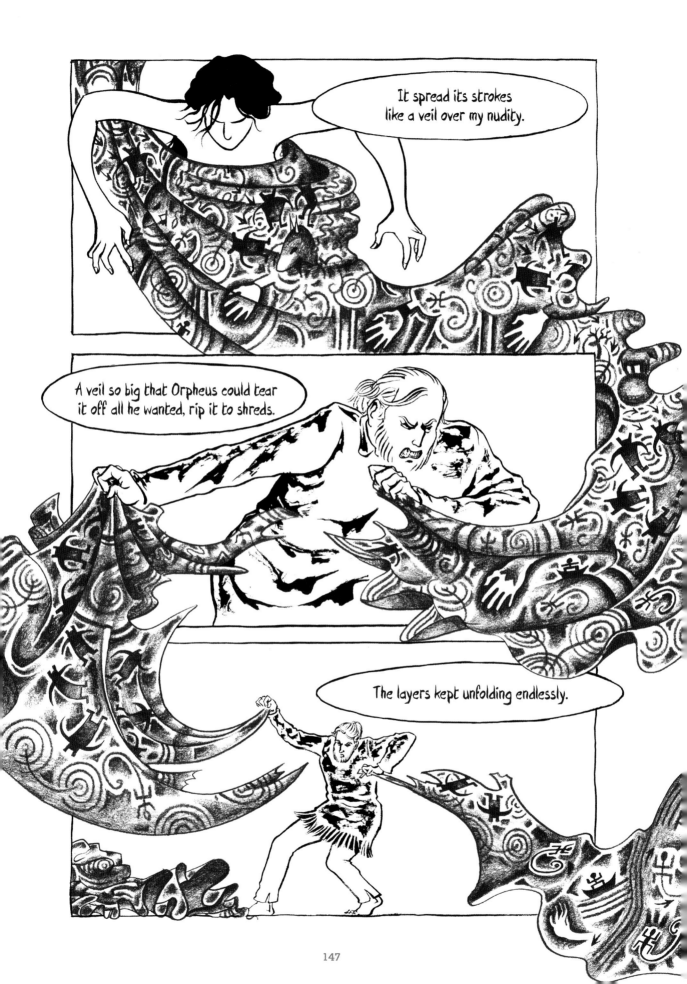

147

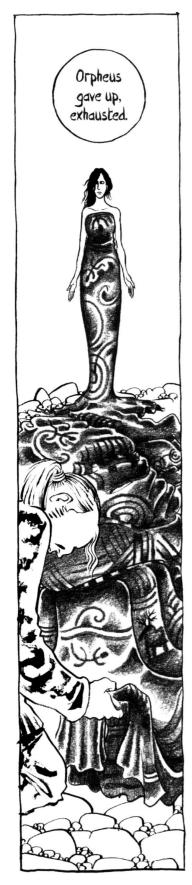

Orpheus gave up, exhausted.

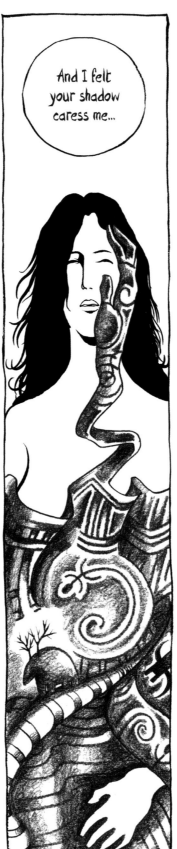

And I felt your shadow caress me...

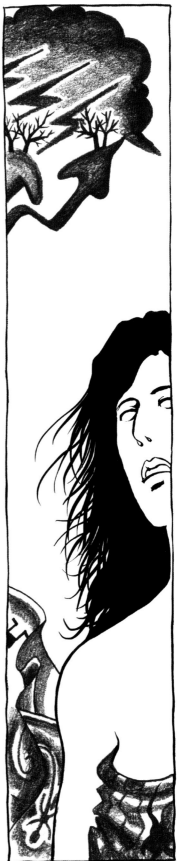

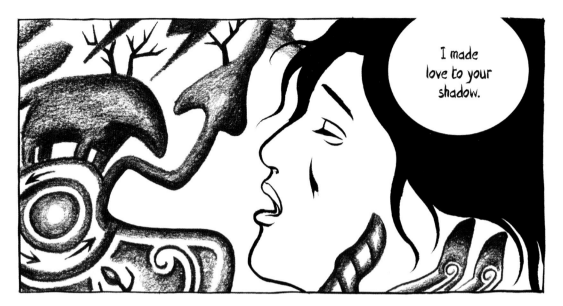

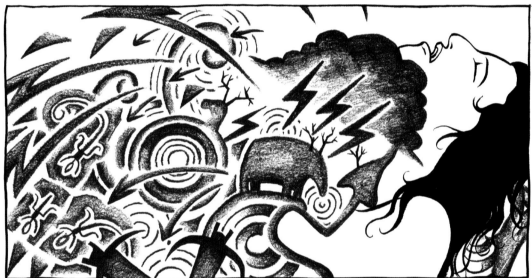

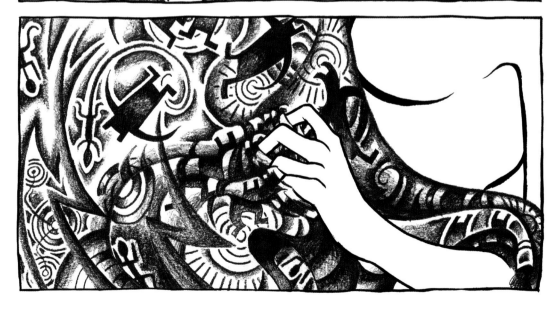

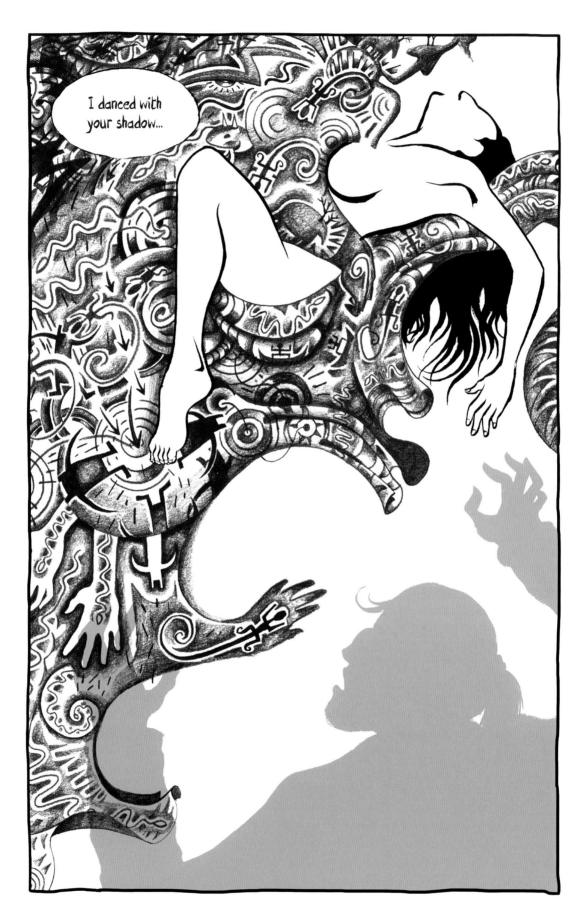

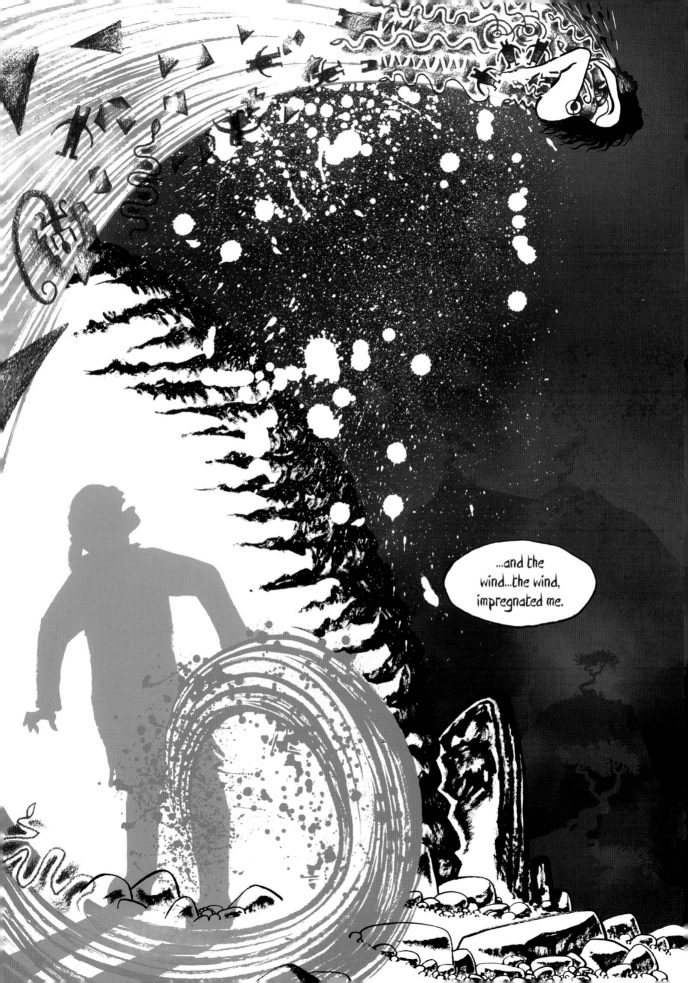

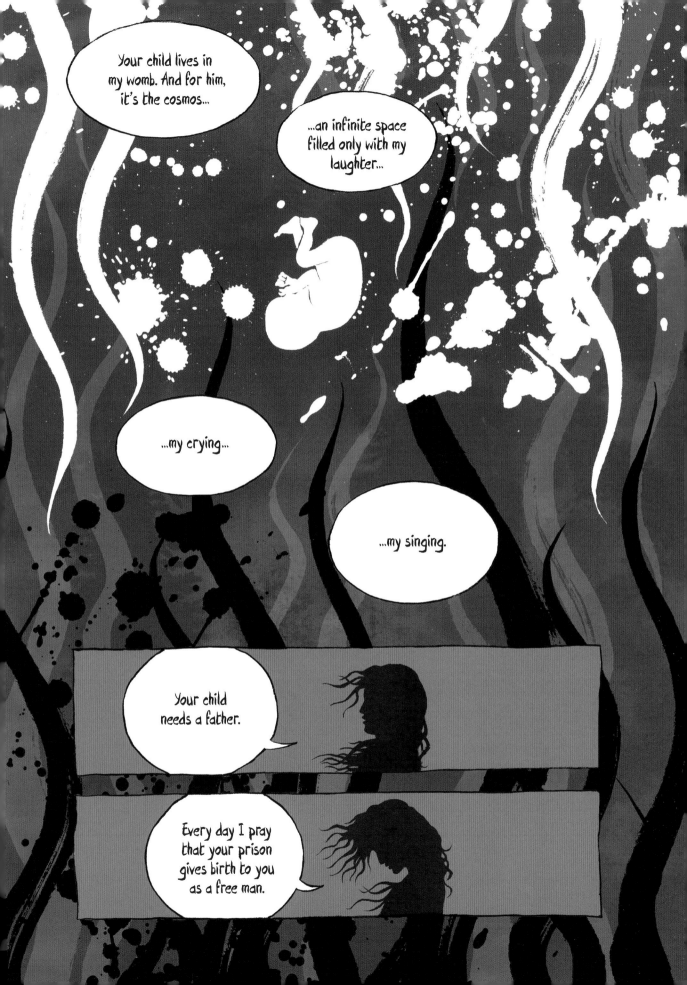

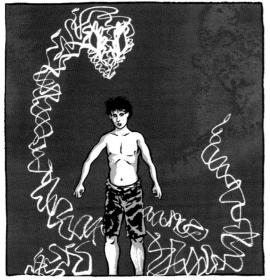

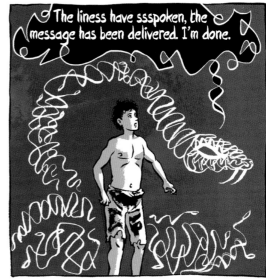

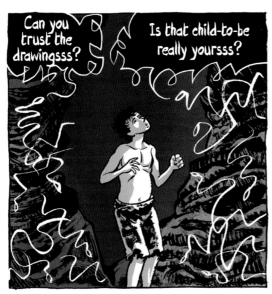

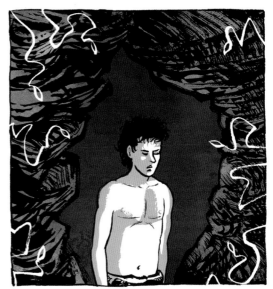

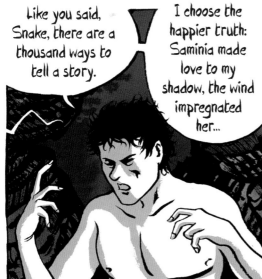

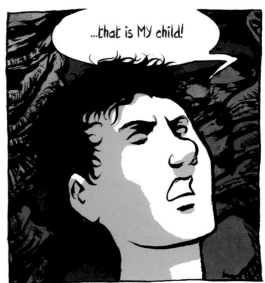

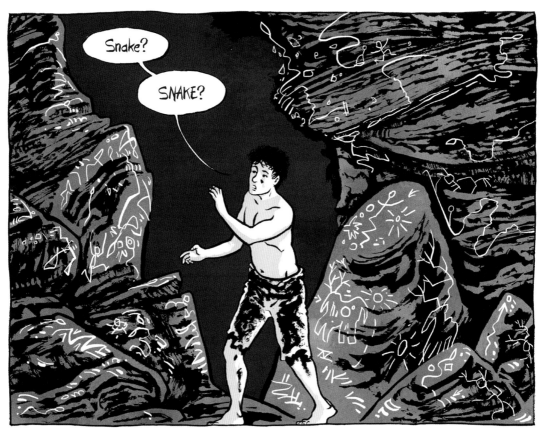

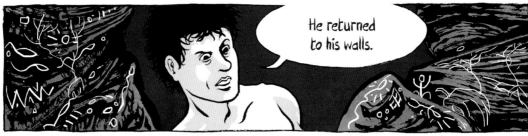

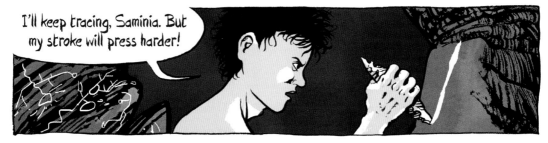

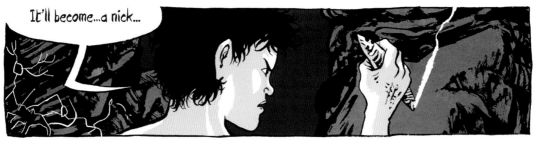

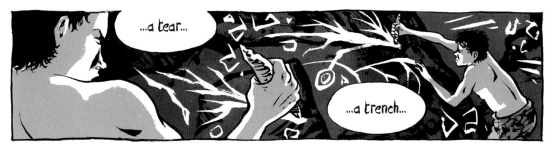

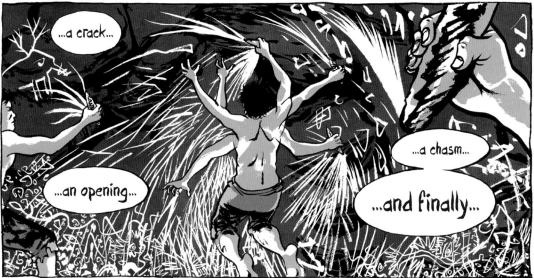

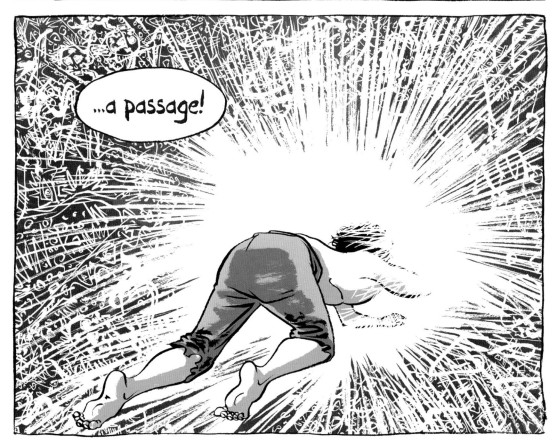

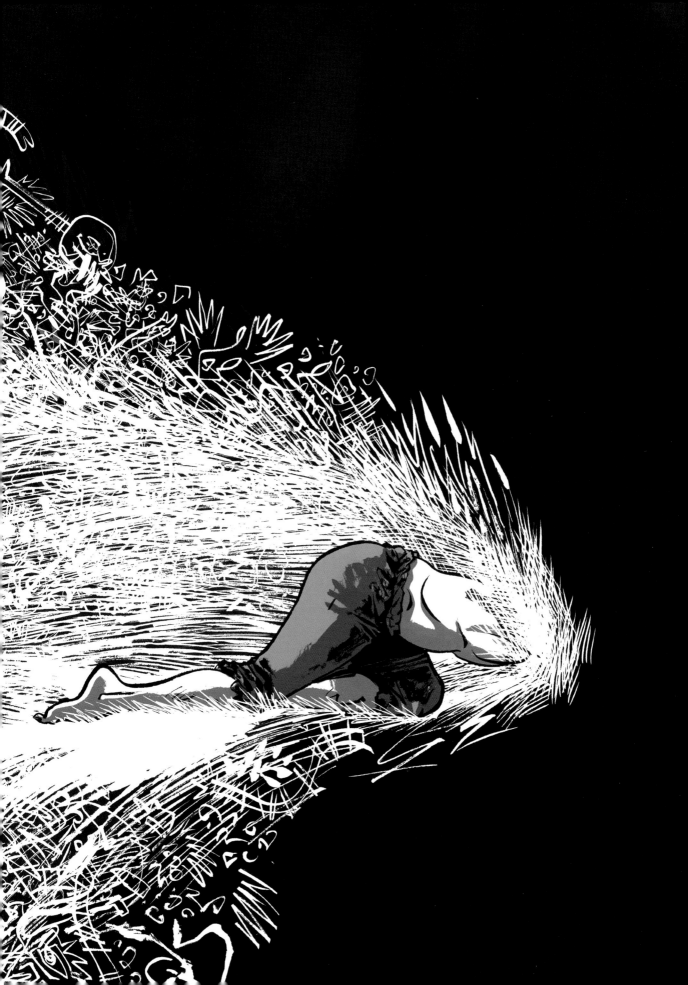

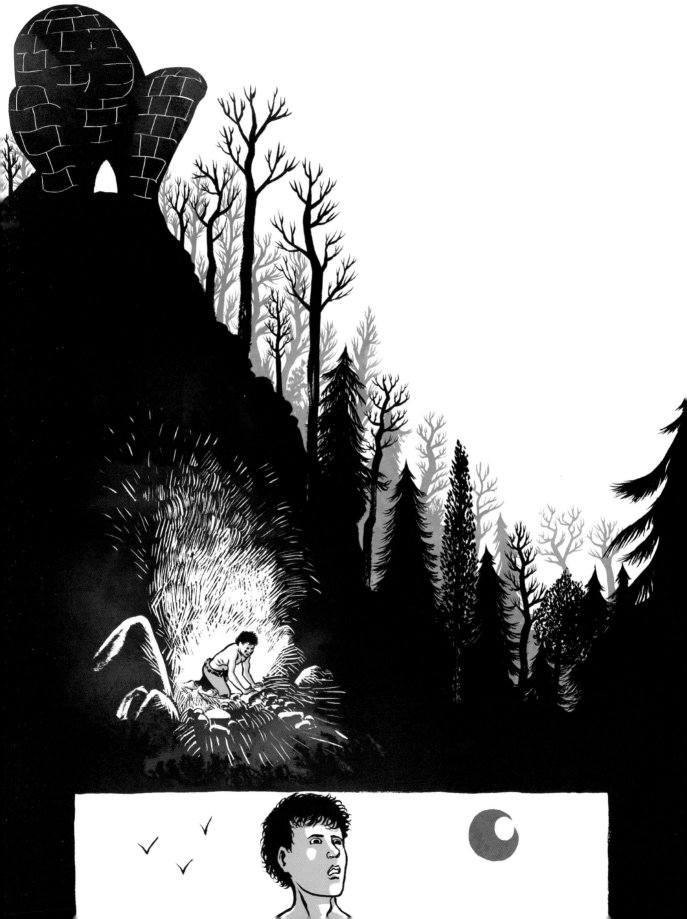

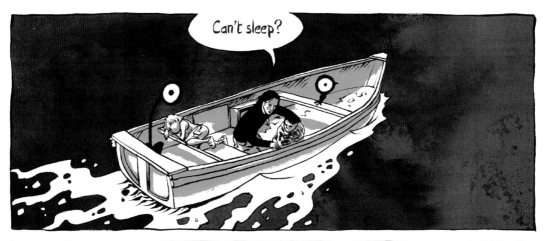

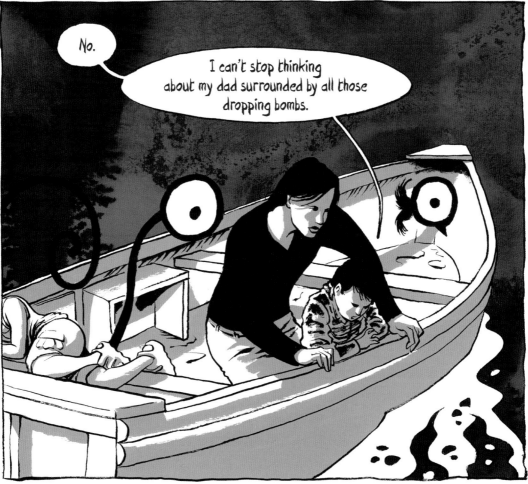

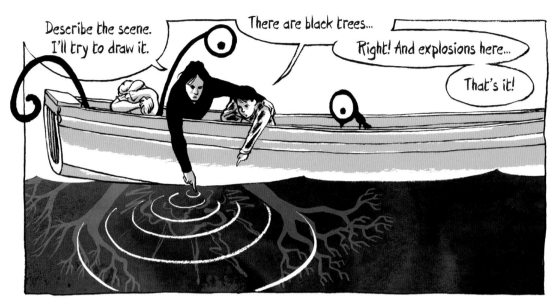

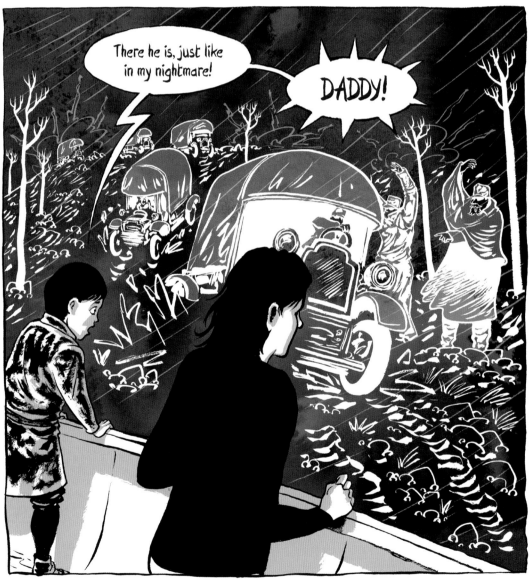

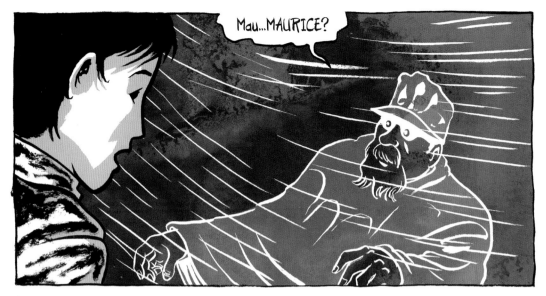

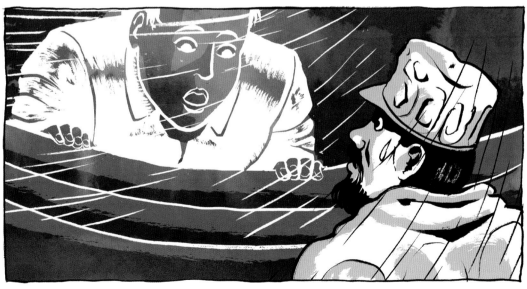

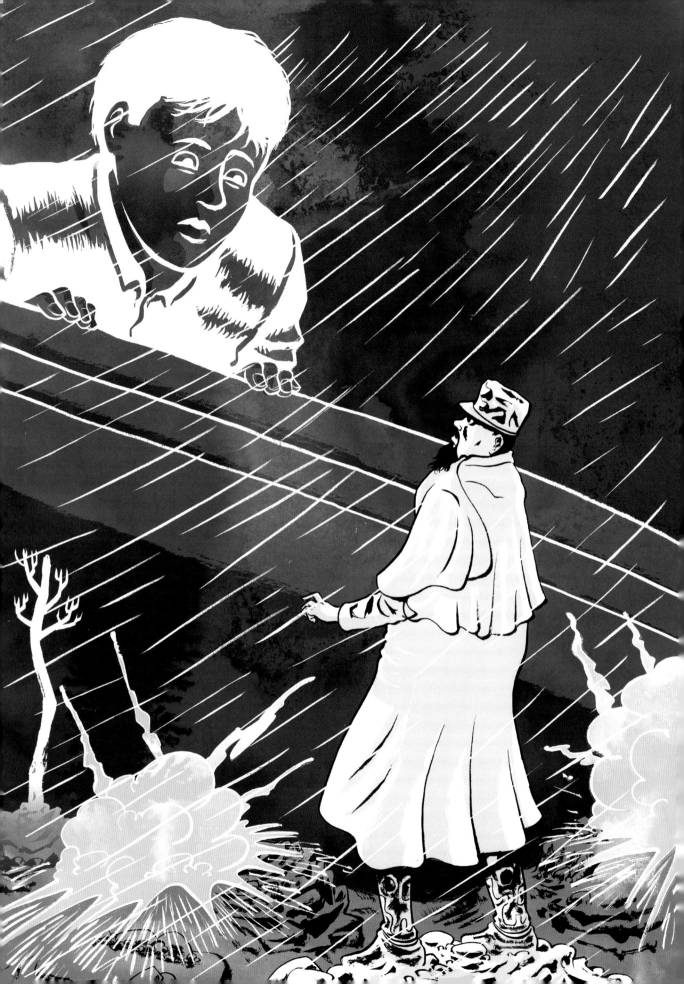

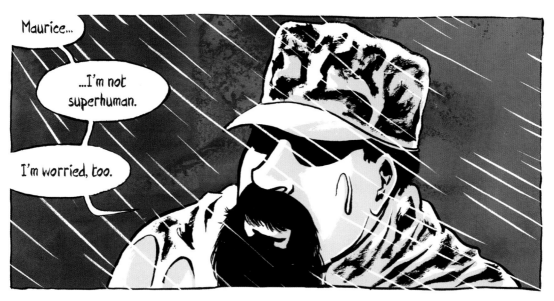

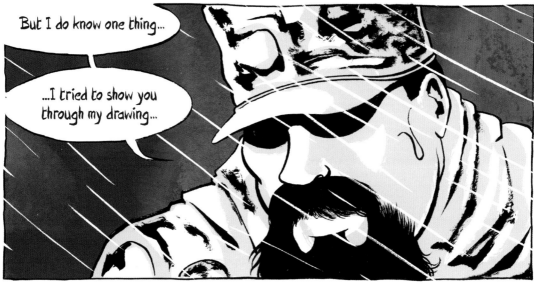

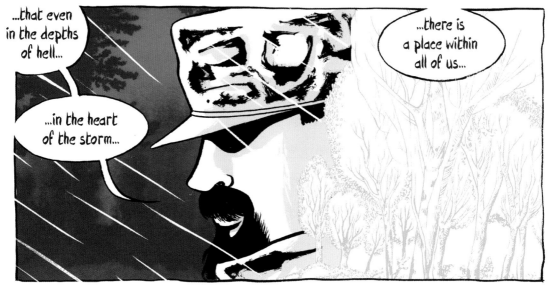

...that nothing can reach.

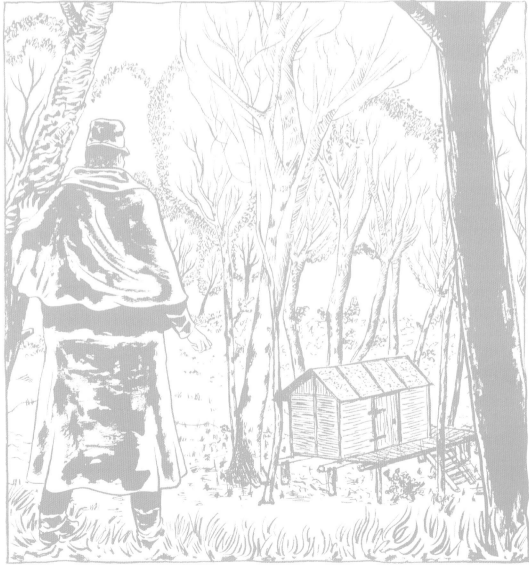

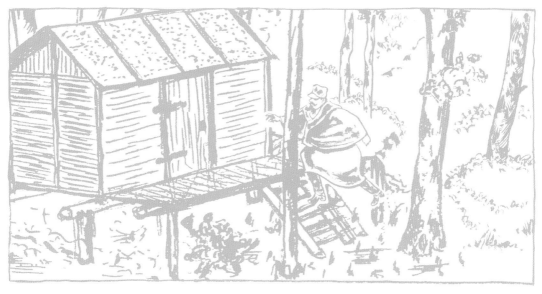

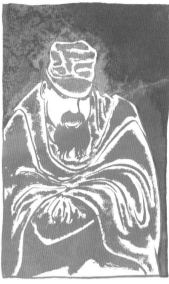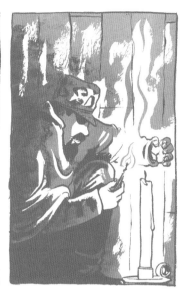
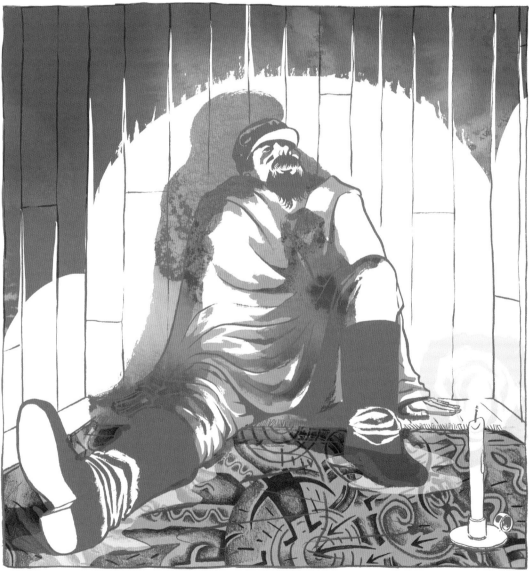

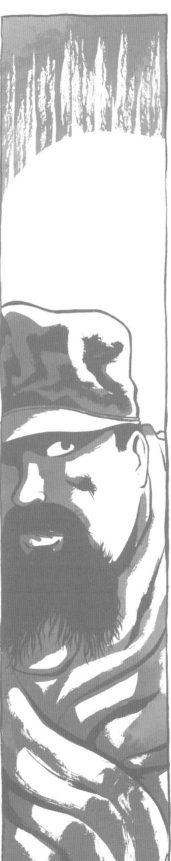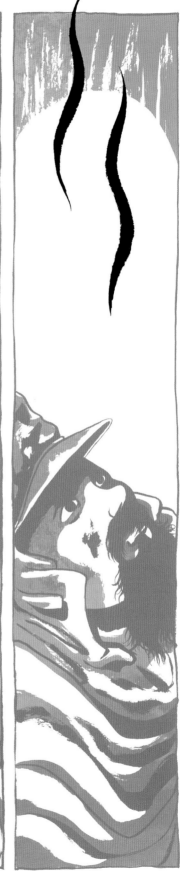

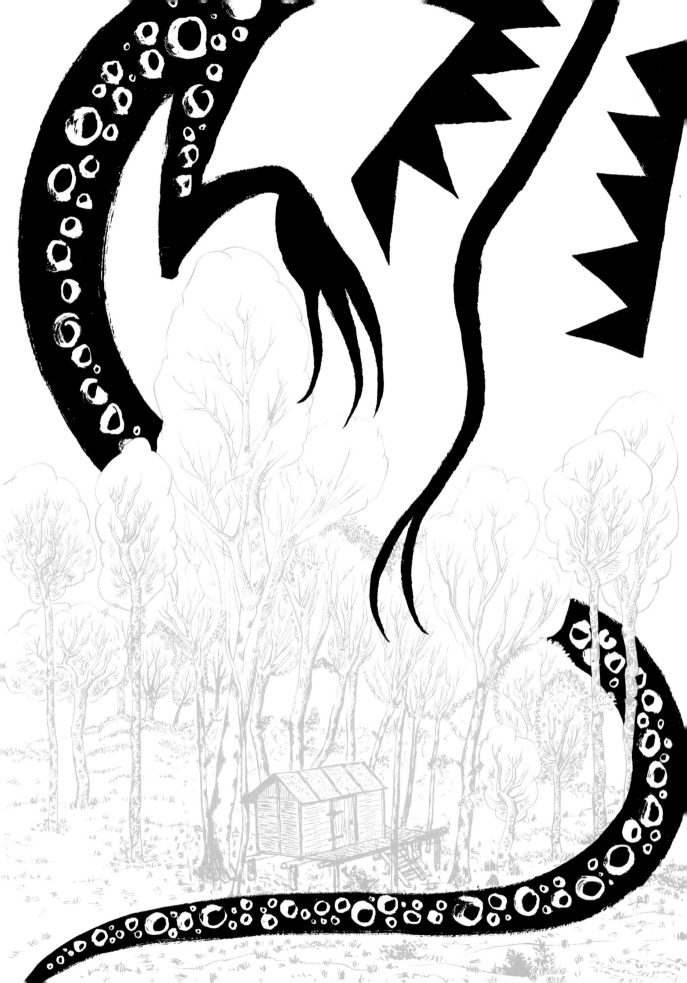

CHIEF! CHIEF!

THE THORCERER PRITHONER!

HE'Z ETHCAPED!

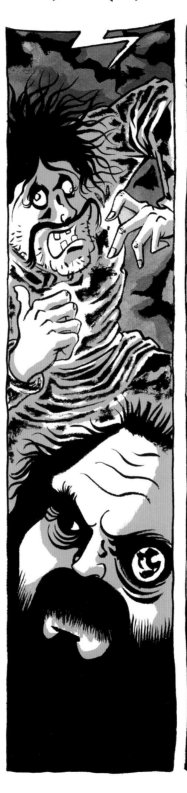

So what?

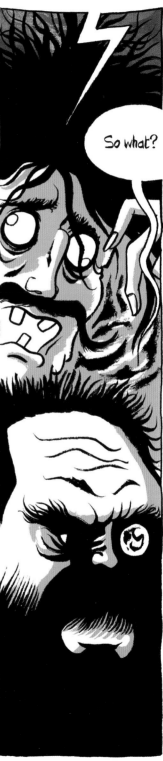

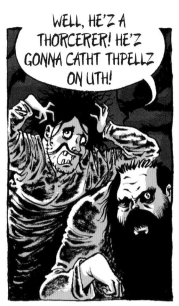

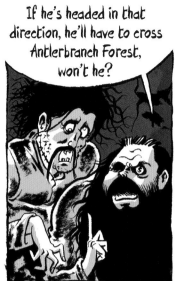

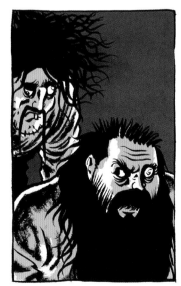

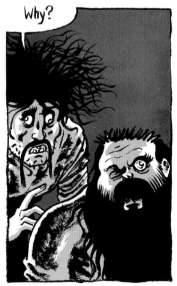

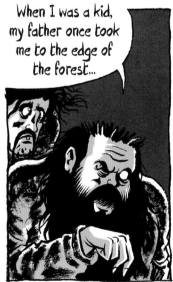

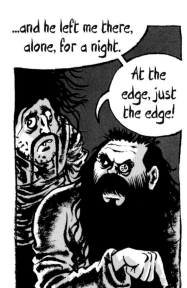
...and he left me there, alone, for a night.

At the edge, just the edge!

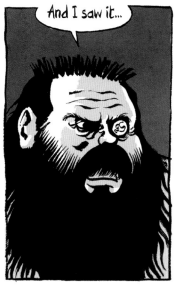
And I saw it...

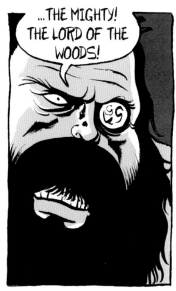
...THE MIGHTY! THE LORD OF THE WOODS!

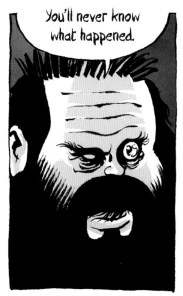
You'll never know what happened.

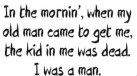
In the mornin', when my old man came to get me, the kid in me was dead. I was a man.

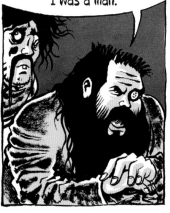

If your sorcerer went into the forest, you can clean out his cell. He won't be coming back.

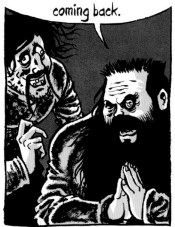

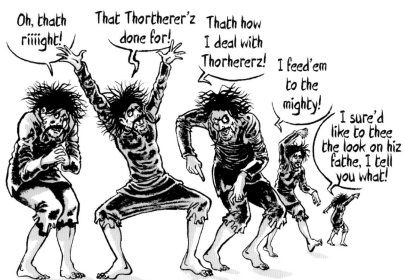
Oh, thath riiiight!

That Thortherer'z done for!

Thath how I deal with Thorhererz!

I feed 'em to the mighty!

I sure'd like to thee the look on hiz fathe, I tell you what!

171

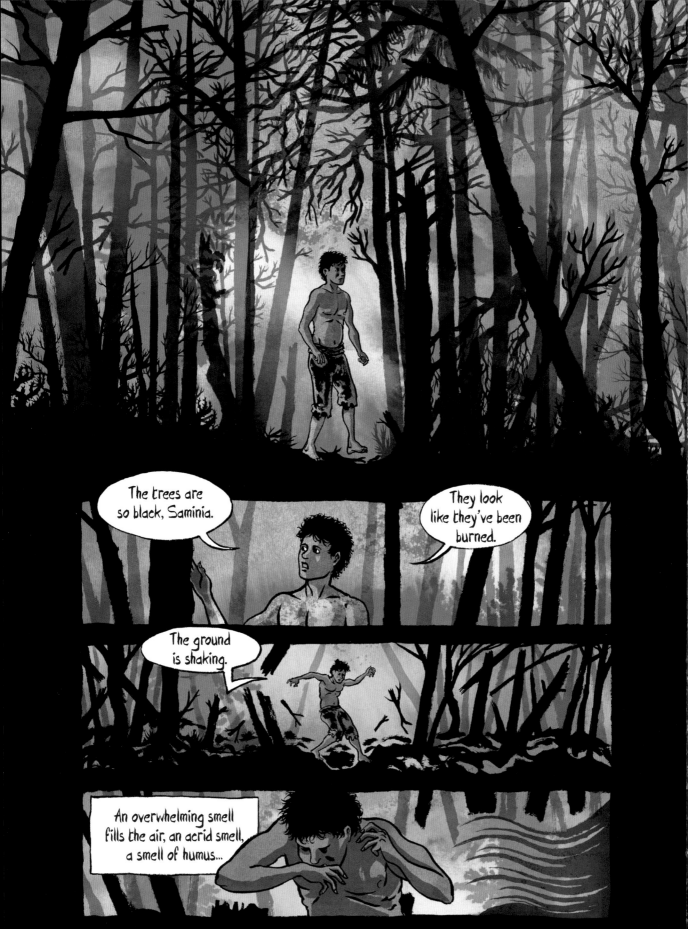

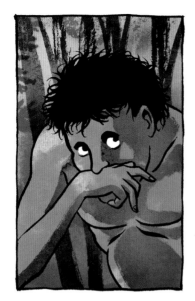

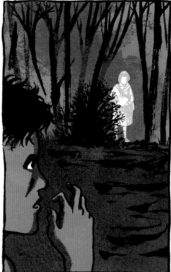

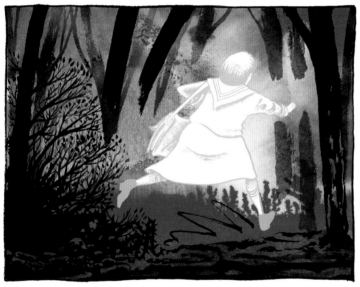

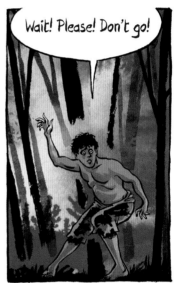

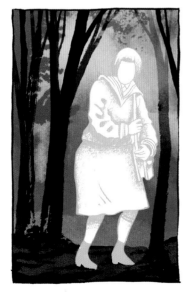

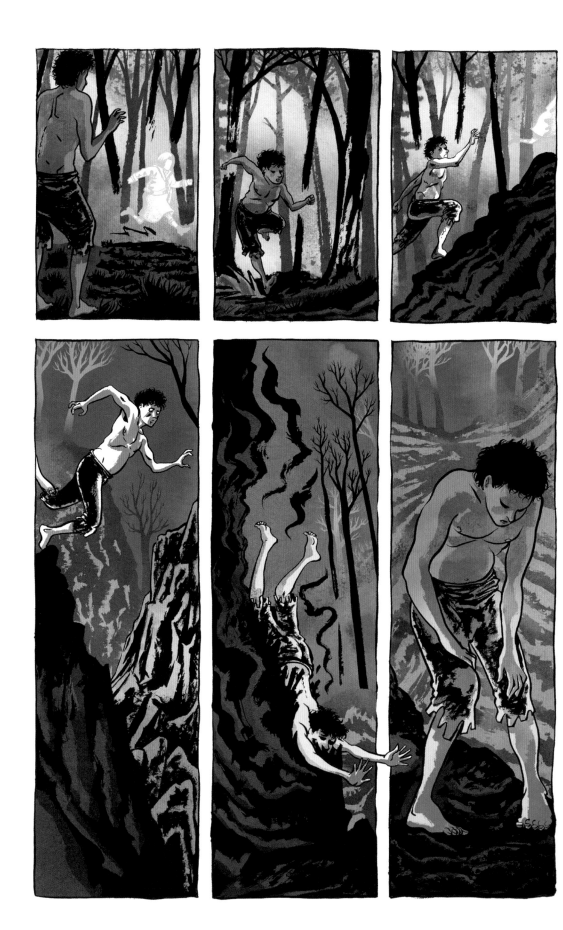

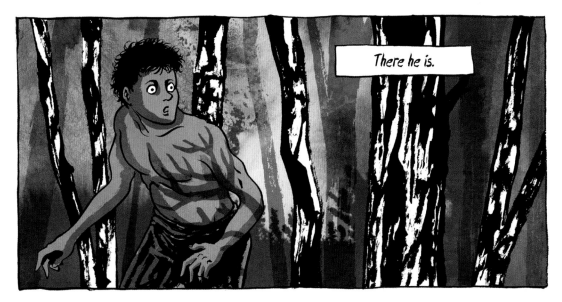

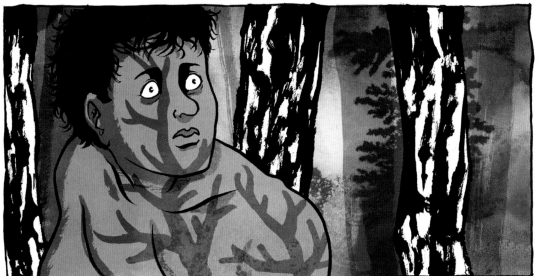

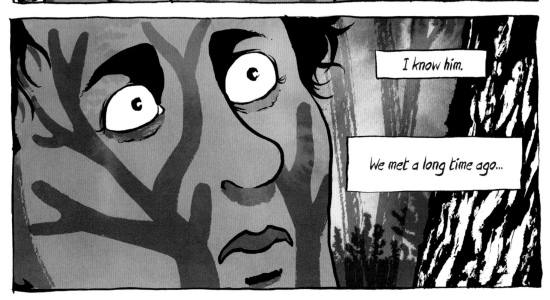

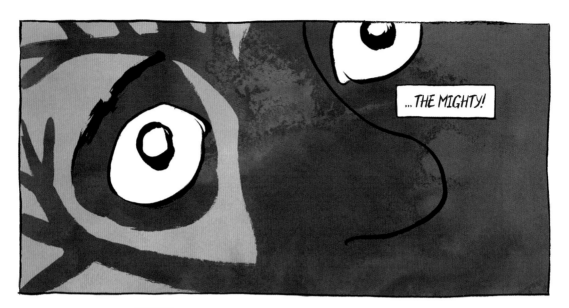

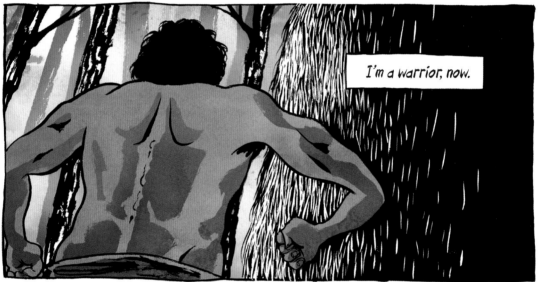

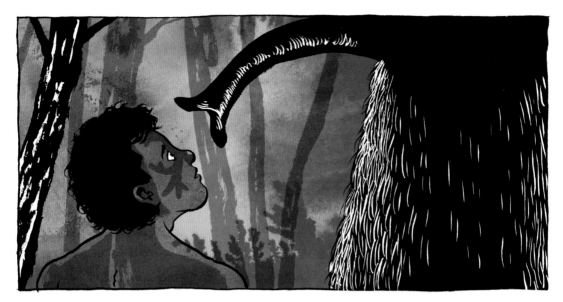

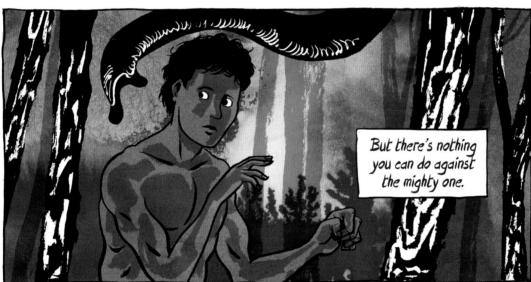

But there's nothing you can do against the mighty one.

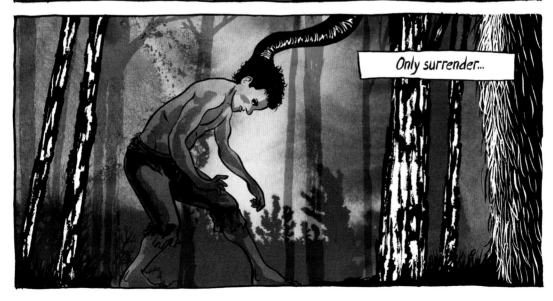

Only surrender...

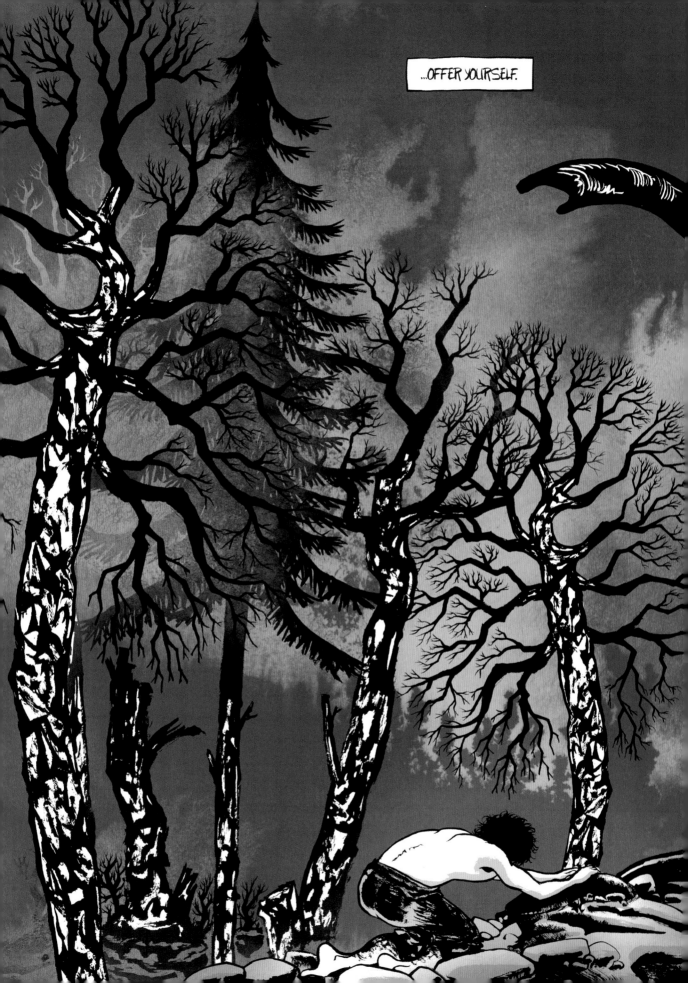

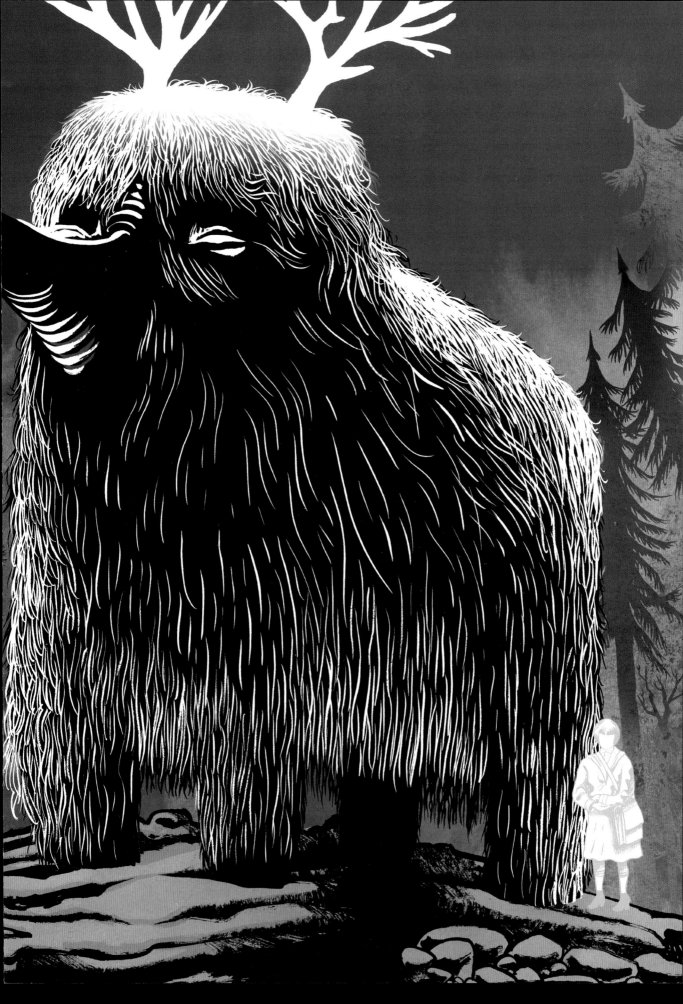

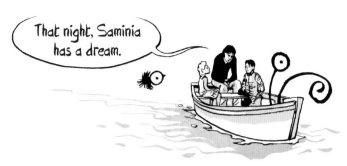

That night, Saminia has a dream.

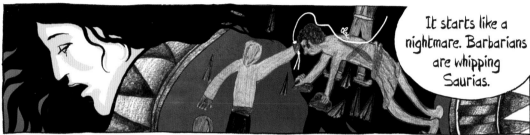

It starts like a nightmare. Barbarians are whipping Saurias.

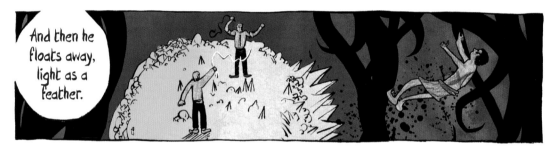

And then he floats away, light as a feather.

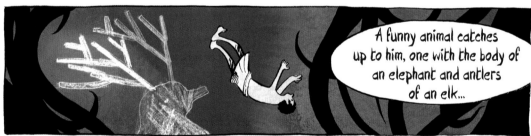

A funny animal catches up to him, one with the body of an elephant and antlers of an elk...

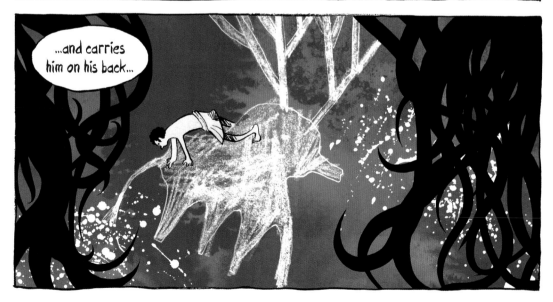

...and carries him on his back...

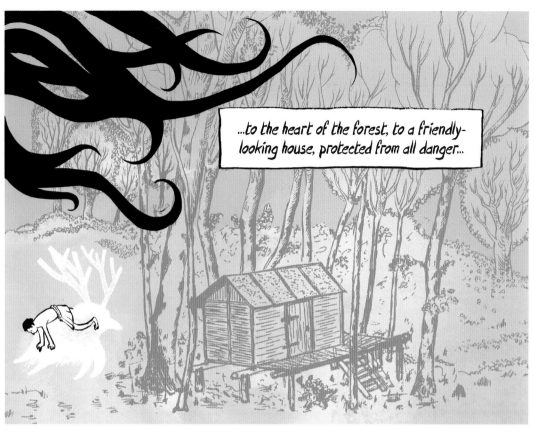

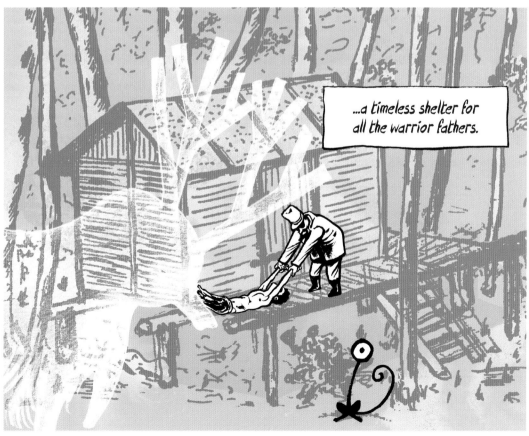

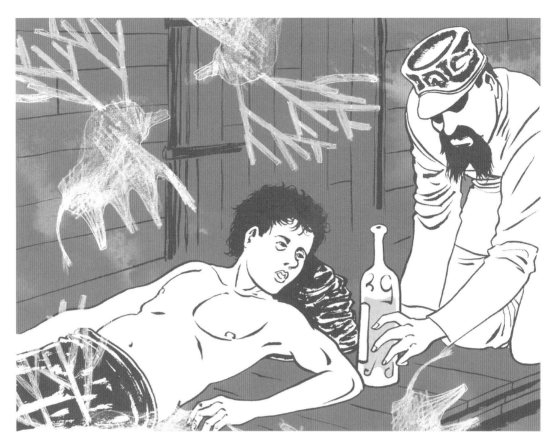

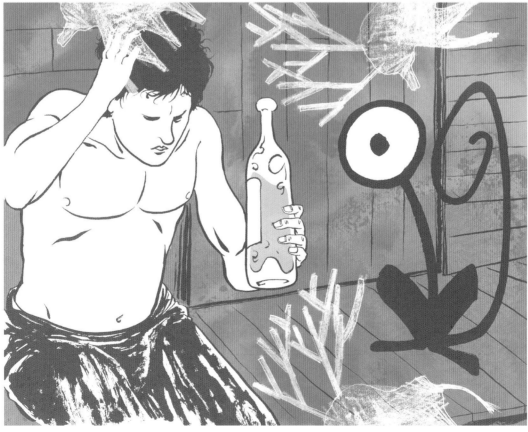

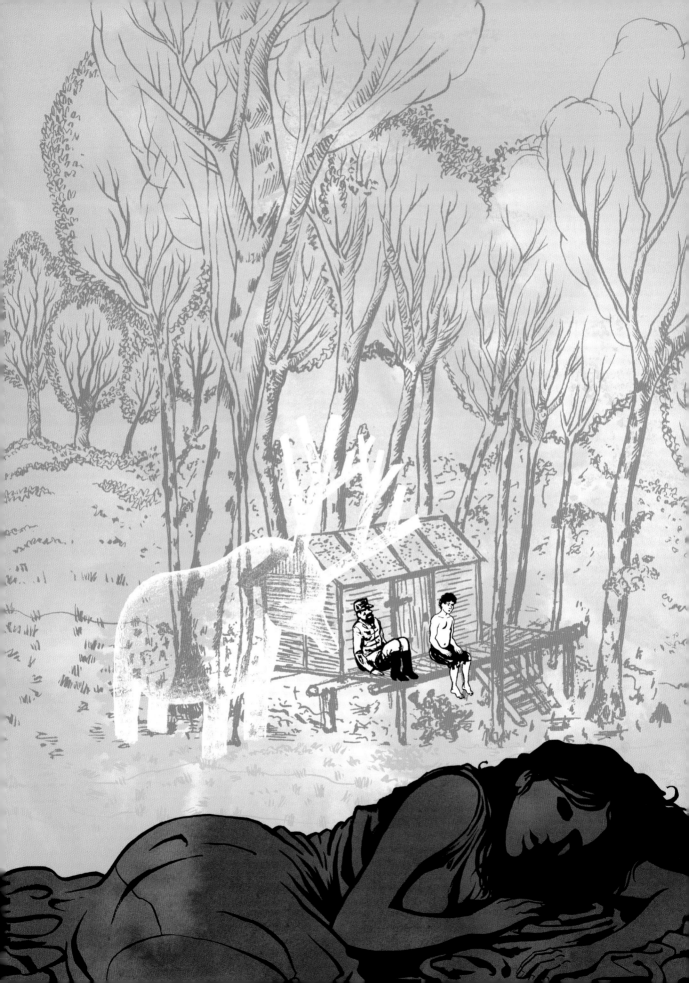

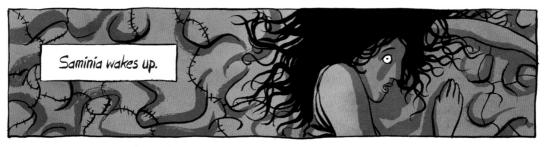

Saminia wakes up.

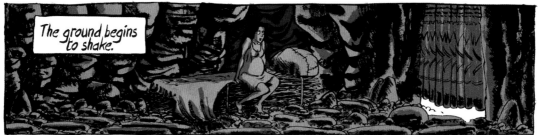

The ground begins to shake.

An acrid smell fills the air. A smell of humus.

NEED FRESH AIR!

AAAAAAAAAAAAAH!

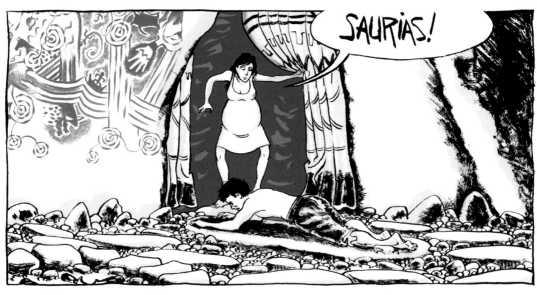

SAURIAS!

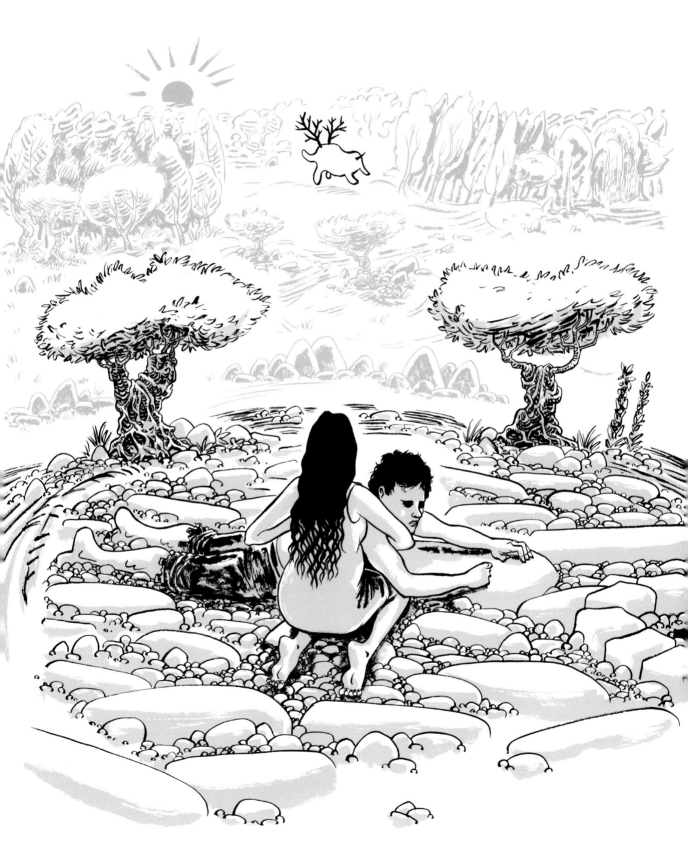

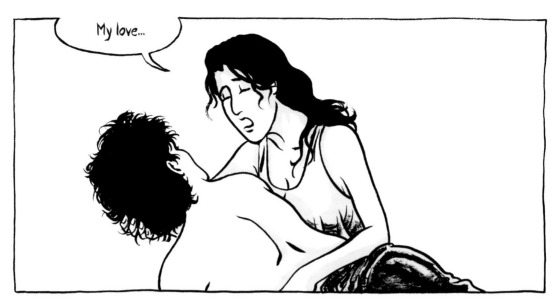

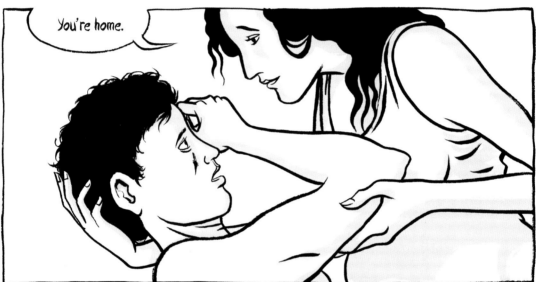

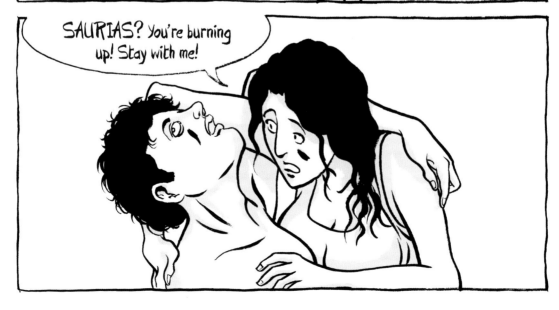

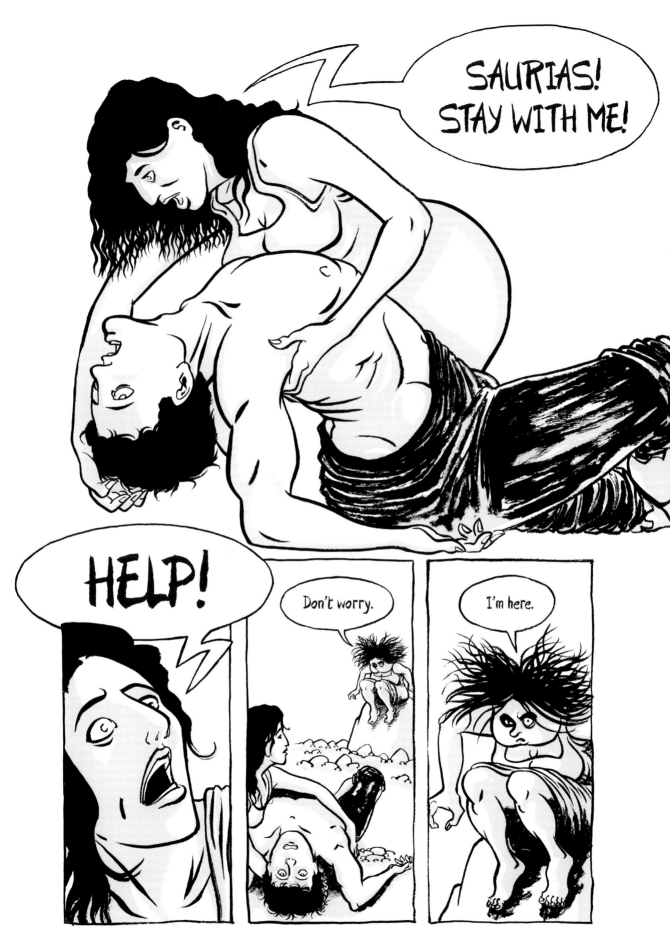

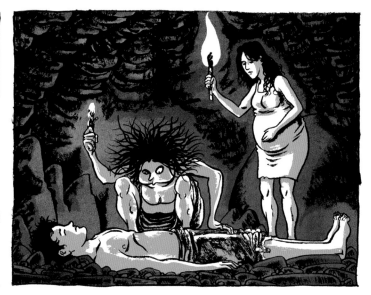

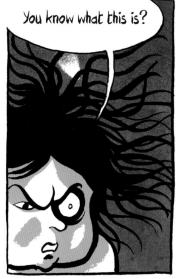

You know what this is?

HAHAHA! SHE DOESN'T EVEN KNOW!

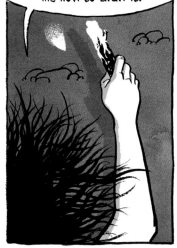

My mother passed it on to me. She taught me how to draw it.

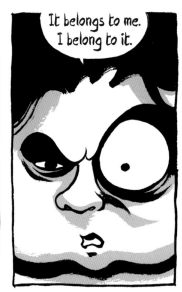

In all my life, this is the only stroke I have ever drawn and the only stroke I will ever draw.

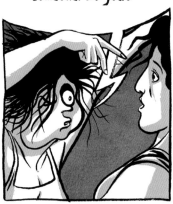

You don't know what it's like to belong to someone! Do you?

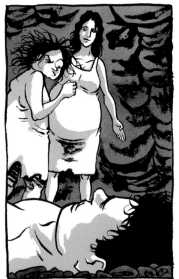

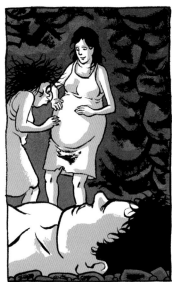

It belongs to me. I belong to it.

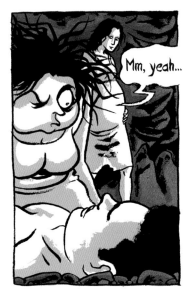

Mm, yeah...

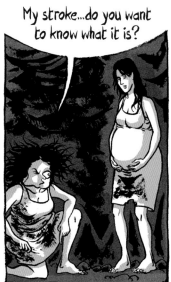

My stroke...do you want to know what it is?

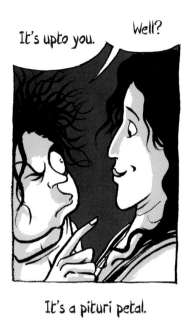

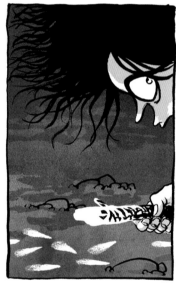

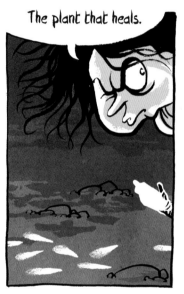

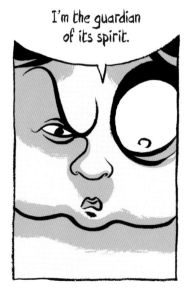

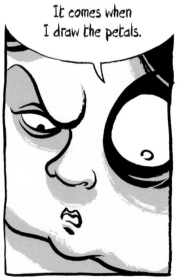

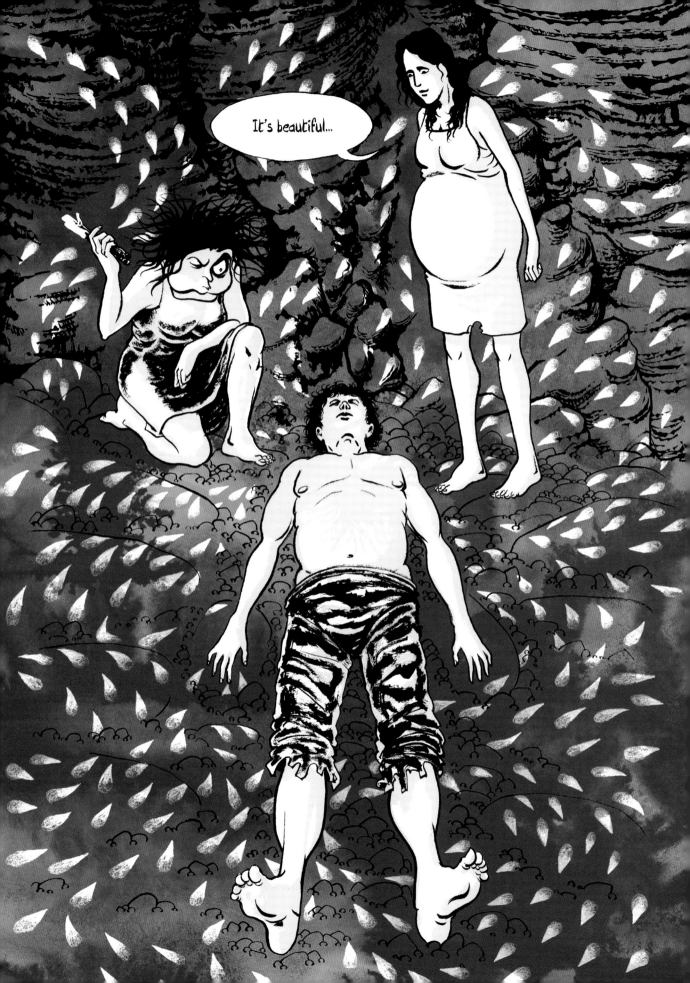

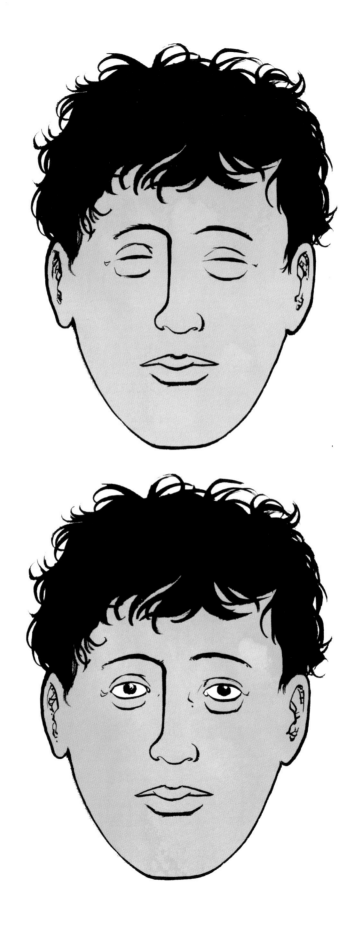

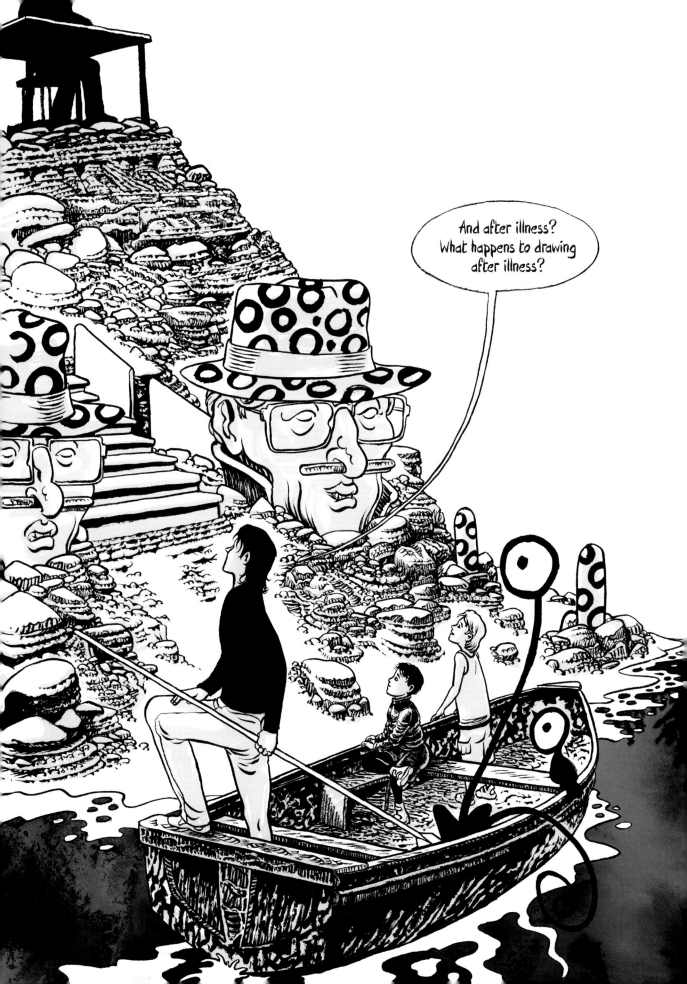

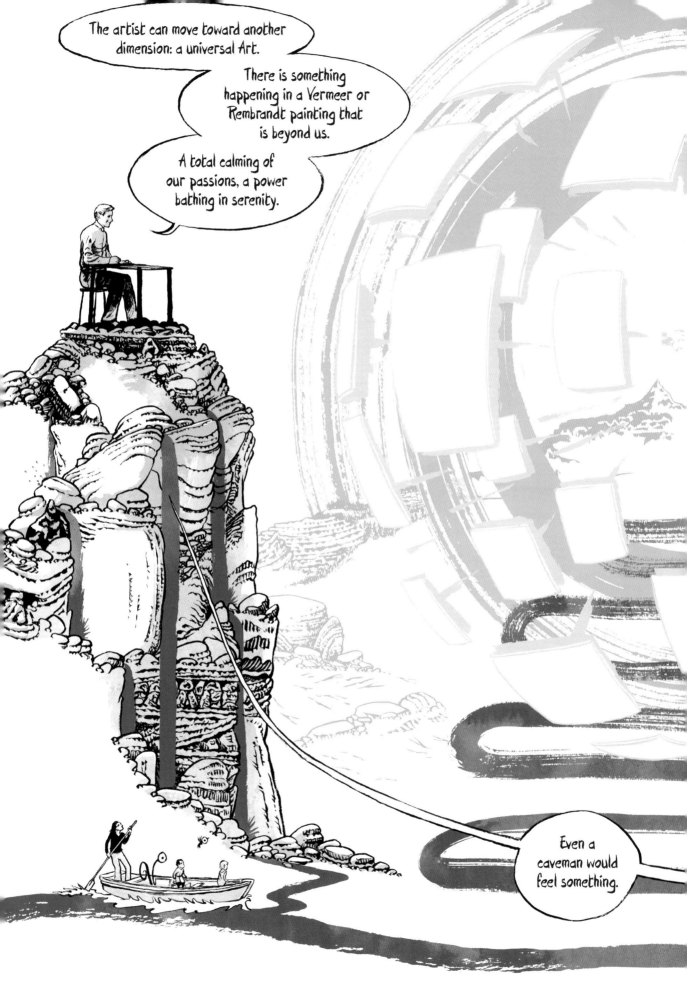

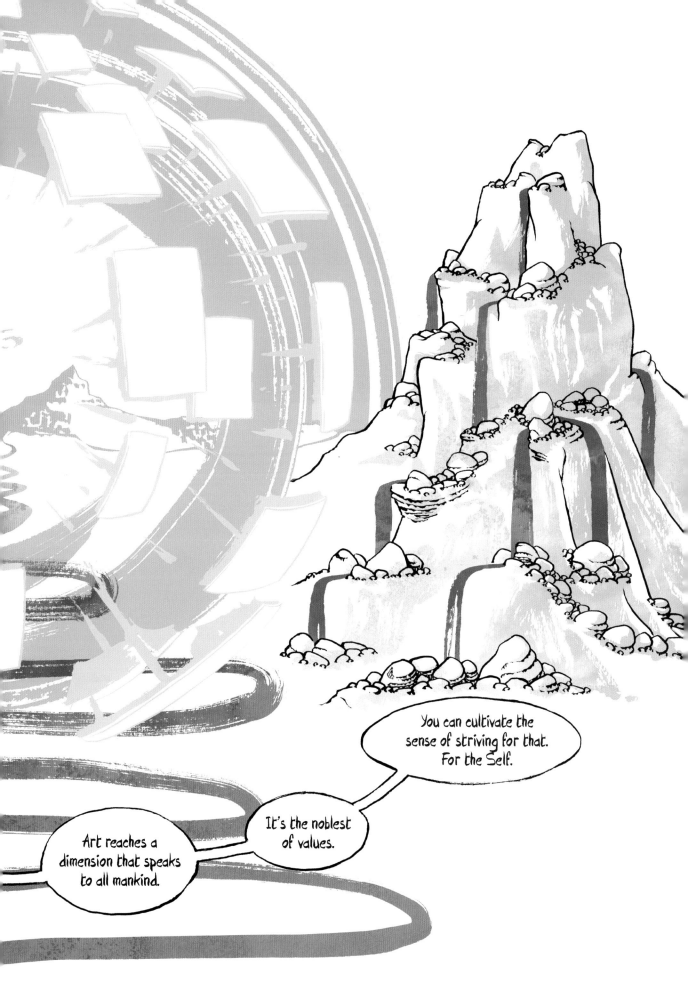

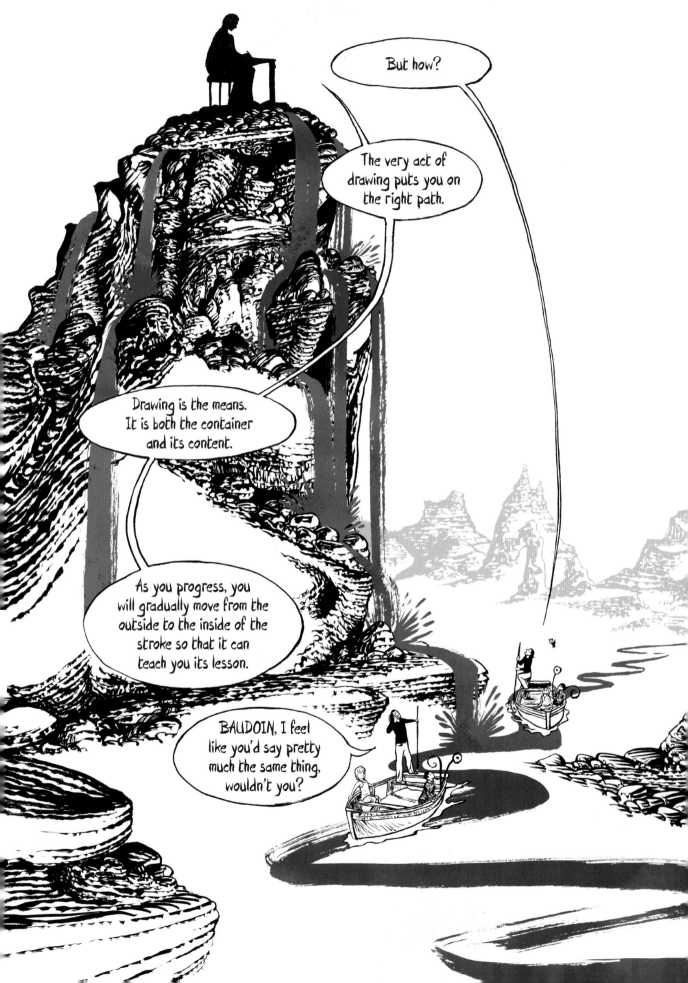

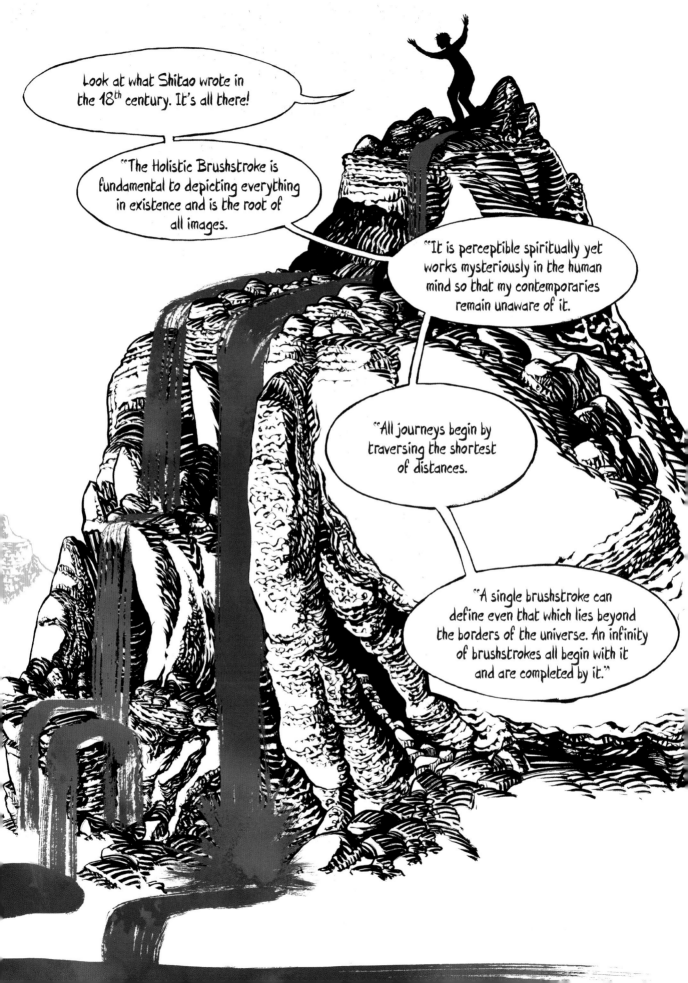

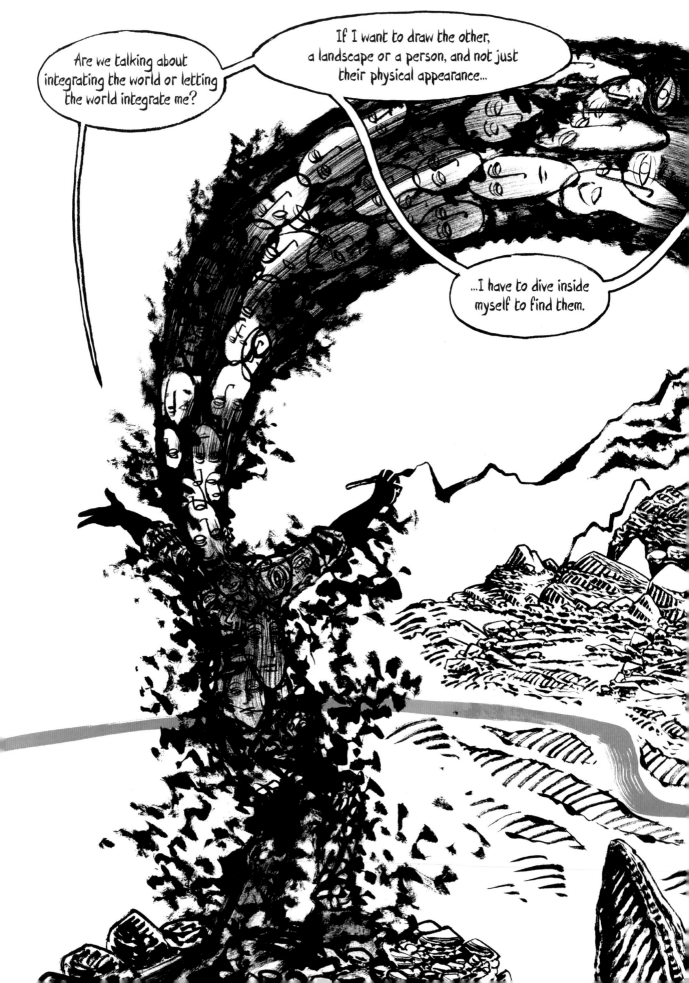

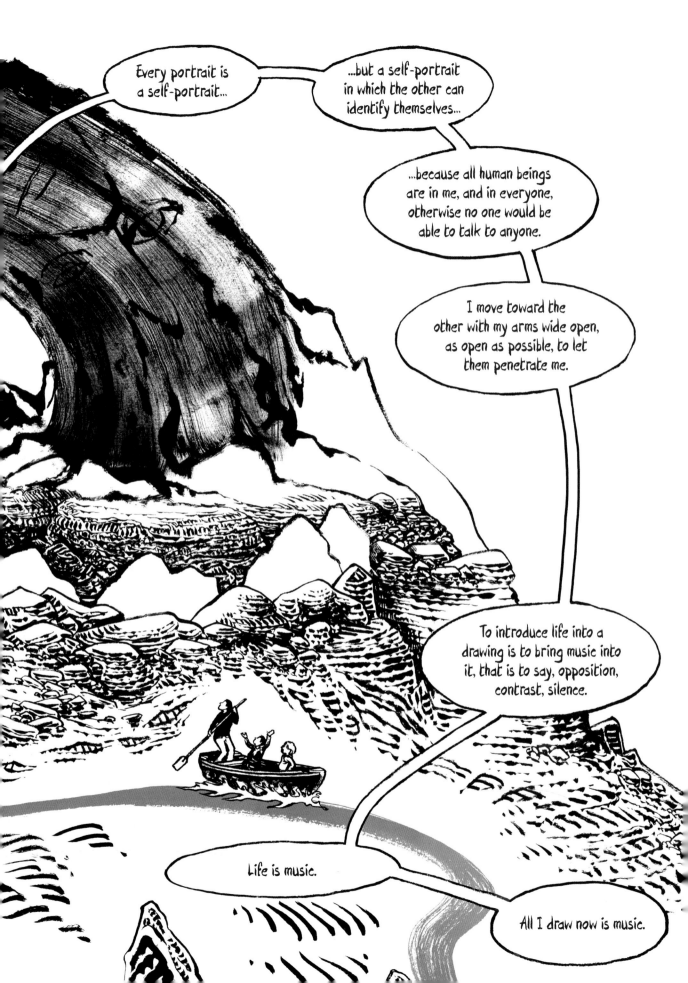

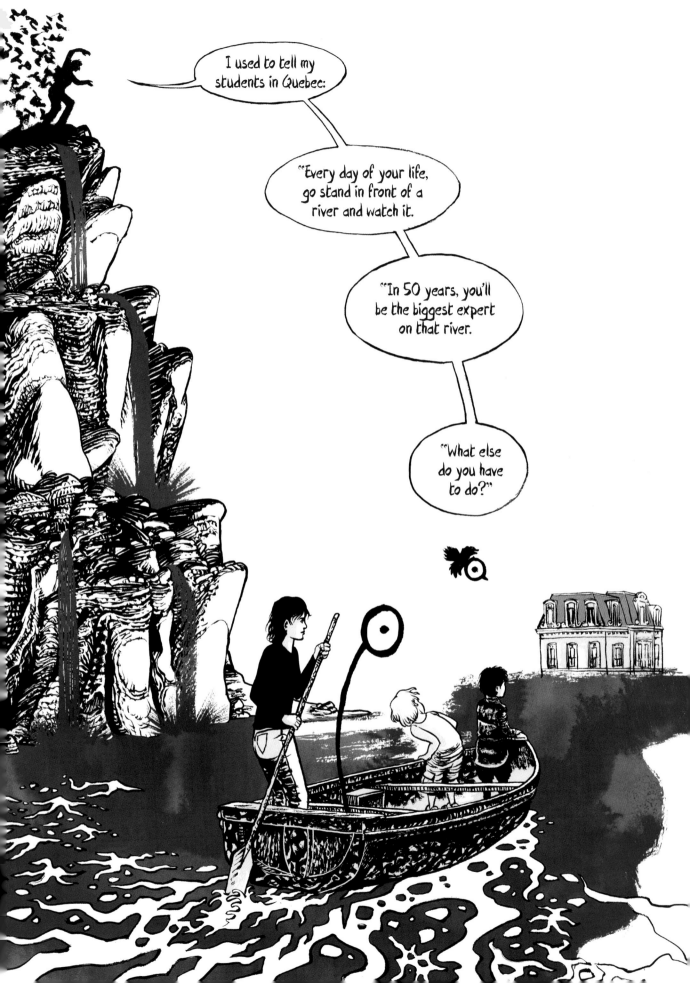

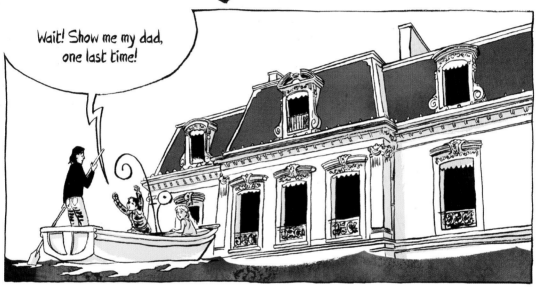

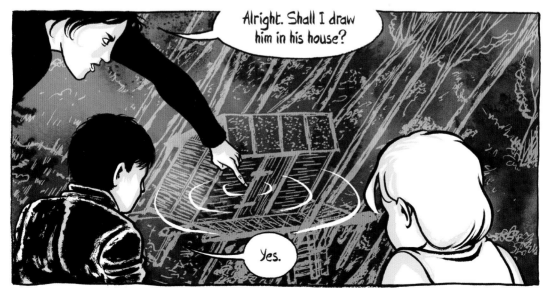

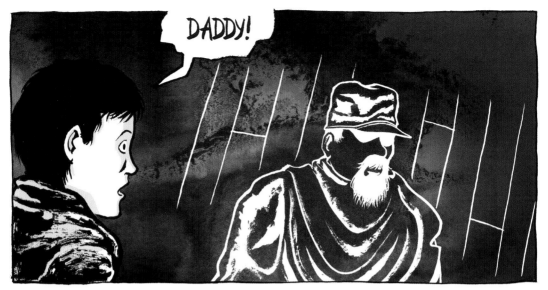

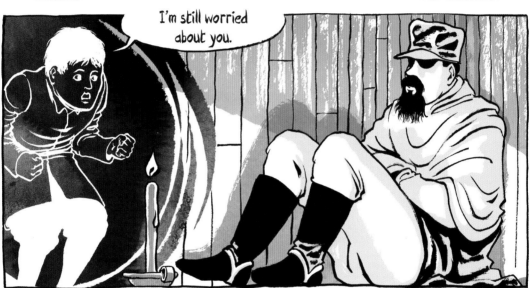

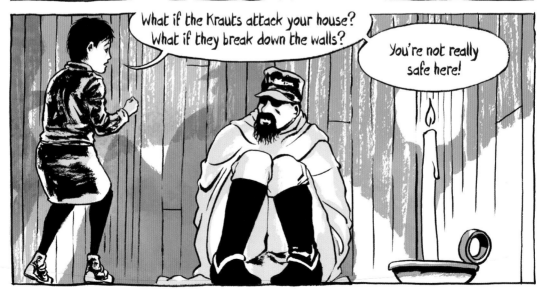

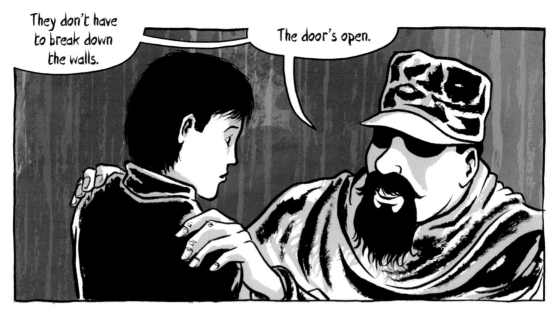

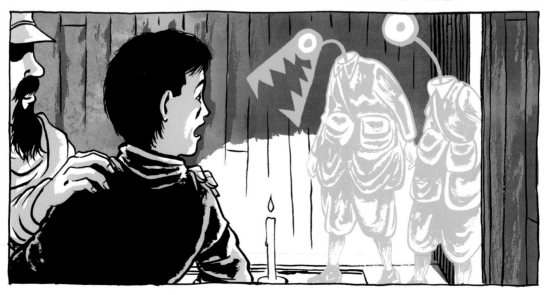

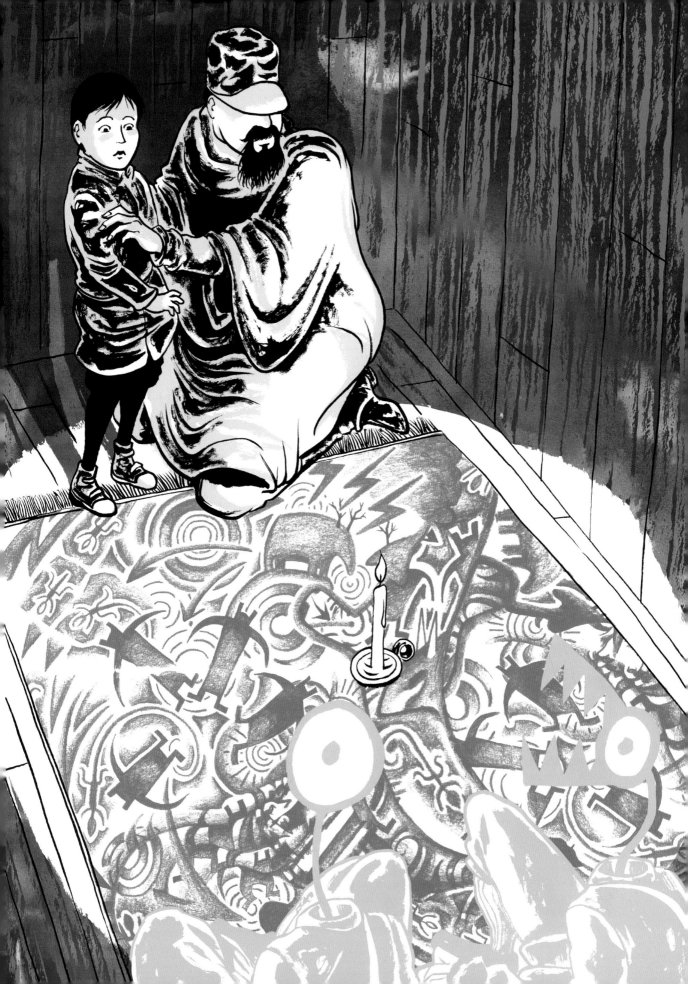

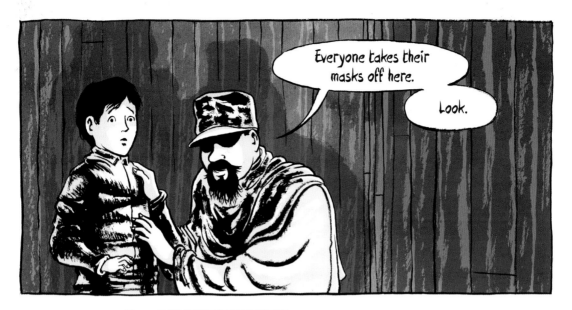

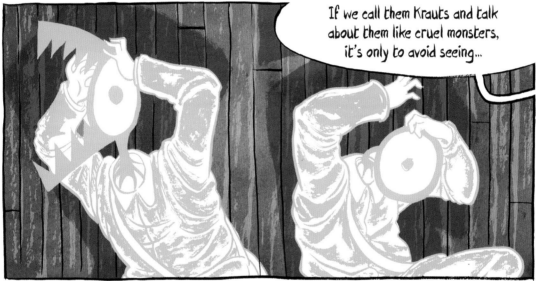

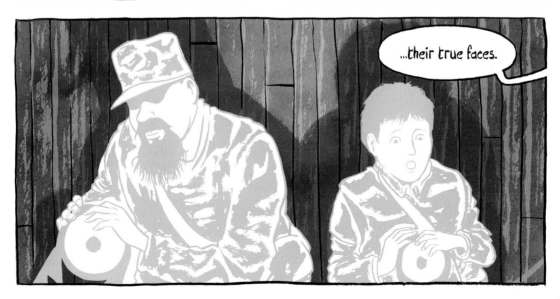

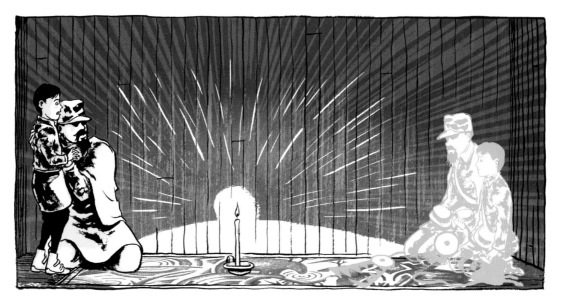

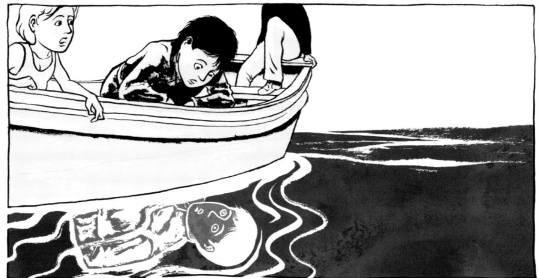

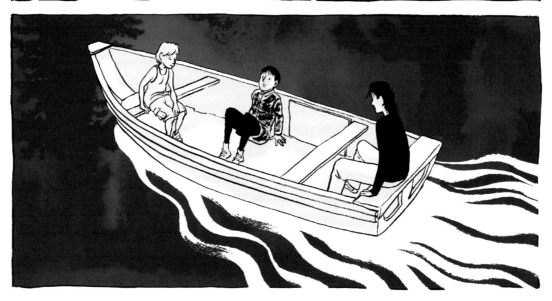

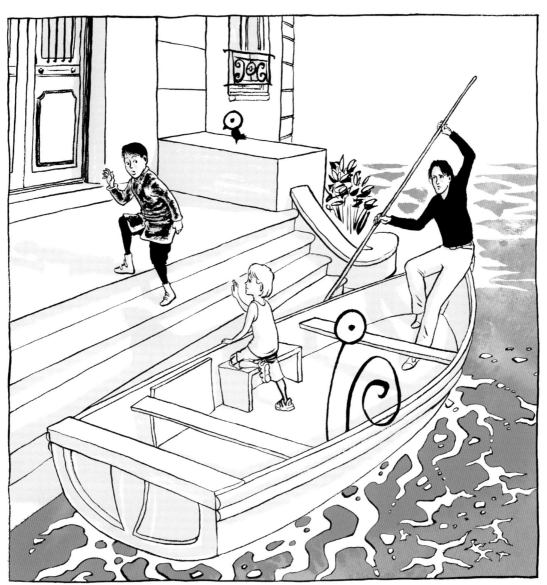

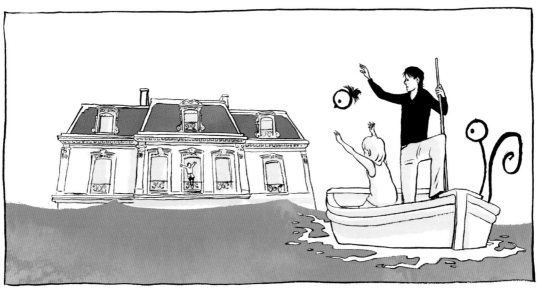

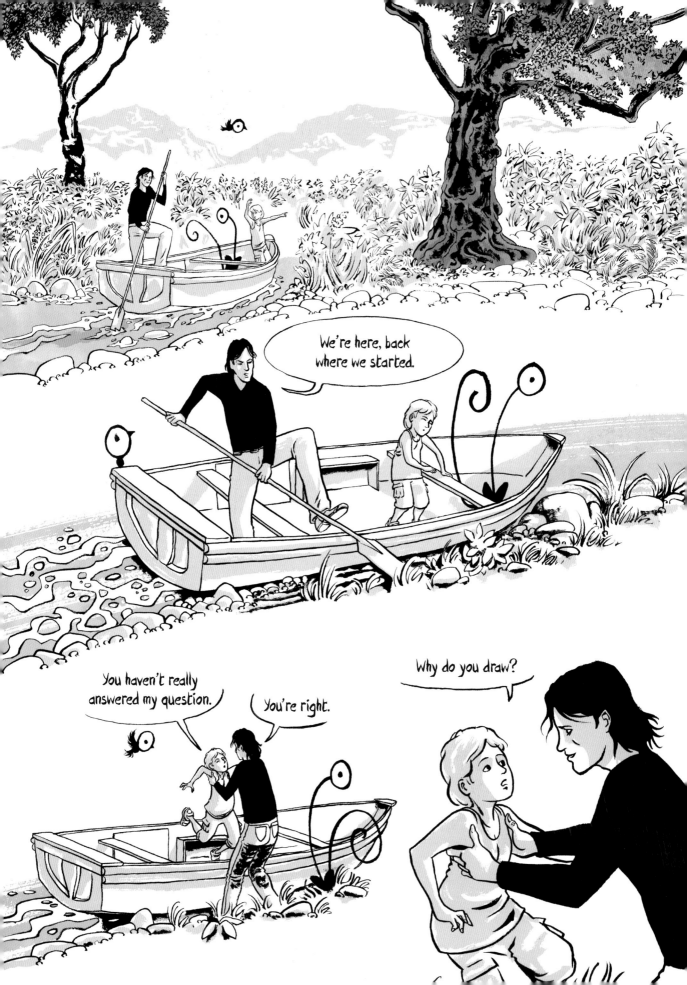

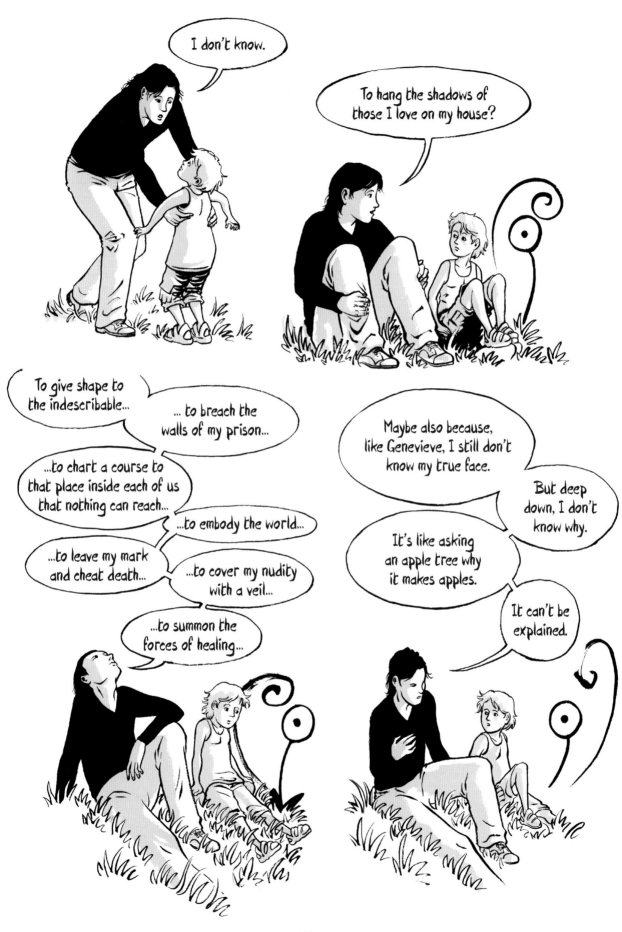

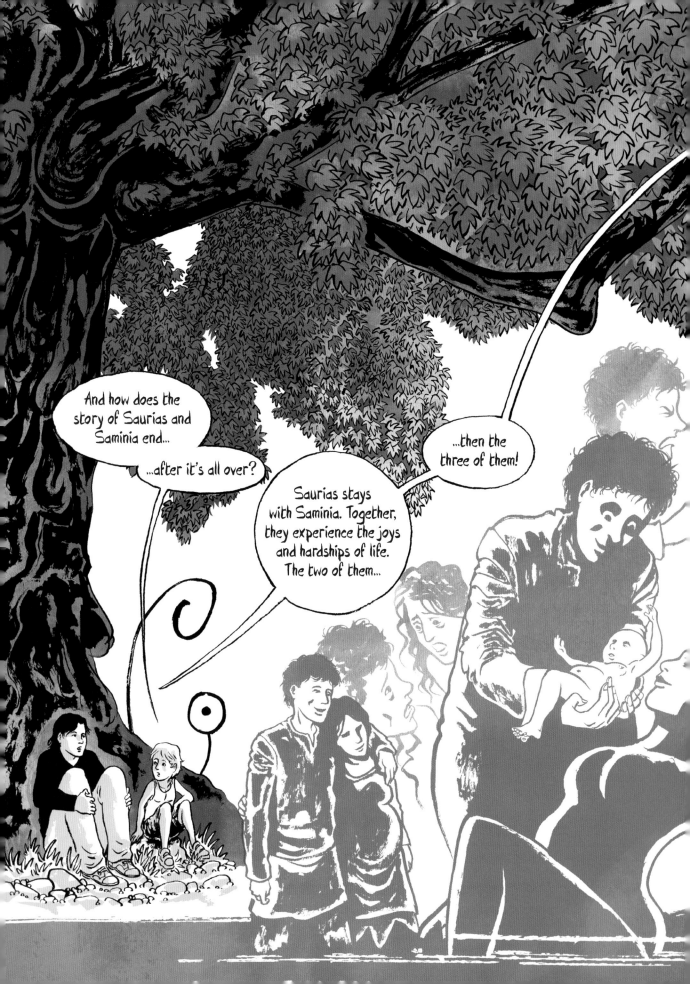

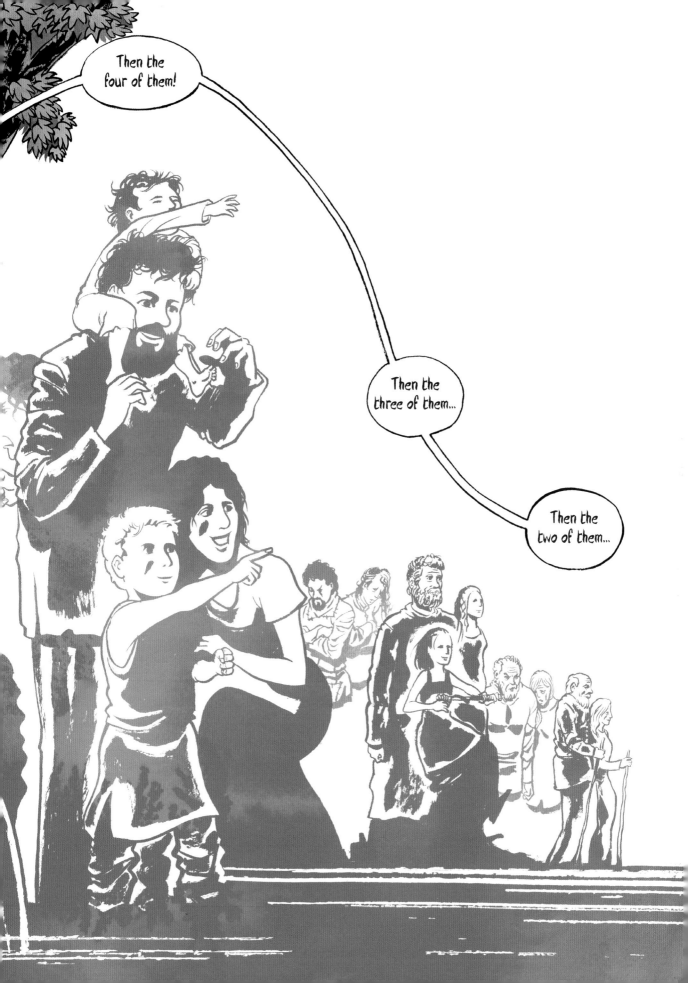

One night, Saurias understands that the time of the Great Passing has come for him.

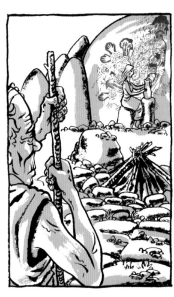

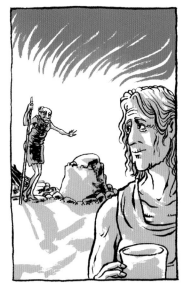

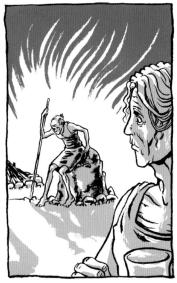

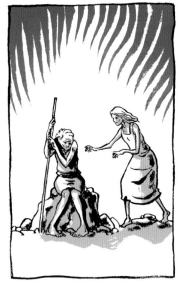

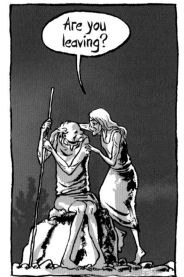

Are you leaving?

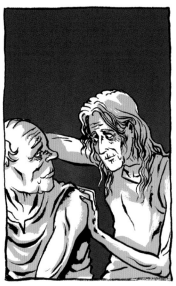

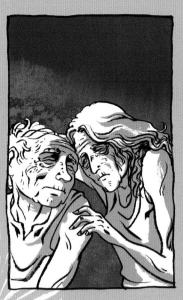

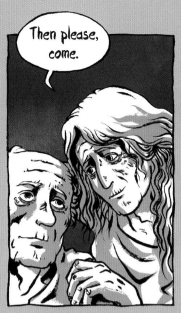

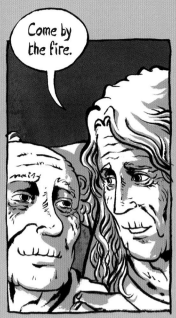

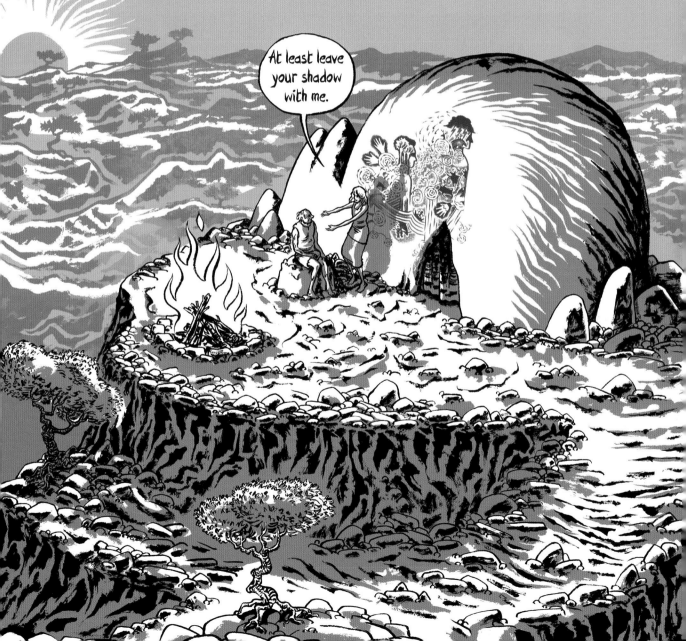

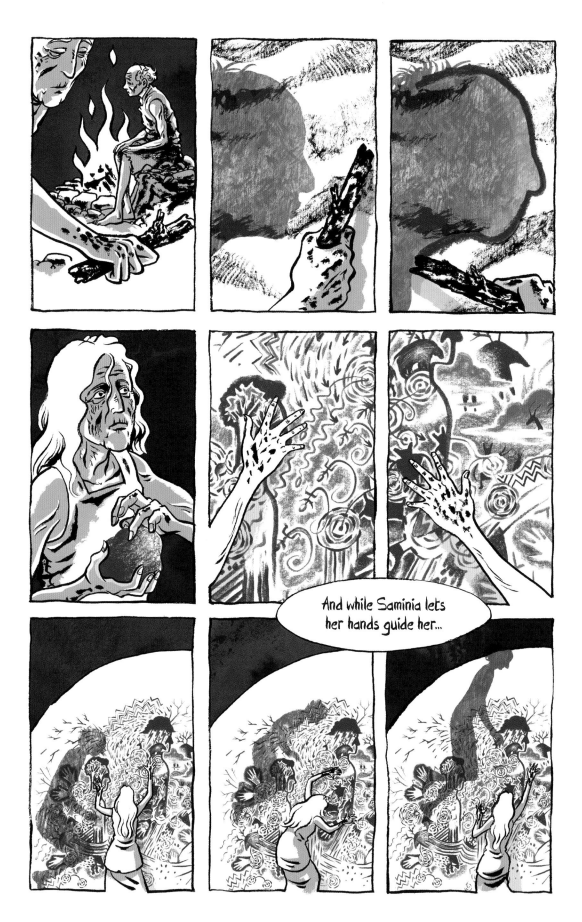

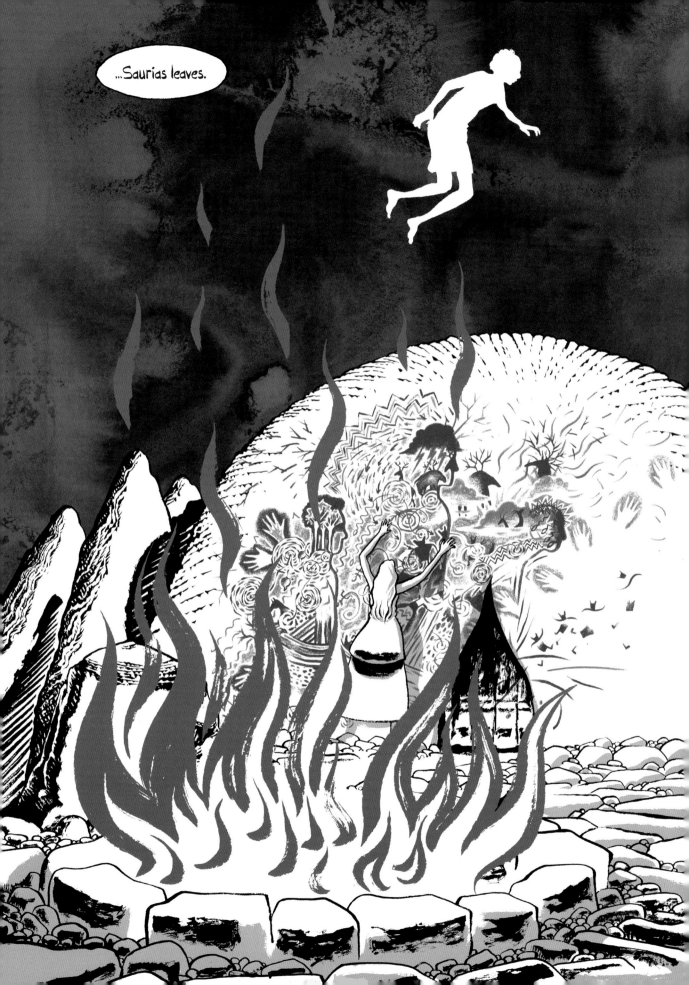

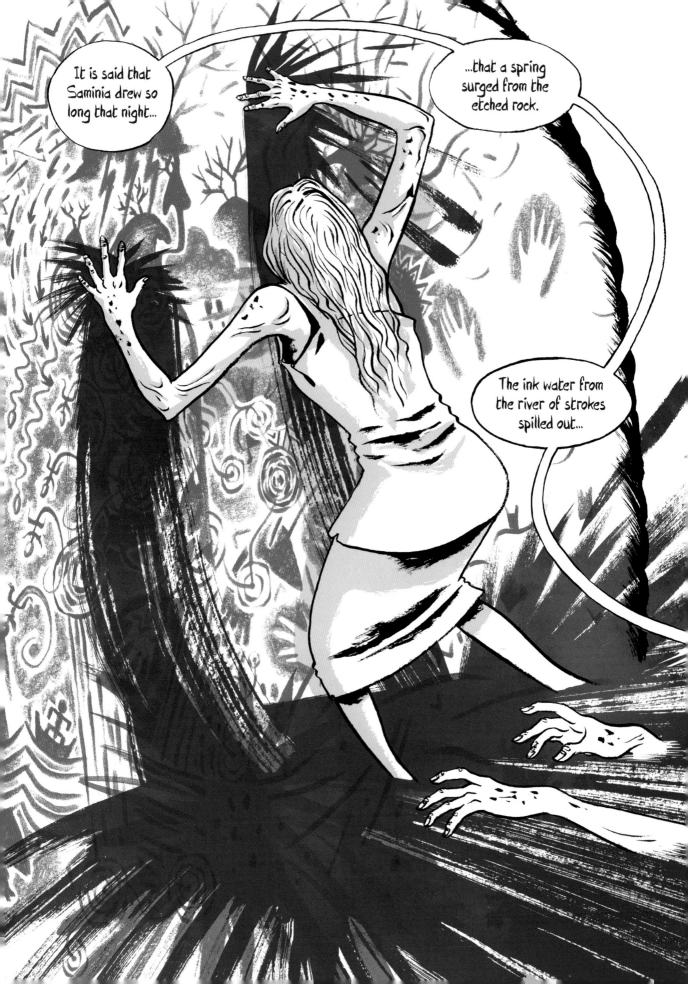

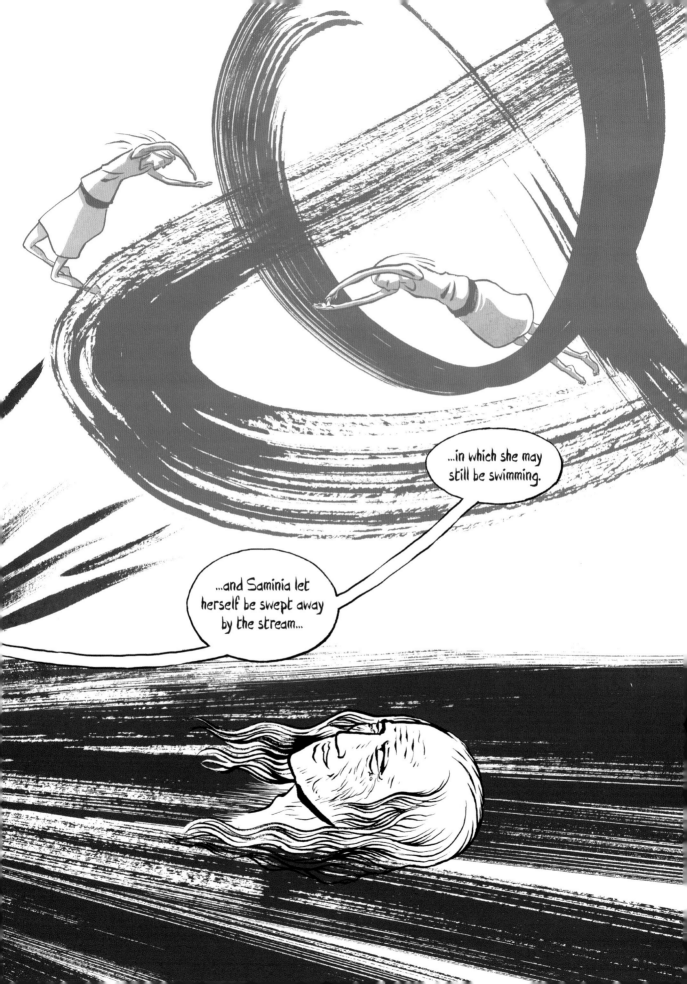

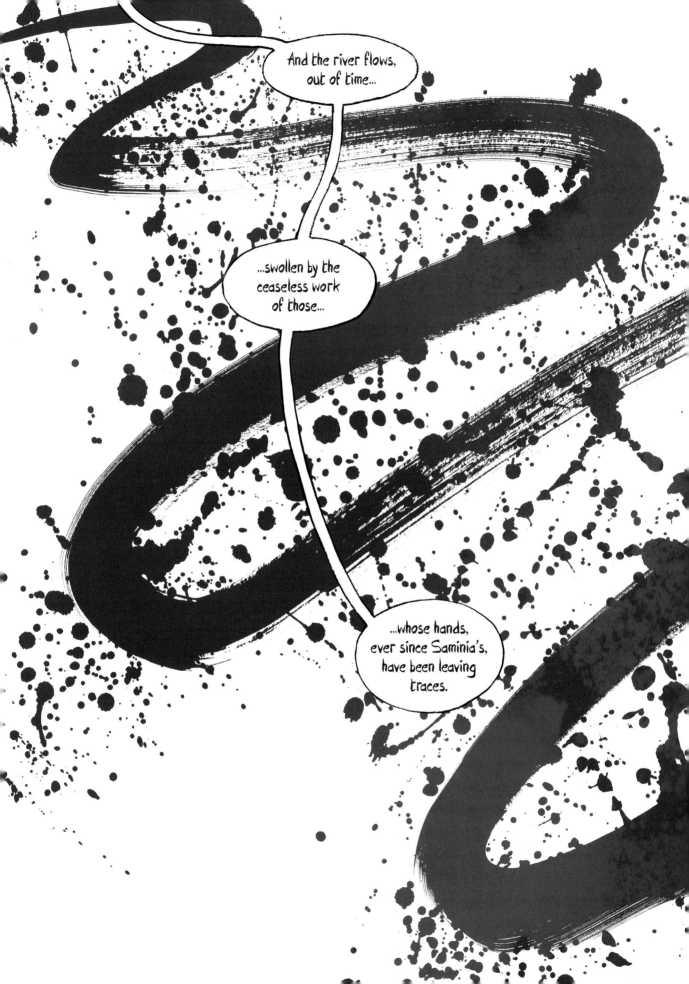

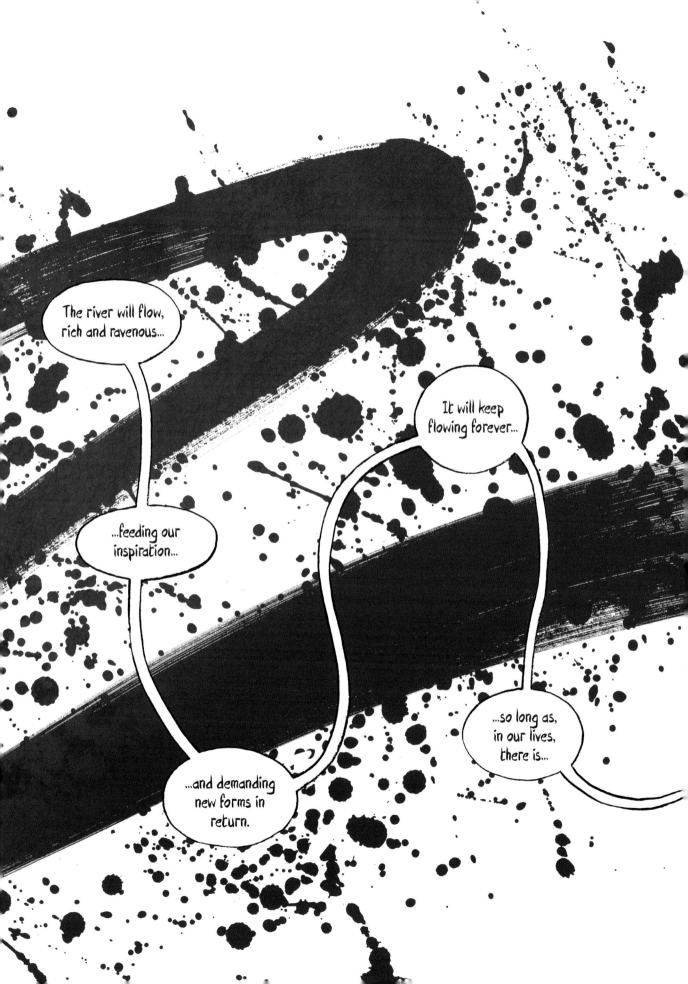

...plenty
of shadow...

...and plenty
of light.

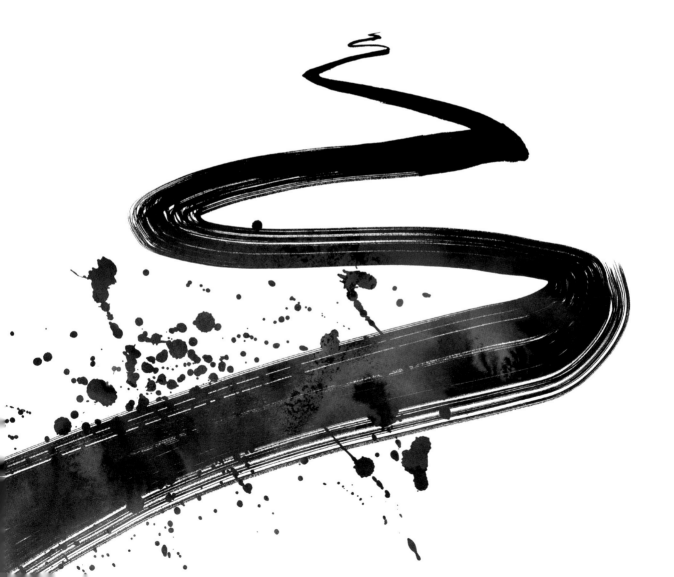

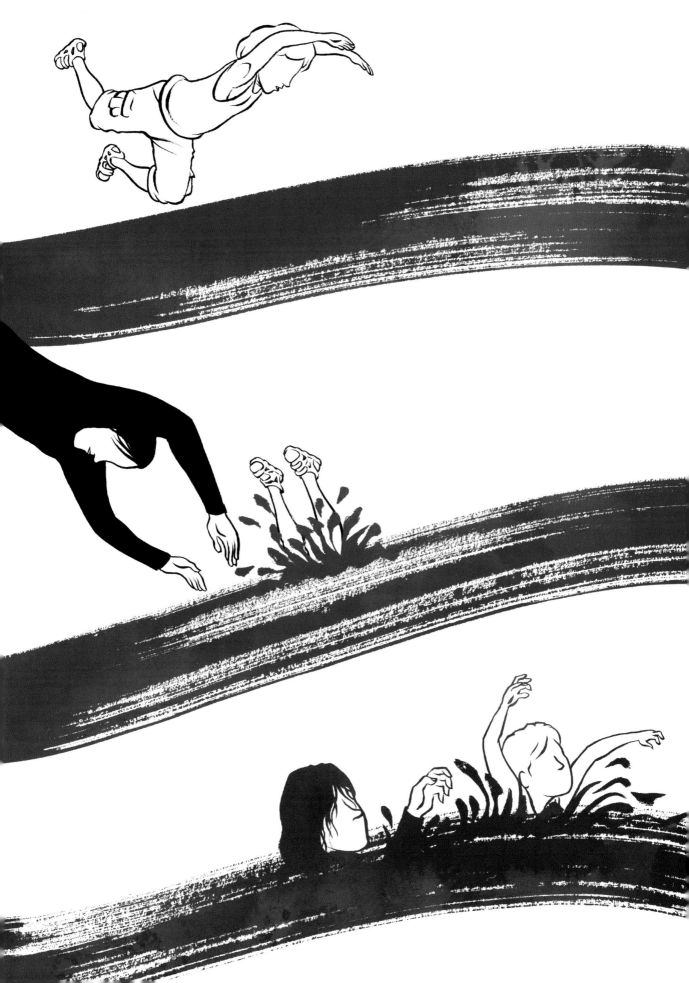

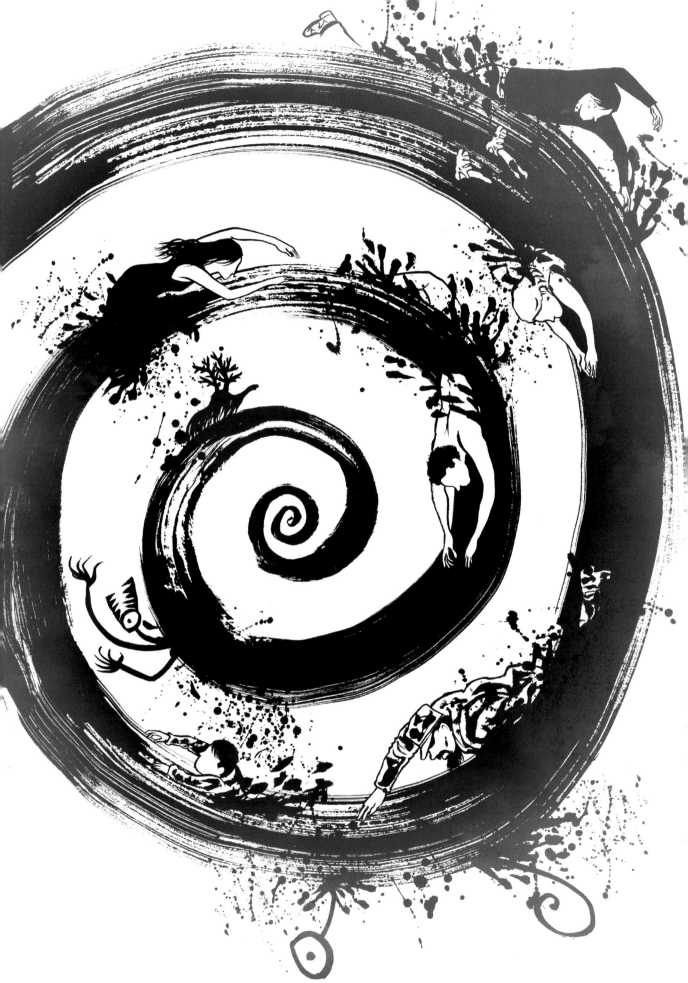

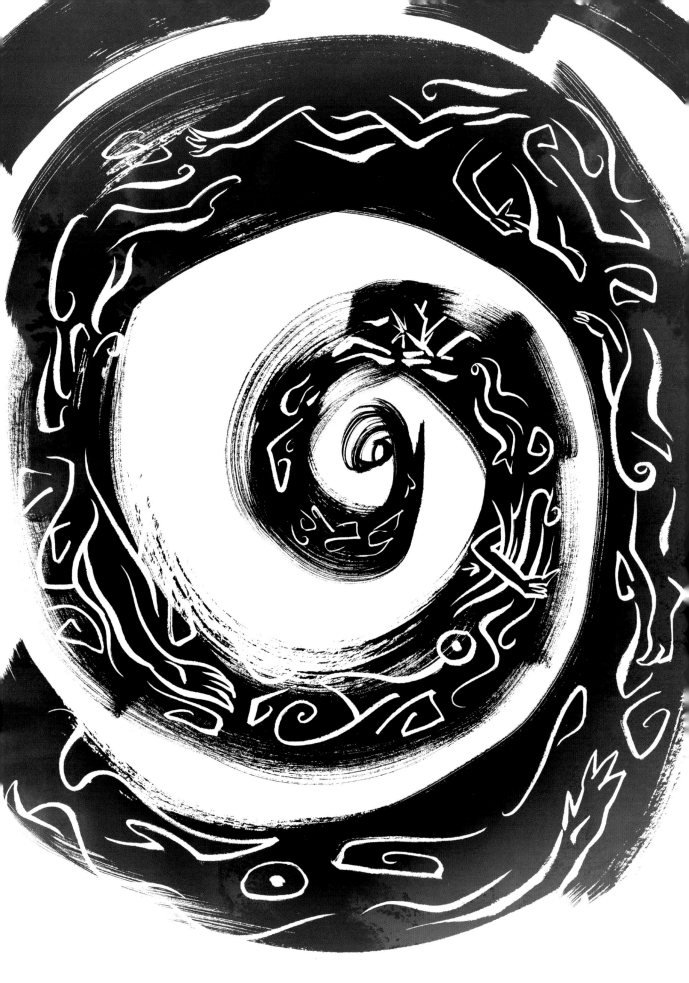

September 2013
June 2019

For the original French-language edition of *River of Ink*, Etienne Appert conducted and incorporated actual interviews with two of his artistic heroes, legends Edmond Baudoin and François Boucq. For this English-language edition, he made contact with another of his idols, the esteemed American cartoonist and innovator Scott McCloud. Their interview, in illustrated form, is included on the following pages as a bonus supplement.

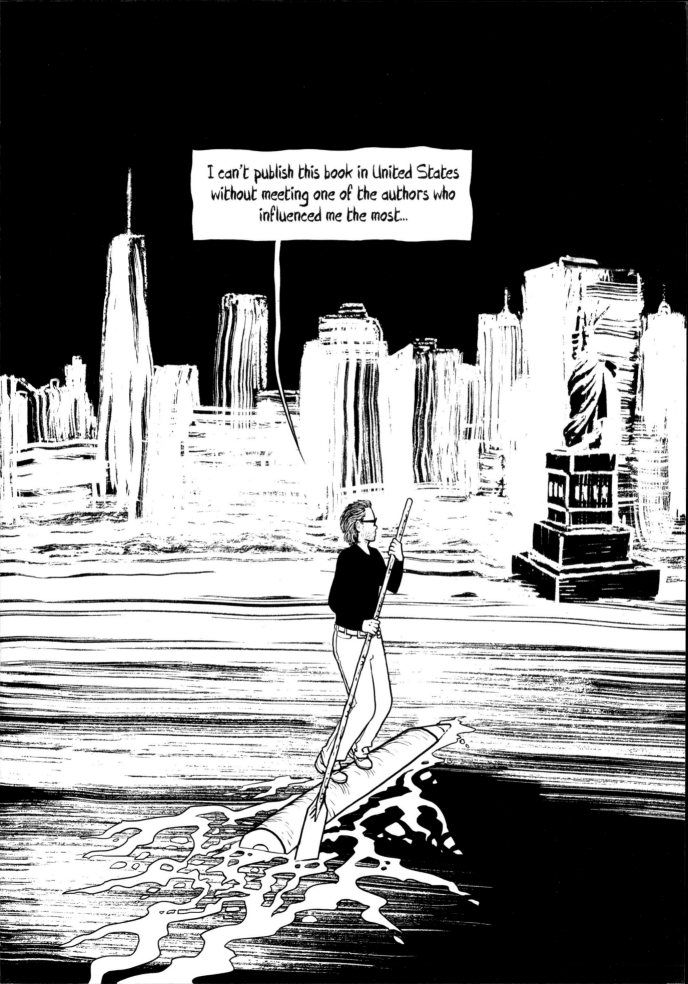

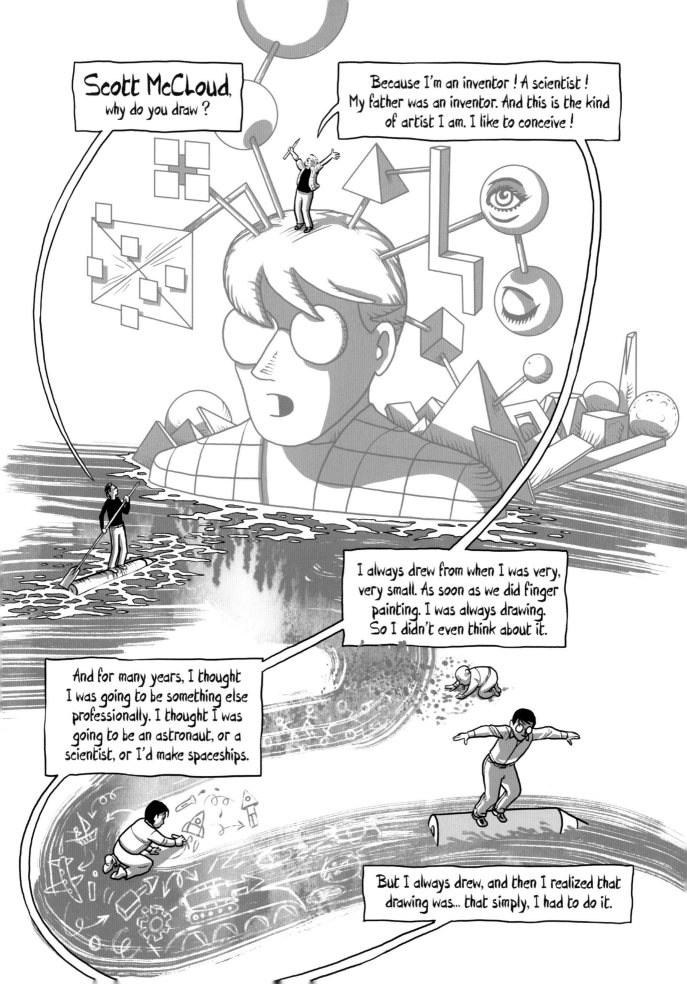

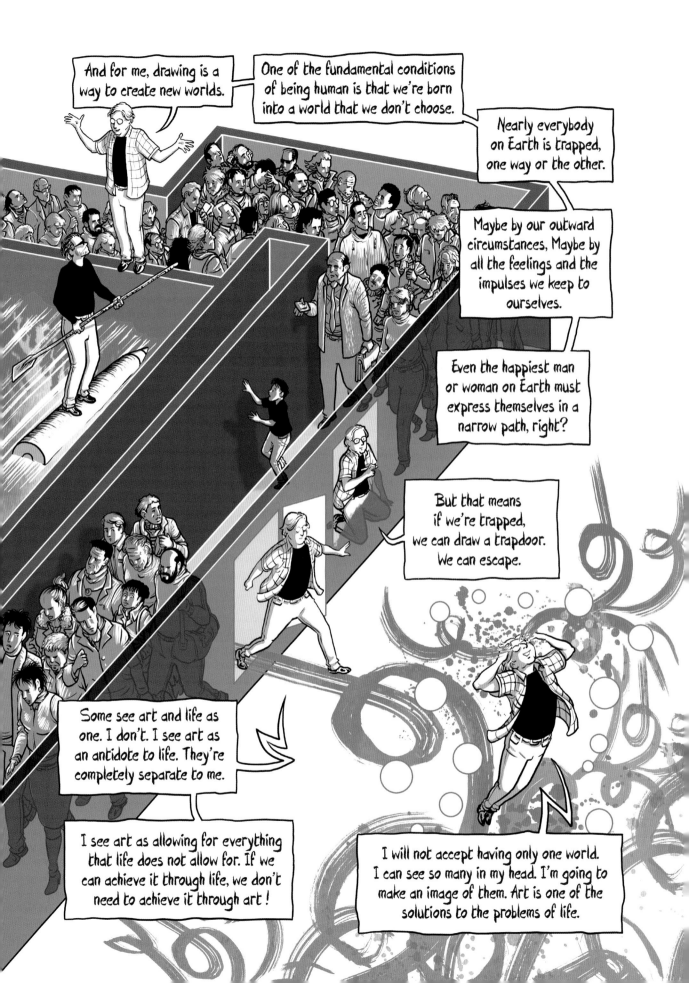

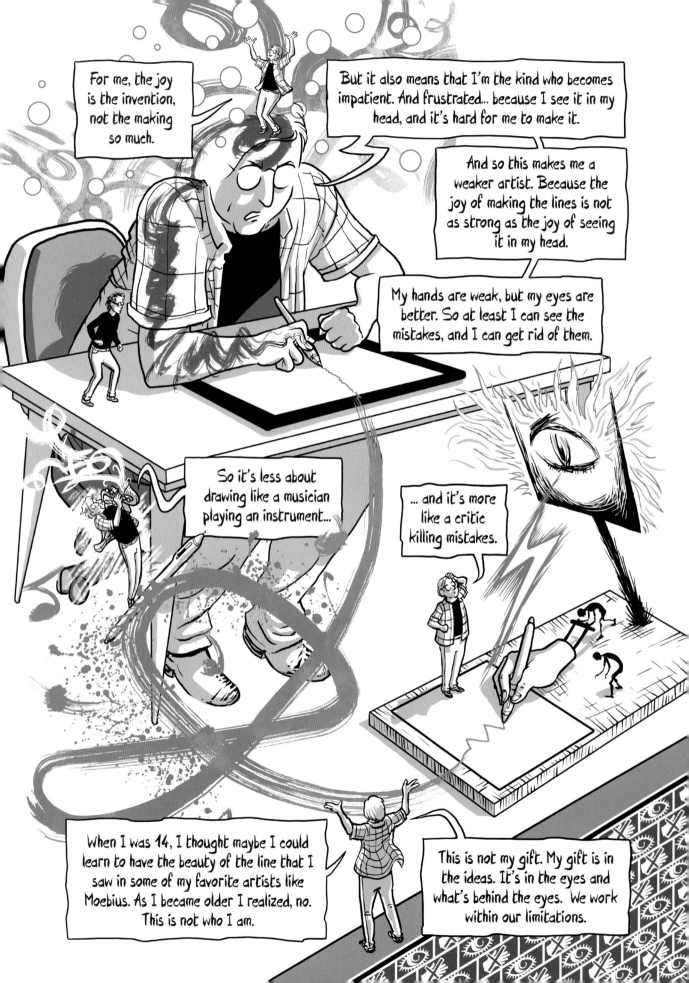

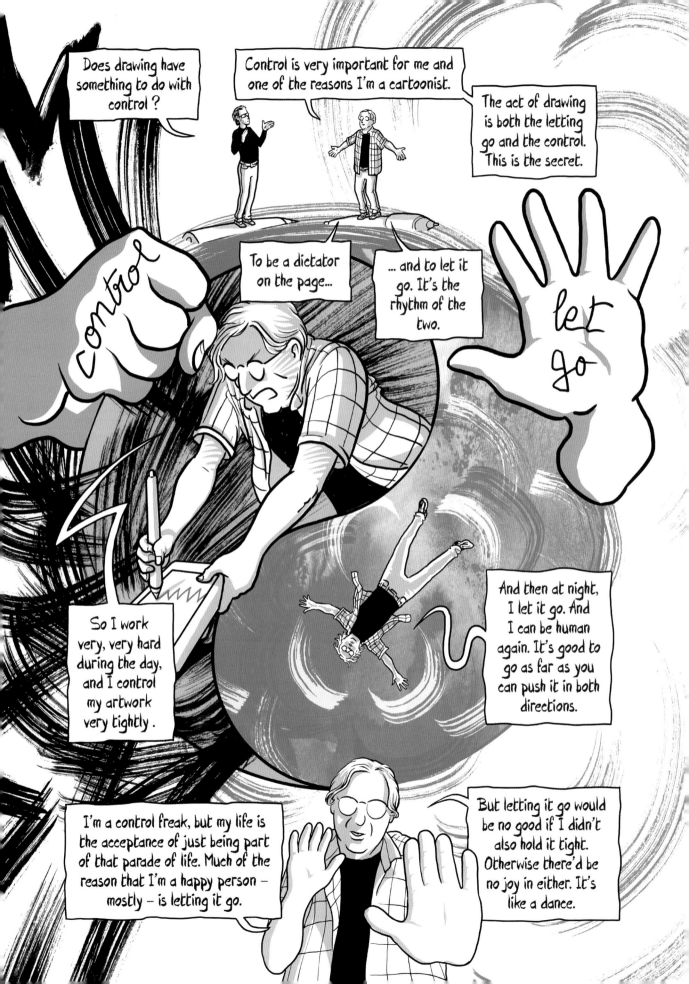

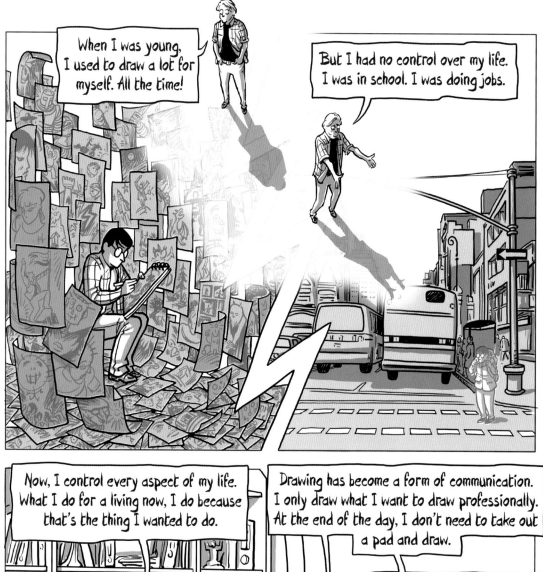

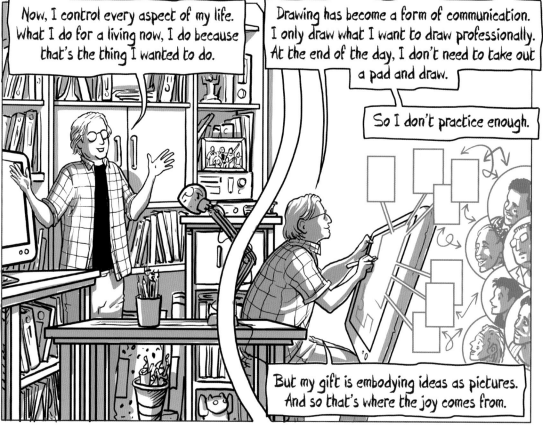

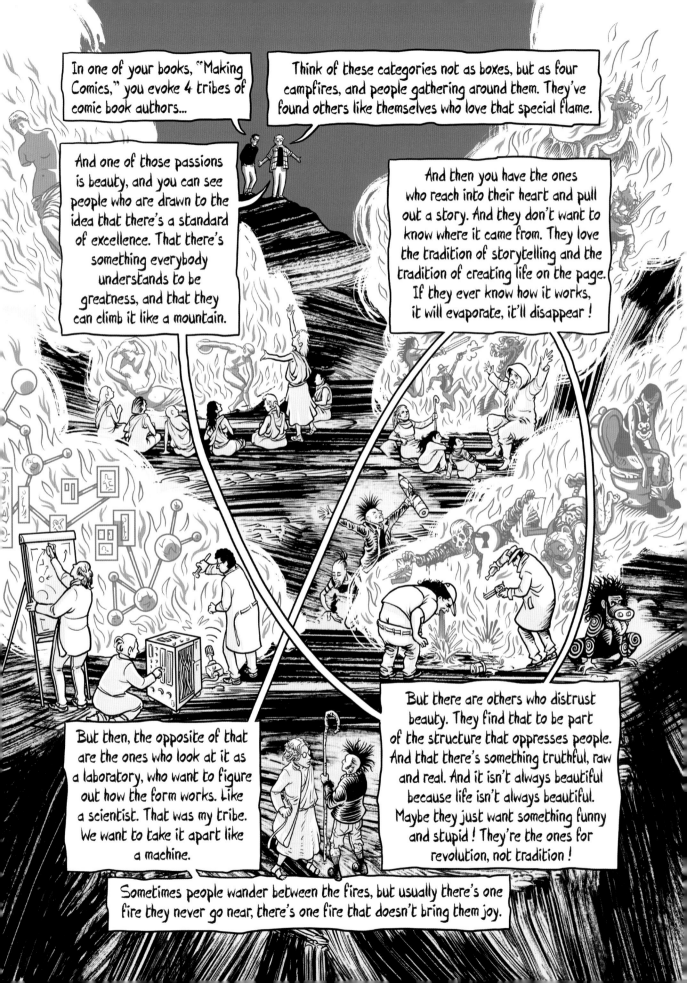

In one of your books, "Making Comics," you evoke 4 tribes of comic book authors...

Think of these categories not as boxes, but as four campfires, and people gathering around them. They've found others like themselves who love that special flame.

And one of those passions is beauty, and you can see people who are drawn to the idea that there's a standard of excellence. That there's something everybody understands to be greatness, and that they can climb it like a mountain.

And then you have the ones who reach into their heart and pull out a story. And they don't want to know where it came from. They love the tradition of storytelling and the tradition of creating life on the page. If they ever know how it works, it will evaporate, it'll disappear !

But then, the opposite of that are the ones who look at it as a laboratory, who want to figure out how the form works. Like a scientist. That was my tribe. We want to take it apart like a machine.

But there are others who distrust beauty. They find that to be part of the structure that oppresses people. And that there's something truthful, raw and real. And it isn't always beautiful because life isn't always beautiful. Maybe they just want something funny and stupid ! They're the ones for revolution, not tradition !

Sometimes people wander between the fires, but usually there's one fire they never go near, there's one fire that doesn't bring them joy.

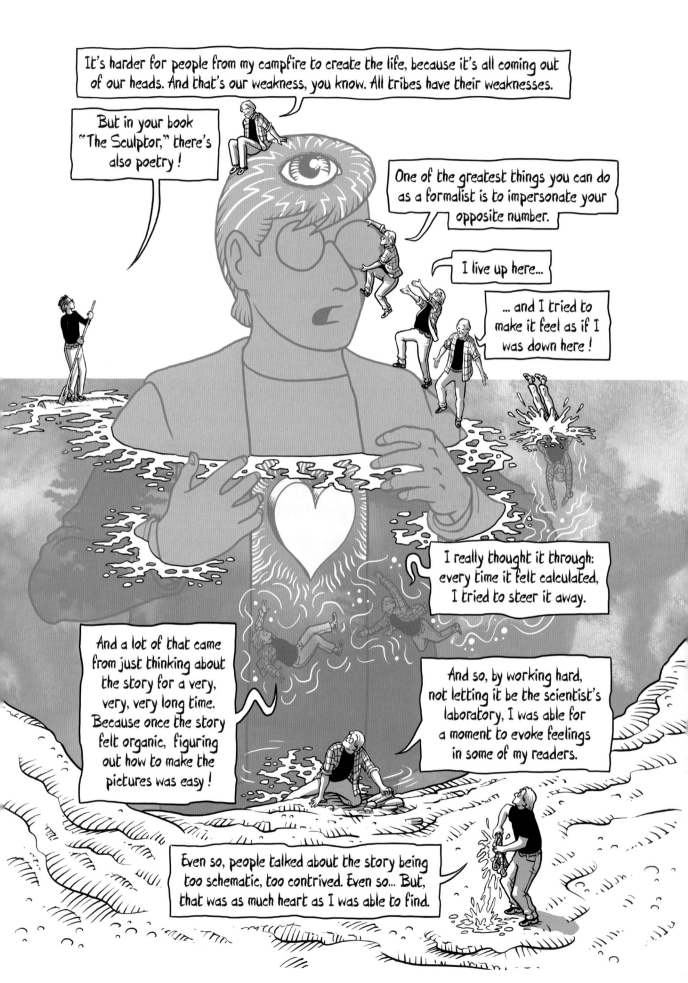

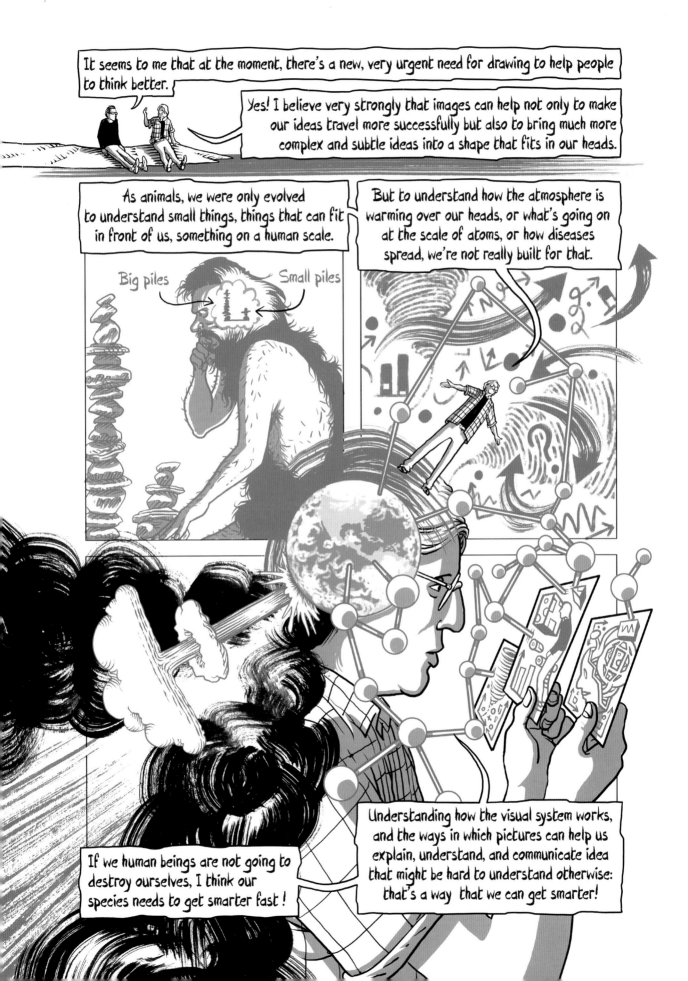

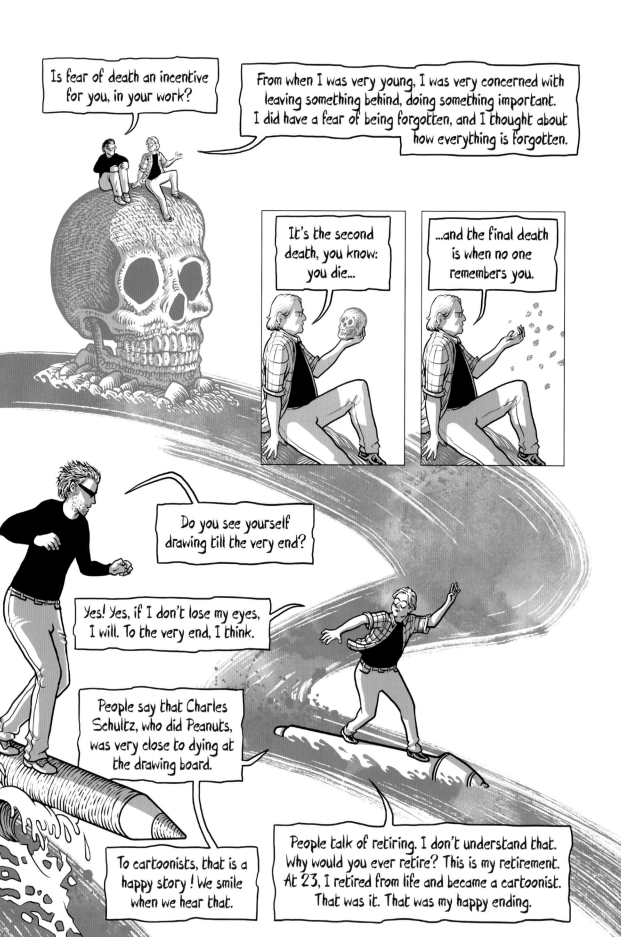

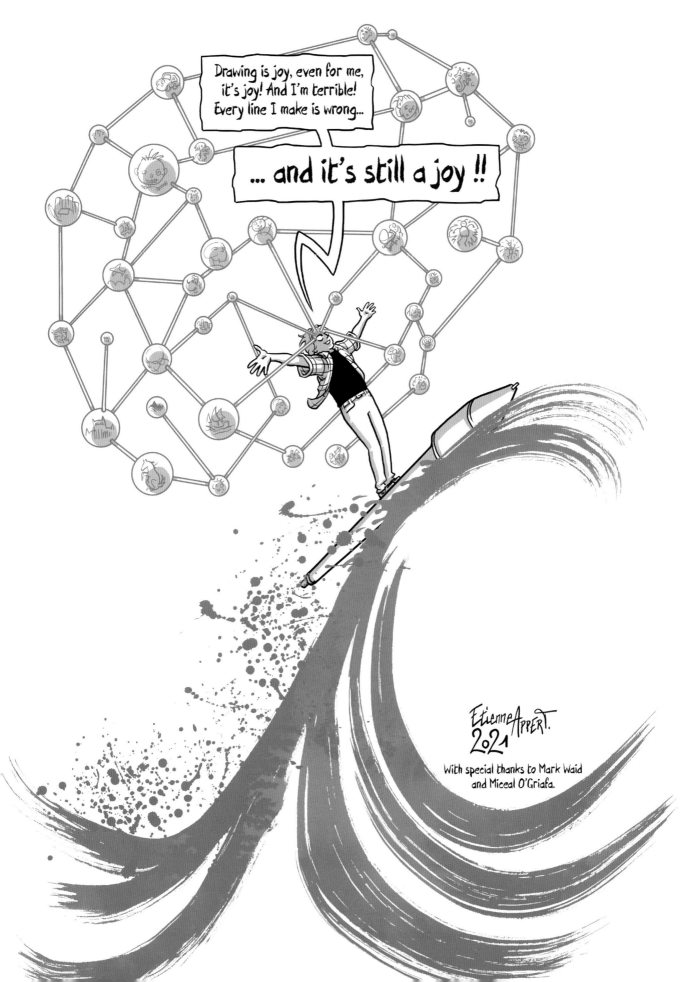

ABOUT THE AUTHOR'S INSPIRATIONS

Edmond Baudoin

Edmond Baudoin, described as "an ink-stained Proust," was born in Nice, France in 1942. An accountant as a young adult, he only began following his lifetime dream of drawing comics professionally at age 33. He made up for lost time, however, soon becoming a prolific author and a guiding light of contemporary European comics, winning prizes at the Angoulême Comics Festival for his books *Couma acò* (Best Album, 1992) and *Le Voyage* (Best Script, 1997). From his earliest works, Baudoin focused on incorporating autobiographical elements into his projects, making him one of the first French cartoonists to explore a genre which has since become one of the most prominent in European literary comics. (American audiences got their first look at Baudoin's work in the final issue of Robert Crumb and Aline Kominsky's anthology, *Weirdo*.) Baudoin's unconventional, brush-heavy illustrative techniques and the philosophical nature of his memoirs have helped make him one of Europe's most respected cartoonists.

François Boucq

Born in 1955 in Lille, France, François Boucq began his career as a cartoonist for magazines such as *Le Point*, *L'Expansion*, and *Playboy*. Though his style has a realistic nature, he excelled in political caricatures and absurdist humor. Beginning in his late twenties, he turned his skills towards graphic novels, working with several prominent writers including Philippe Delan, with whom he created the memorable character of Rock Mastard, and later Alejandro Jodorowsky, his collaborator on *Moon Face*.

In 1998, Boucq was awarded the highest honor in the European graphic novel industry, the Grand Prix de la Ville at the Angoulême Comics Festival. After producing several more original comic works, he resumed his artistic relationship with Jodorowsky in 2001, and together they created *Bouncer*, a bleak and compelling western which quickly became one of the most popular continuing series currently being published in Europe.

Boucq is perhaps most famous for his surreal works starring his creation, the leopard-skin-wearing insurance agent Jérôme Moucherot.

Scott McCloud

Scott McCloud is an American cartoonist and comics theorist best known for his non-fiction graphic novels about comics: *Understanding Comics* (1993), *Reinventing Comics* (2000), and *Making Comics* (2006). McCloud established himself as a comics creator in the 1980s with *Zot!* and rose to prominence in the industry shortly thereafter as an advocate for creators' rights and in the then-nascent field of digital comics. McCloud's innovative "24 Hour Comics"–24-page comics created and finished all within a 24-hour span–has become an international annual event with thousands of participants. His long-awaited graphic novel *The Sculptor* was released in 2015, reaffirming his place in the history of American graphic fiction. McCloud continues to lecture and teach his theories, having spoken at MIT, Google, Harvard, Pixar, DARPA, The Sydney Opera House, and more than 400 other destinations over the years.